ILLUSTRATION. PLAY

CRAVING FOR THE EXTRAORDINARY

viction:ary

Illustration • Play
Craving For The Extraordinary

First published and distributed by viction:workshop ltd.

viction:ary

Unit C, 7th Floor, Seabright Plaza,
9-23 Shell Street, North Point, Hong Kong
URL: www.victionary.com
Email: we@victionary.com

Edited and produced by viction:workshop ltd.

Book design by viction:design workshop
Concepts & art direction by Victor Cheung

©2008 viction:workshop ltd.
The copyright on the individual texts and design work is held by the respective designers and contributors.

Fourth edition
ISBN 978-988-98229-3-4

EUR & US edition
Printed and bound in China

Acknowledgement

We would like to thank all the designers and companies who made a significant contribution to the compilation of this book. Without them, this project would not have been possible.

We would like to thank all the producers for their invaluable assistance throughout. Its successful completion also owes a great deal to many professionals in the creative industry who have given us precious insights and comments. We are also very grateful to many other people whose names do not appear on the credits for making specific input and continuous support the whole time.

Future Editions

If you would like to contribute to the next edition of Victionary, please email us your details to submit@victionary.com

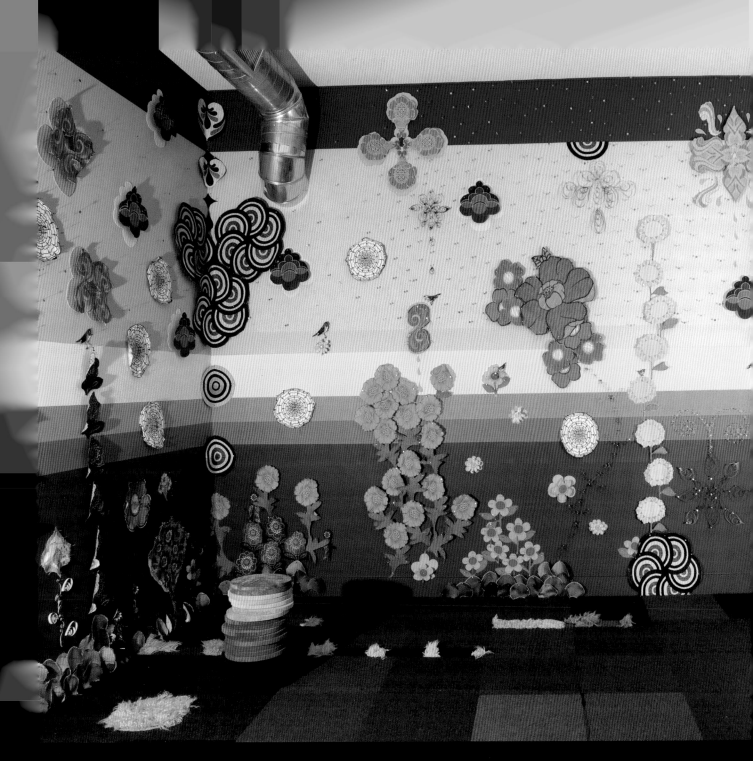

TITLE: Morning Glory

MEDIA: Installation

MATERIAL: Paint, Textiles - Curtains from the 60s and 70s, Felt, Pins, Floor pieces – Plywood, Suede, Carpet, Taxidermy rooster

DESCRIPTION: Morning Glory is a common name for over a thousand species of flowering plants in the family the Convolvulaceae , belonging to the following genera: Calystegia, Convolvulus, Ipomoea, Merremia and Rivea.

As the name implies, morning glory flowers, which are funnel-shaped, open at morning time, allowing them to be pollinated by hummingbirds, butterflies, bees and other daytime insects and birds, as well as Hawkmoth at dusk for longer blooming variants. The flower typically lasts for a single morning and dies in the afternoon. New flowers bloom each day. The flowers usually start to fade a couple of hours before the petals start showing visible curling. They prefer full sun throughout the day, and mesic soils. In cultivation, most are treated as perennial plants in tropical areas, and as annual plants in colder climates, but some species tolerate winter cold.

Chase back to its origin, it was first known in China for its medicinal uses and was introduced to the Japanese in the 9th century. The site was named at the places like Mexico and America at Museum of

TITLE: Spring Drawings
MEDIA: Drawings
MATERIAL: Gouache, Pen, Quilling (paper craft)
DESCRIPTION: A series of words and scenes that the artist used to describe the title:

Time for play; Growth; Renewal; Laying in bed sipping tea, reading and listening to the rain; The smell of earthworms and oak; Streets covered with earthworms after a big storm; Flowers starting to bloom; Return of the sun; Baby animals; The sound of birds chirping; Listening to the river crackle as it melts; Return of snakes; More people on the streets; Armyworms falling from the trees; The cat going outside more; Barbeques with Mojitos; Looking forward to summer; Allergies; Sunlight glittering and bouncing off the leaves; Smell of cut grass and more.

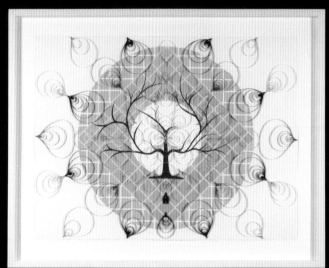

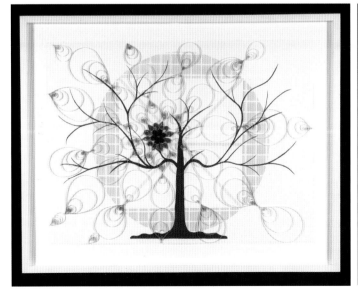

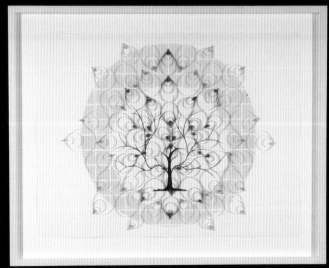

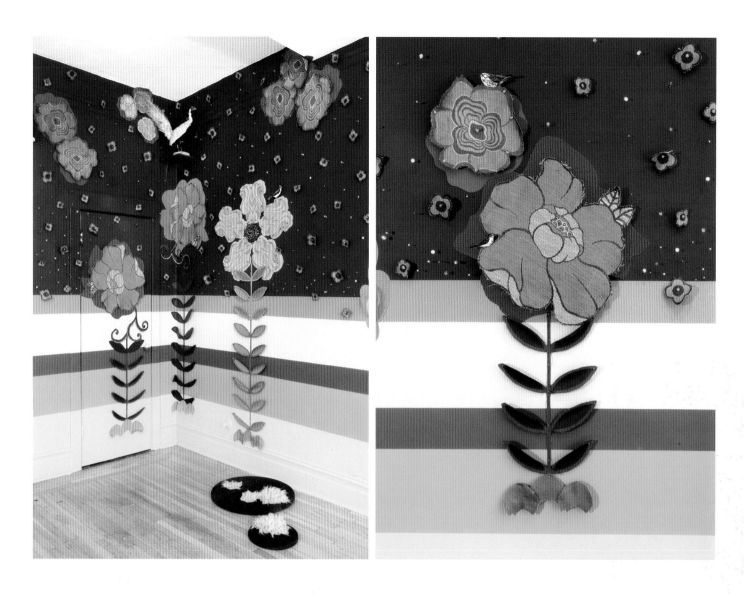

TITLE: Night Bloom

MEDIA: Installation

MATERIAL: Paint, Textiles – Curtains from the 60s and 70s, Felt, Pins, Floor pieces – Plywood, Suede, Carpet

DESCRIPTION: Night Bloom is inspired by Wilson's love of patterns and textiles and the complex relationships and evolution between conventional/structured practices and e nvironments (physical and psychological) and those of a dissenting and organic nature. Visually this has translated into the intersections and historical contexts between fine art, design, architecture, and traditional crafts. The landscape of Night Bloom is a fantastical flourish of colors, shapes, and textures that aims to give viewers the same experience of magical awe that one has in the Big Sky country.

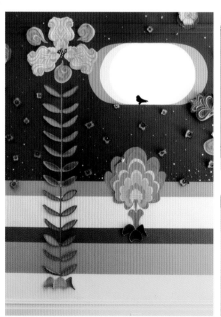

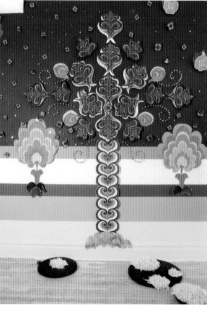

MEGAN WILSON

San Francisco, USA

MEGAN WILSON GREW UP IN MONTANA. SHE RECEIVED HER BFA FROM THE UNIVERSITY OF OREGON IN 1992 AND AN MFA FROM THE SAN FRANCISCO ART INSTITUTE IN 1997. HER WORK HAS BEEN EXHIBITED IN MANY PLACES LIKE SAN FRANCISCO AT SOUTHERN EXPOSURE, THE SAN FRANCISCO ART COMMISSION, AND IN PUBLIC SPACES THROUGHOUT SAN FRANCISCO, LOS ANGELES AND INTERNATIONALLY IN JAPAN, INDONESIA, FRANCE, INDIA, ETC.

WILSON IS A RECIPIENT OF A 2000 GRANT AWARD FROM THE GUNK FOUNDATION, A 2001 GRANT AWARD FROM THE ART COUNCIL/ARTADIA, AND AN INDIVIDUAL ARTIST COMMISSION GRANT AWARD IN 2005/06 FROM THE SAN FRANCISCO ARTS COMMISSION.

SHE IS ALSO A FREELANCE WRITER AND ART CRITIC. IN 2000-2001 SHE WAS A WEEKLY CON-TRIBUTING ARTS WRITER FOR THE SF BAY GUARDIAN. SHE CO-FOUNDED THE SAN FRANCISCO BASED ARTS WEBSITE WWW.STRETCHER.ORG.

WILSON IS CURRENTLY WORKING ON HER PROJECT HOME 1996-2008 THAT WAS STARTED IN 2004 AND WILL BE COMPLETED IN 2007/08, THANKS TO A GENEROUS INDIVIDUAL ARTIST COMMISSION GRANT FROM THE SAN FRANCISCO ARTS COMMISSION.

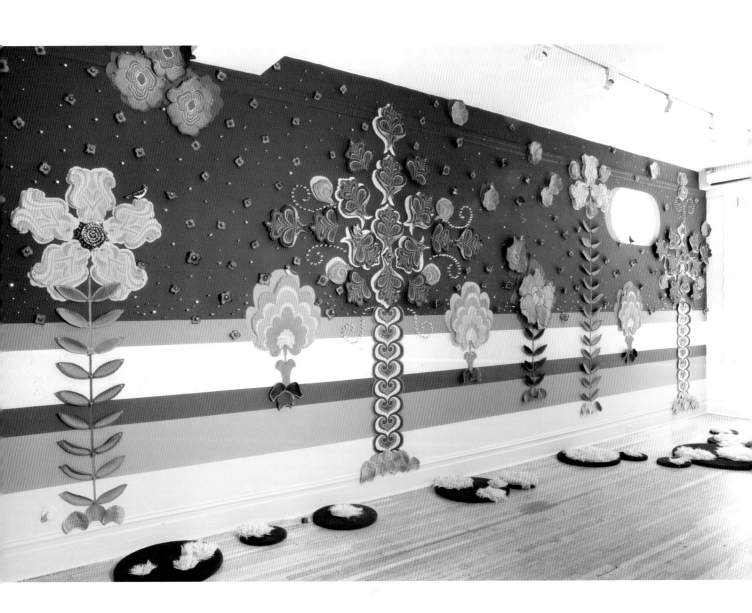

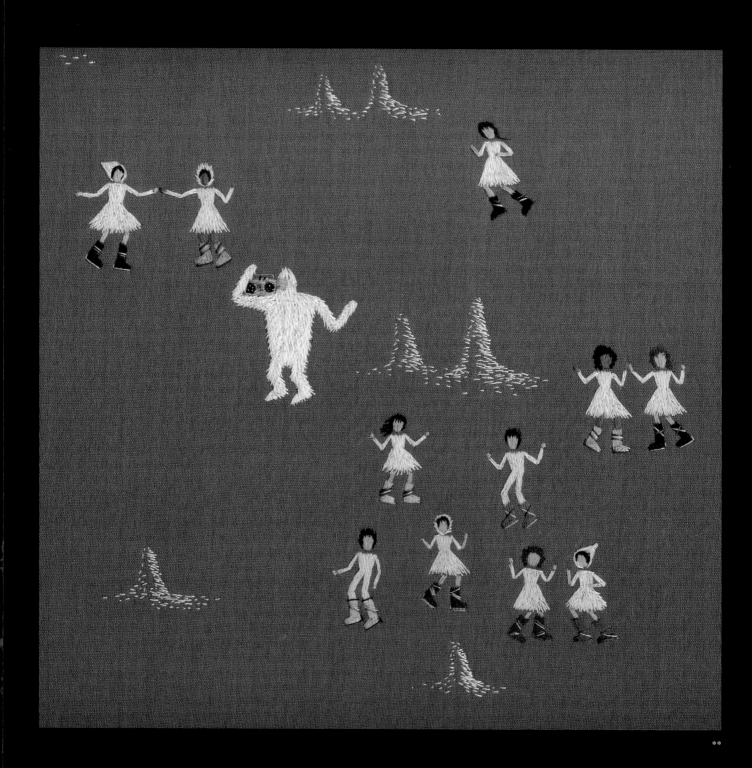

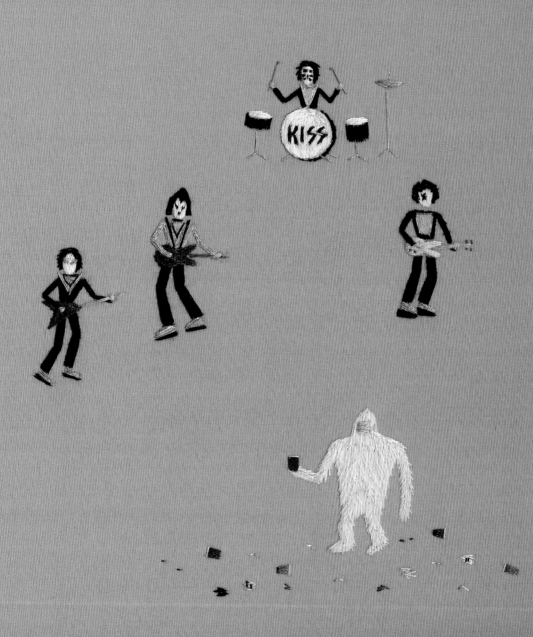

TITLE: Pink Break-dance*
MEDIA: Hand embroidery
MATERIAL: Polished cotton
DESCRIPTION: The name is pretty self-explanatory. People there are having fun and break-dancing with yetis.

TITLE: Kong Talks To Kitt**
MEDIA: Hand embroidery
MATERIAL: Polished cotton
DESCRIPTION: This piece shows King Kong talking to Kitt the car. They are friends.

TITLE: Crystal Apocolypse***
MEDIA: Hand embroidery
MATERIAL: Polished cotton
DESCRIPTION: This shows elves and yetis in battle gear and with some crystals.

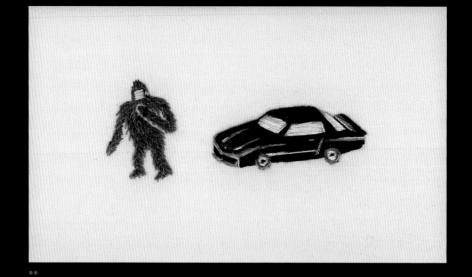

**

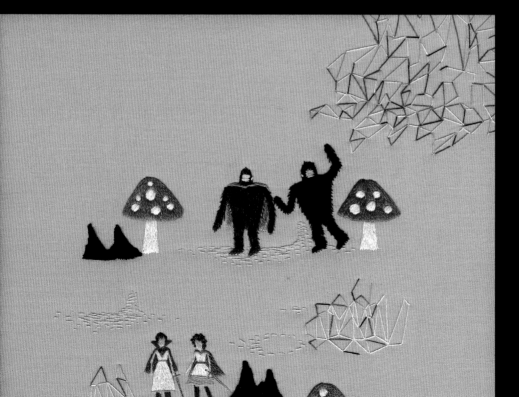

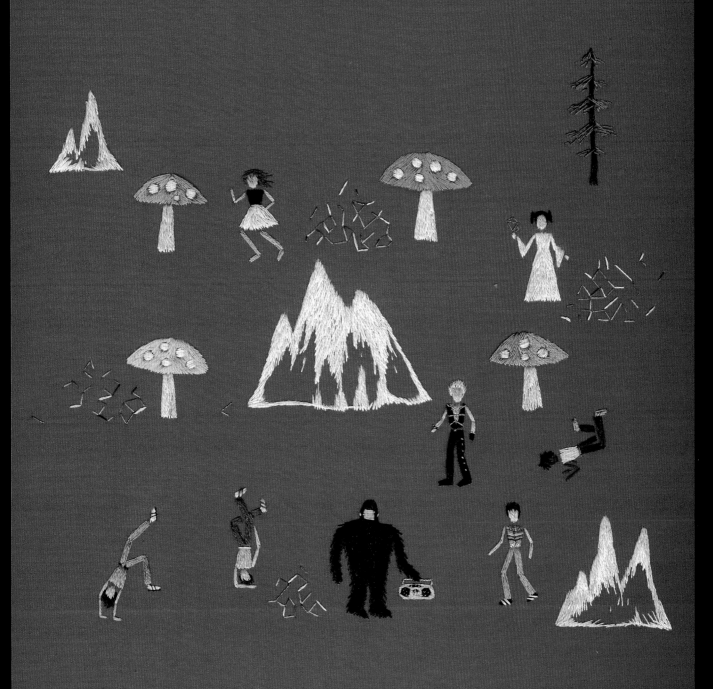

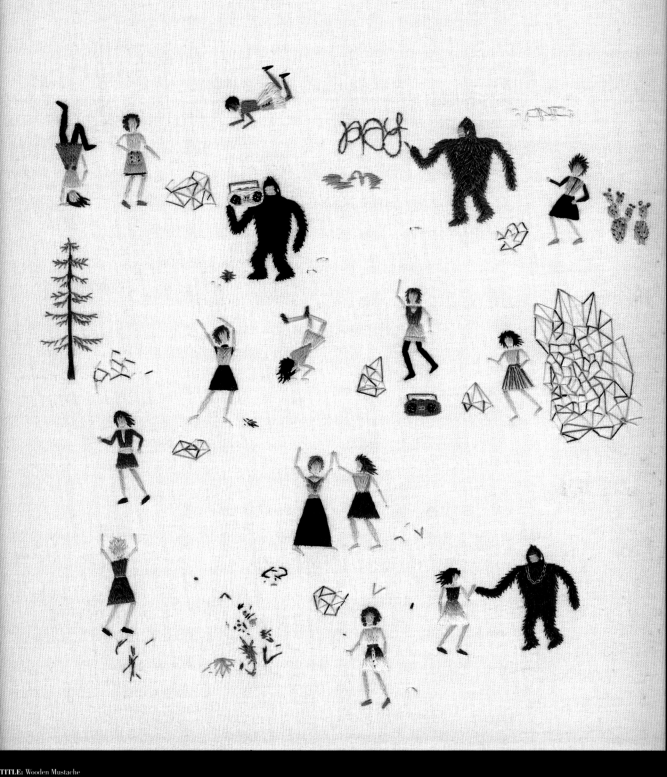

TITLE: Wooden Mustache
MEDIA: Hand embroidery
MATERIAL: Polished cotton
DESCRIPTION: This piece shows a bunch of happy
elves in Los Angeles wearing Wooden Mustache clothes
— a rad LA label.

MATERIAL: Polished cotton
DESCRIPTION: This piece depicts King Kong with Robert Indiana's sculpture from the 60's that Megan thinks is awesome.

TITLE: Yeti & Franz Kline**
MEDIA: Hand embroidery
MATERIAL: Polished cotton
DESCRIPTION: This piece shows a yeti looking at a Franz Kline piece. Megan thinks he is smoking a cigarette too which you would probably not be able to do in a museum so maybe he owns it.

*

**

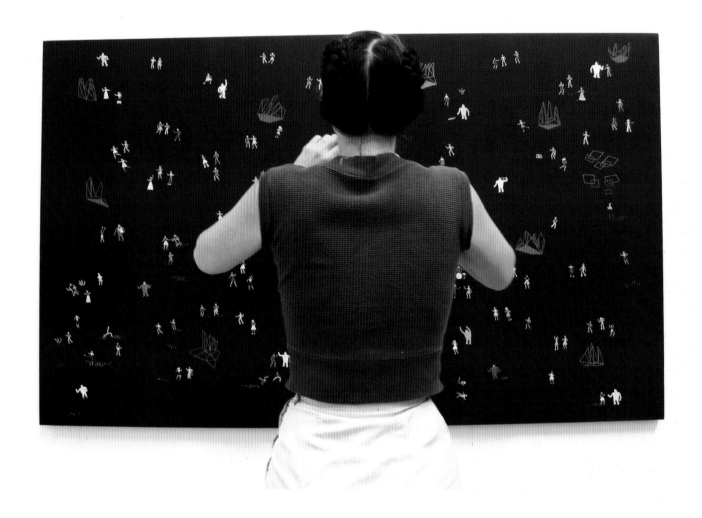

MEGAN WHITMARSH

Los Angeles, USA

WHEN MEGAN WAS A KID SHE USED TO ILLUSTRATE BUFFY STE. MARIE SONGS AND WRITE LETTERS TO JANIS JOPLIN AND MAKE GIANT, JOINTED PAPER DOLLS OUT OF MANILA FOLDERS.

MEGAN MADE HER FIRST COMIC BOOK WHEN SHE WAS 5 ABOUT A FAMILY OF RABBITS WHO DID STUFF LIKE EATING ICE CREAM AND WATCHING MORK & MINDY (AUTOBIOGRAPHICAL OF COURSE). SHE SEES HER CURRENT ARTISTIC PROCESS AS A SLIGHTLY EVOLVED CONTINUATION OF THESE PRACTICES. THE SLIGHT EVOLUTION MEGAN REFERS TO WOULD BE HER ADULT CONSCIOUSNESS OF THE CONTEXT IN WHICH SHE LIVES. PARTICULARLY EVIDENT IN LOS ANGELES (WHERE SHE LIVES) ARE THE CONTRA-DICTIONS OF MODERN LIFE. IT HAS THE BEAUTY AND DRAMA OF NATURE EXISTING SIMULTANEOUSLY WITH RAMPANT DEVELOPMENT AND SEEDY CONCRETE WASTELANDS POPULATED BY TRASH.

MEGAN IS ATTEMPTING TO RECONCILE THE ATAXIA OF THIS MODERN WORLD WITH HER NATURALLY OPTIMISTIC VISION OF A FUTURE POPULATED BY SUPERNATURAL AND PRECIOUS THINGS. IN OTHER WORDS, SHE WANTS TO TRANSFORM THE MULTIPLICITY OF ORDINARY LIFE INTO MAGICAL YET ACCESSIBLE MOMENTS.

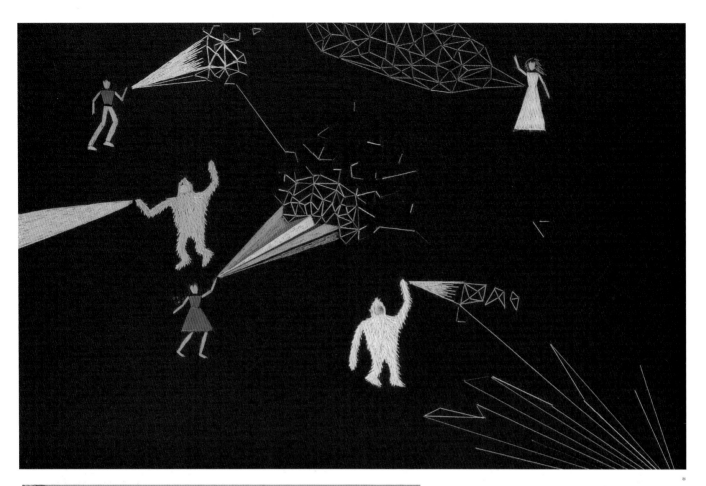

*

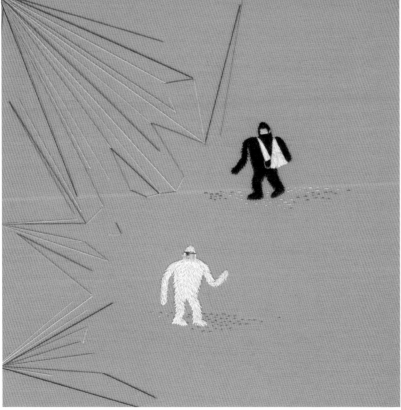

**

TITLE: Cryptic Crpytozoic*
MEDIA: Hand embroidery
MATERIAL: Polished cotton
DESCRIPTION: This piece is about creating and magic.
It contains a secret written in it.

TITLE: Injured Yetis**
MEDIA: Hand embroidery
MATERIAL: Polished cotton
DESCRIPTION: This shows some yetis after a battle.

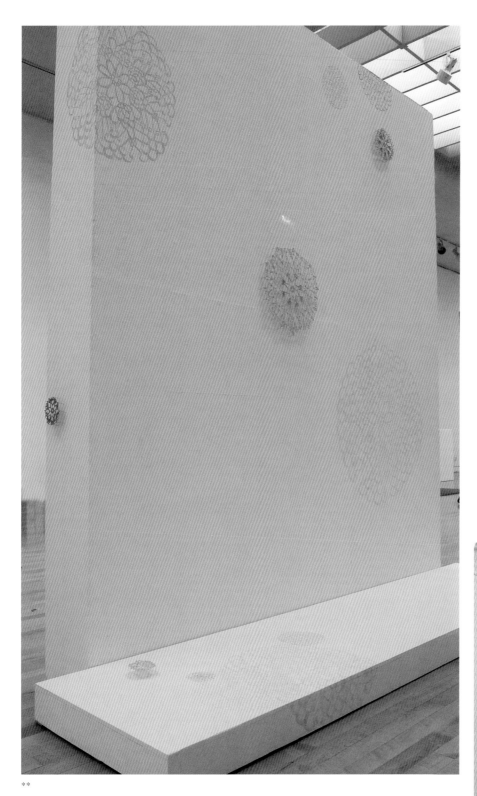

**

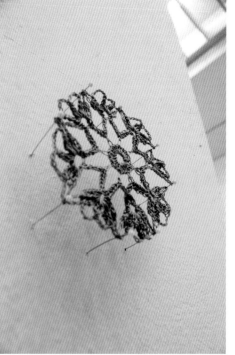

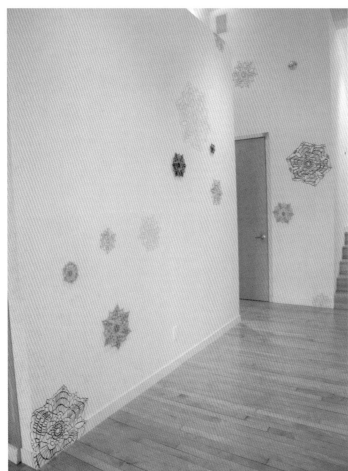

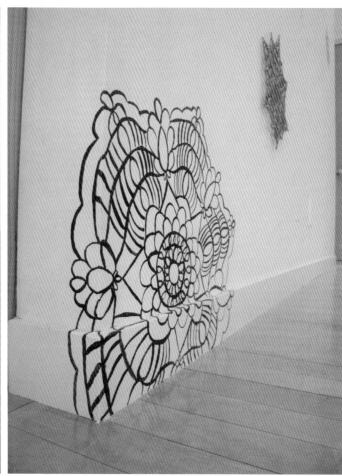

*

TITLE: Wall Work :: Louisiana Star Doily (Installation at Katrina Traywick
Contemporary Art, California)* / Wall Work :: Lily Pond Doily (Installation
at The Richmond Art Center, California)**

MEDIA: Acrylic paint, Crochet thread, Glasshead pins

MATERIAL: Painted and crocheted doilies, Walls

DESCRIPTION: When Lisa started creating doily drawings, she really
wanted to see them in a more 3D context. She is interested in monumental-
izing something normally seen as insignificant, playing with scale, taking
something normally seen flat on a bed of on a table and putting it on the wall.
She is incredibly interested in the interplay between what is 2D and 3D and
what is shadow. Building on the ideas from Lisa's first doily installation, she
did a second one adding 2-vellum drawings into the mix. She was thrilled
to start from the floor and go up, over, and around a freestanding wall – in a
sense playing with more traditional idea of sculpture.

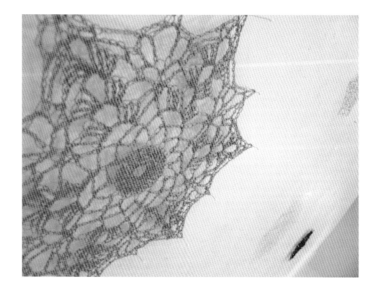

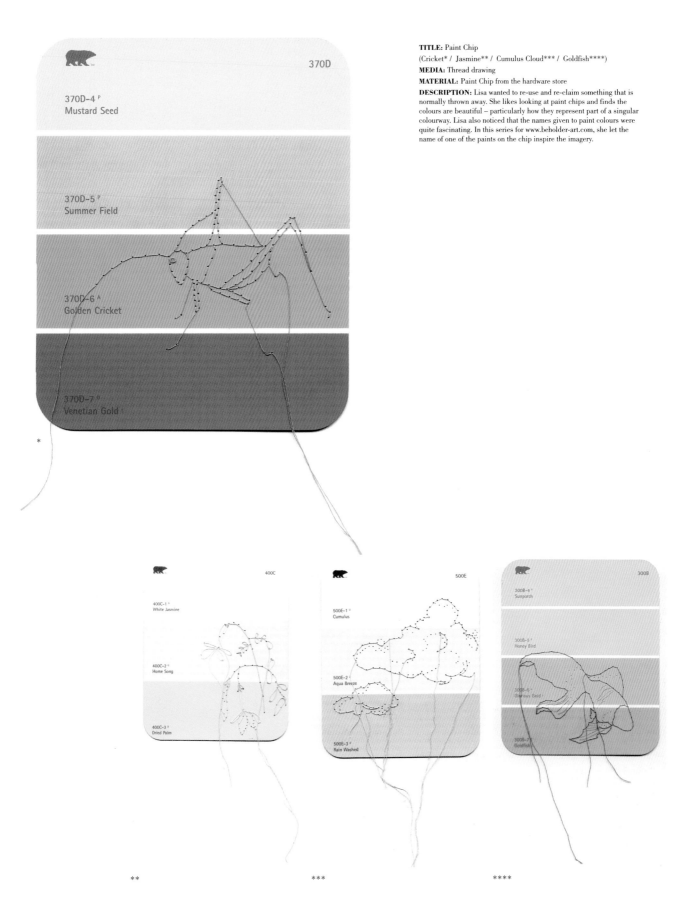

370D

370D-4 P
Mustard Seed

370D-5 P
Summer Field

370D-6 A
Golden Cricket

370D-7 B
Venetian Gold

*

TITLE: Paint Chip
(Cricket* / Jasmine** / Cumulus Cloud*** / Goldfish****)
MEDIA: Thread drawing
MATERIAL: Paint Chip from the hardware store
DESCRIPTION: Lisa wanted to re-use and re-claim something that is normally thrown away. She likes looking at paint chips and finds the colours are beautiful – particularly how they represent part of a singular colourway. Lisa also noticed that the names given to paint colours were quite fascinating. In this series for www.beholder-art.com, she let the name of one of the paints on the chip inspire the imagery.

400C

400C-1
White Jasmine

400C-2
Home Song

400C-3
Dried Palm

500E

500E-1
Cumulus

500E-2
Aqua Breeze

500E-3
Rain Washed

300B

300B-4
Sunporch

300B-5
Honey Bird

300B-6
Glorious Gold

300B-7
Goldfish

** *** ****

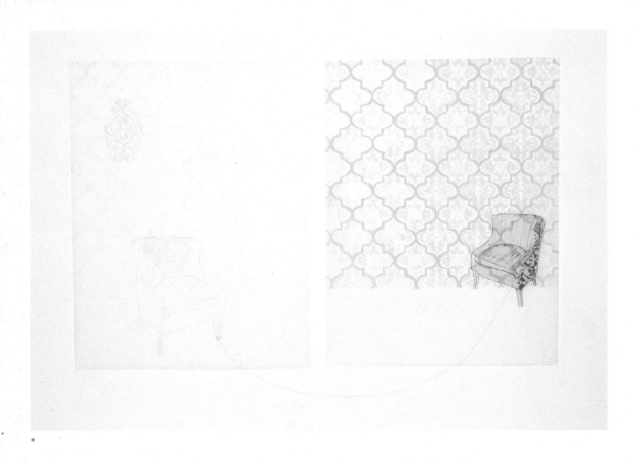

*

TITLE: Orange Chair :: Past and Present* / A Bed Dreams a Blue Doily Dream**
MEDIA: Mixed media drawing
MATERIAL: Coloured pencil, Watercolour, Duralar, Thread
DESCRIPTION: For this series of bed and chair drawings, Lisa wanted to remove the bed from its proper surroundings. By taking something that can be read as nostalgic out of its context, she attempted to recontextualize the viewer's association to these objects. Beds, doilies, wallpaper, and bedspreads come with their own symbolism and historic relevance. Lisa is trying to tap into that – as well use the beds as stand in for relationships and concepts about memory, loss, dreams etc.

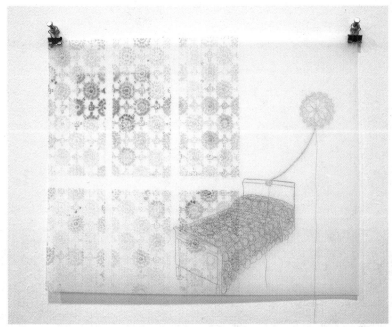

**

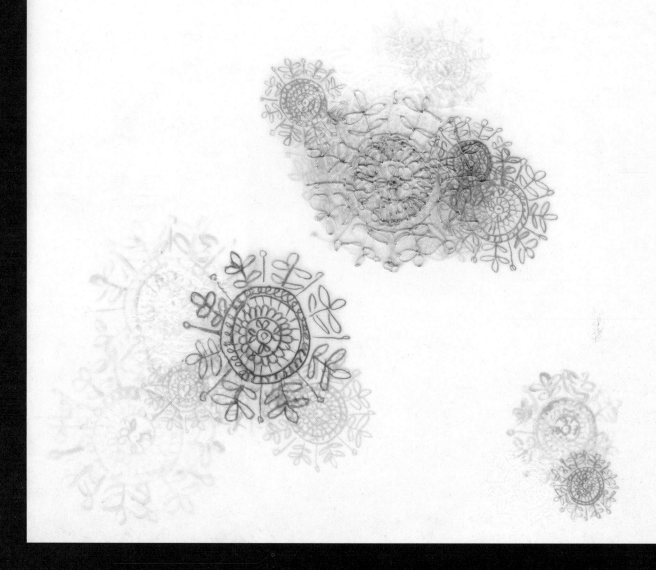

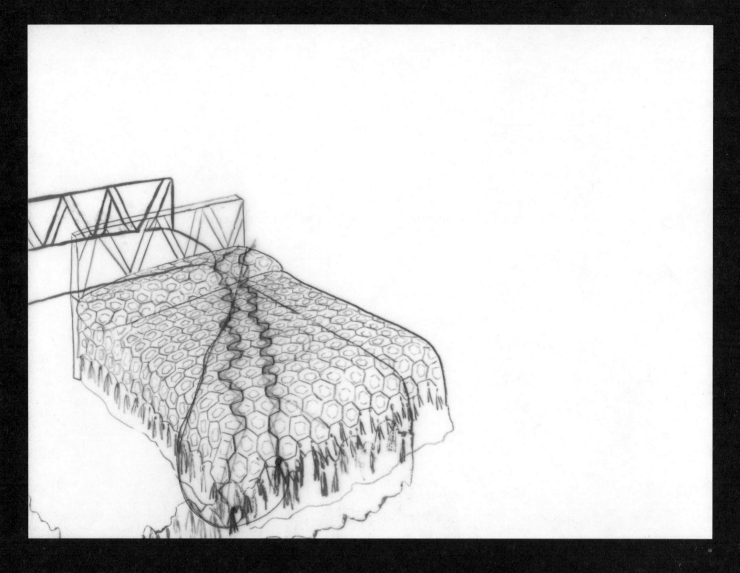

TITLE: Bed Drawing :: Texas Hold Em*

MEDIA: Mixed media drawing

MATERIAL: Coloured pencil, Watercolour, Duralar, Thread

DESCRIPTION: Stemming from the artist's interest in historical domesticity, Lisa has collected many books on doilies and crochet patterns. These books have pictures of finished projects in rooms. For this series of bed and chair drawings, Lisa wanted to remove the bed from its proper surroundings. By taking something that can be read as nostalgic out of its context, she attempted to recontextualize the viewer's association to these objects. Beds, doilies, wallpaper, and bedspreads come with their own symbolism and historic relevance. Lisa is trying to tap into that – as well use the beds as stand in for relationships and concepts about memory, loss, dreams etc.

TITLE: Doily Drawing : Pilot Wheel**

MEDIA: Mixed media drawing

MATERIAL: Coloured pencil, Watercolour, Duralar, Thread

DESCRIPTION: Lisa loves the shape, feel, texture and social implications of the doily, as well as the idea of taking something out of its element and presenting it in a new way. Lisa is very interested in pattern, colour, and shape and how they work in a field – particularly how negative space operates. In this work she uses both sides of the Duralar to help create a depth of field. Usually one or more doily is actually stitched onto the paper to play with one's sense of 2D and 3D.

TITLE: Coagulant Rifle Target (Dogwood* / Salad Burnet** / Installation Shot***)

MEDIA: Watercolour

MATERIAL: Vintage rifle target

DESCRIPTION: For this series Lisa researched plants that have historically and traditionally been used in wound care and in the treatment of bleeding. Since there's a target around, she thought it was appropriate to point out what plants you might want to look for in case of being shot.

TITLE: Mended Target :: Shisha Stitch – Variegated red/white****

MEDIA: Traditional embroidery stitching

MATERIAL: Shot rifle target

DESCRIPTION: A friend of Lisa who works across the street from a shooting range in NY sent her a stack of rifle targets that had been used for practice. After sitting a long while in the studio, Lisa finally realized that she was doing so much work with thread and embroidery and that one of the major

properties of sewing that she loved was its mending capability. So Lisa decided to mend the targets – using pretty embroidery stitches and bright colours. In this way she is attempting to fix the damage of the bullet holes. In a way Lisa also sees these as helping her conquer a fear of guns.

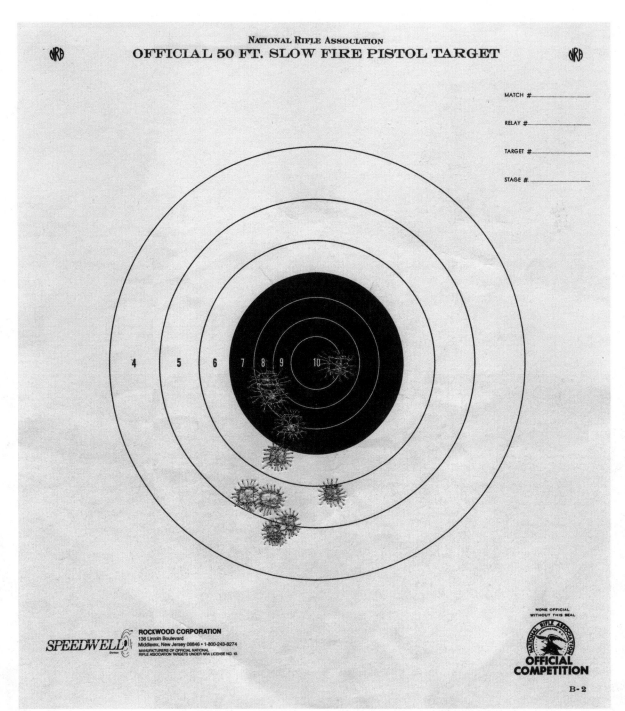

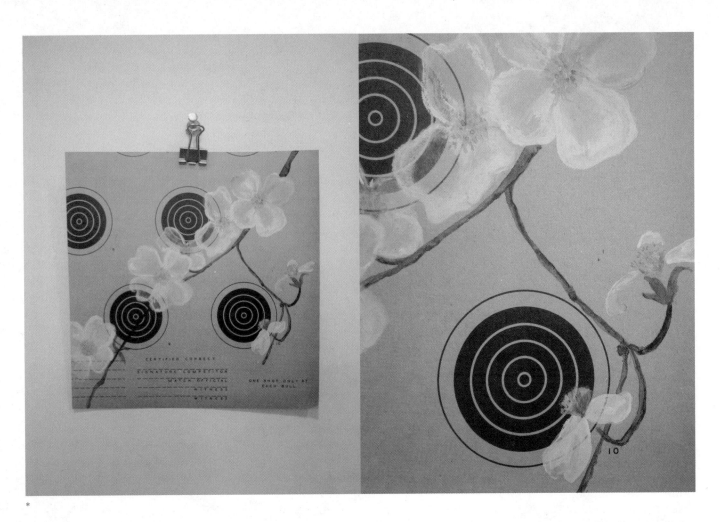

*

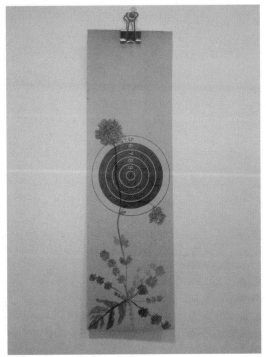

**

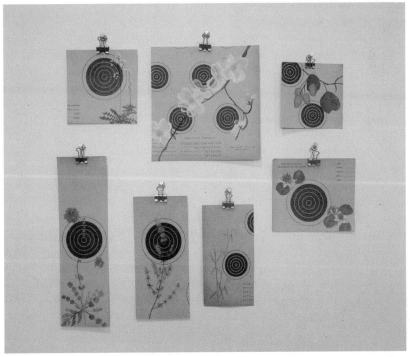

TITLE: Wallet Size Me : 1980*

MEDIA: Embroidery

MATERIAL: Satin

DESCRIPTION: Instead of showing the perfect front side of the embroidery, here Lisa shows the backside. She likes the idea of showing what is normally hidden – both physically and psychologically. The long threads immediately straddle the line between beauty and decay.

Lisa had done a whole series of portraits in this method based on found photographs of children (usually vintage). She thought it was time for her to approach it more personally and so she collected all the school portrait pictures of herself from 1975-1985 and recontextualized them as embroidery. This was the first time Lisa put features into the faces. In the past she had kept the children faceless so that they were more of an 'every child.' This didn't seem right when representing herself.

TITLE: Connect 3 Thoughts** / Connect Guts over Long Distance***

MEDIA: Embroidery

MATERIAL: Ink, Canvas

DESCRIPTION: Lisa sees the drawings of dresses as anonymous women of the world. They are stylized and old fashioned to imply a relationship to domesticity and traditional women's roles. She sees the embroidery as symbolizing the connection between these women. How do our thoughts, minds, hearts, guts connect over time and space. What do we all share?

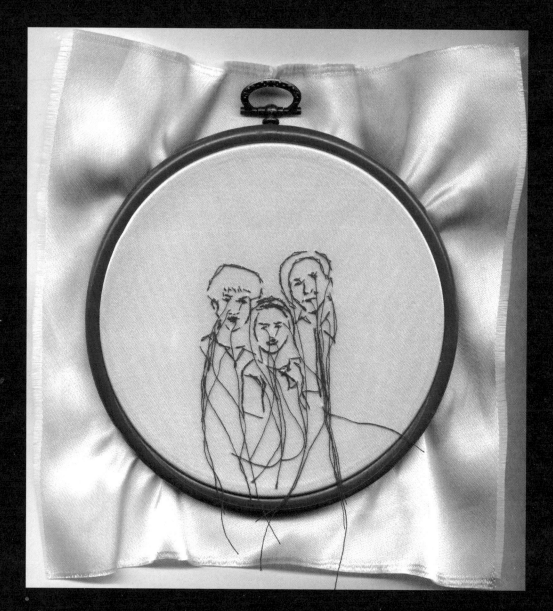

*

**

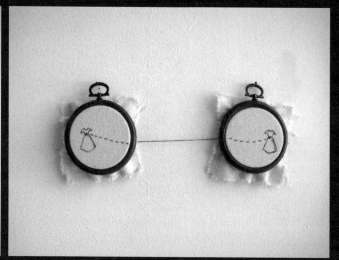

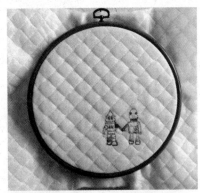

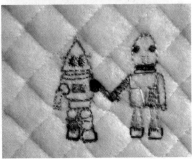

*

TITLE: Yonezawa Robot & X70 in love* /
Mr. Atomic** / Atomic Robot Man***

MEDIA: Embroidery

MATERIAL: Quilting

DESCRIPTION: Wanting to flip traditional ideas of
masculine and feminine Lisa decided to create little tin toys
(something hard) out of embroidery and on quilting (some-
thing soft). She also wanted to portray these toys with some
semblance of emotion. Toys generally only get to show one
sentiment – She likes the idea of expanding that.

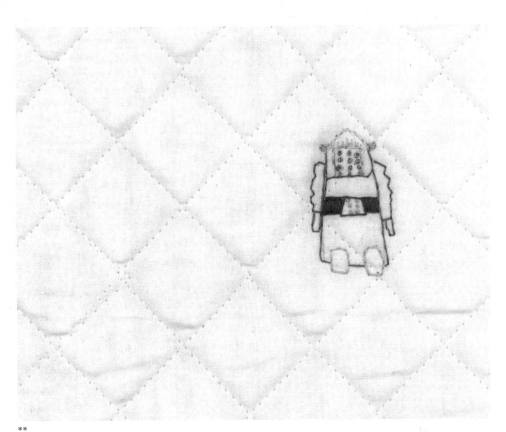

**

TITLE: Synchronized Tanks :: Orange, Yellow and Gray Argyle

MEDIA: Installation

MATERIAL: Felt tanks, Wall

DESCRIPTION: These are photos of a felt tank installation Lisa did at the Koumi Machi Museum in Japan. This piece deals with her thoughts on gender identity – she wanted to take an item like a tank (normally read as masculine and threatening) and create a feminine, cute twist by using bright colours, a soft material (felt), and having them march in an argyle pattern.

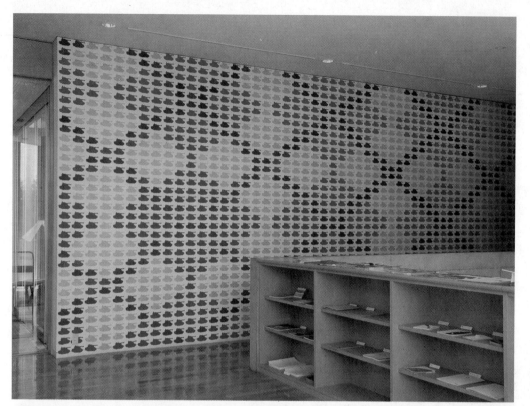

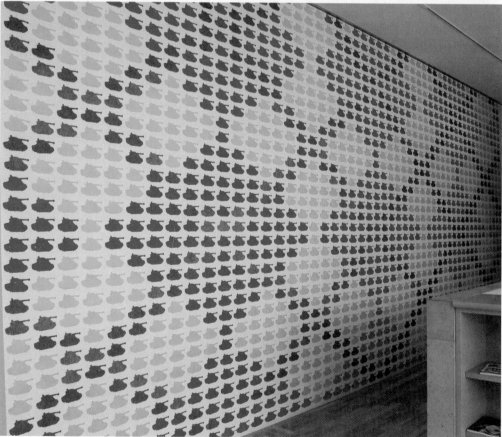

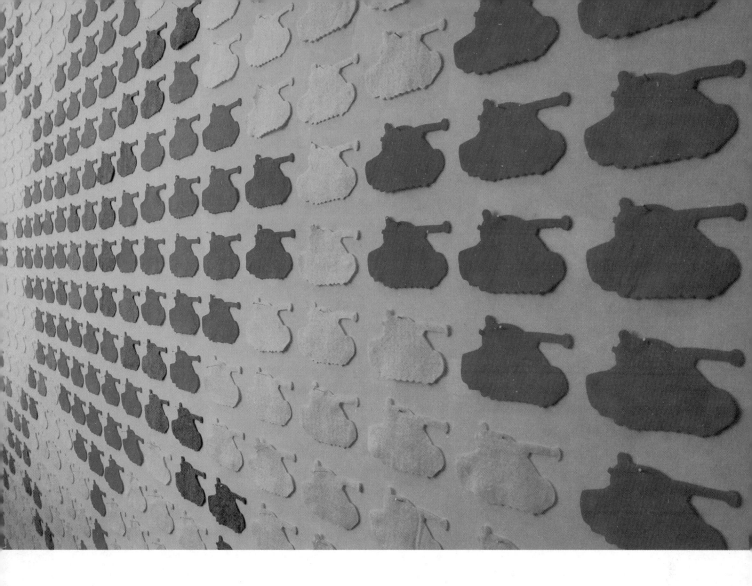

LISA SOLOMON

Oakland, USA

LISA SOLOMON RECEIVED HER BA IN ART PRACTICE FROM UC BERKELEY IN
1995 AND HER MFA FROM MILLS COLLEGE IN 2003.

SHE IS PROFOUNDLY INTERESTED IN THE IDEA OF HYBRIDIZATION (SPARKED
FROM HER HAPPA HERITAGE). HER MIXED MEDIA WORKS REVOLVE THEMATI-
CALLY AROUND DOMESTICITY, CRAFT, AND MASCULINE AND FEMININE TRIG-
GERS. LISA LIVES IN OAKLAND WITH HER HUSBAND AND PETS.

SHE IS INSPIRED BY THE 'MUNDANE' AND DETAILS, AND ENJOYS HOW TEACH-
ING STIMULATES HER MIND AND ART PRACTICE. SHE LOVES TO SIT IN HER
SUNNY YARD AND GARDEN. HER STUDIO IS FORTUNATELY 5 MINUTES FROM
HER HOUSE AND SHE TRIES TO GO THERE AS OFTEN AS SHE CAN.

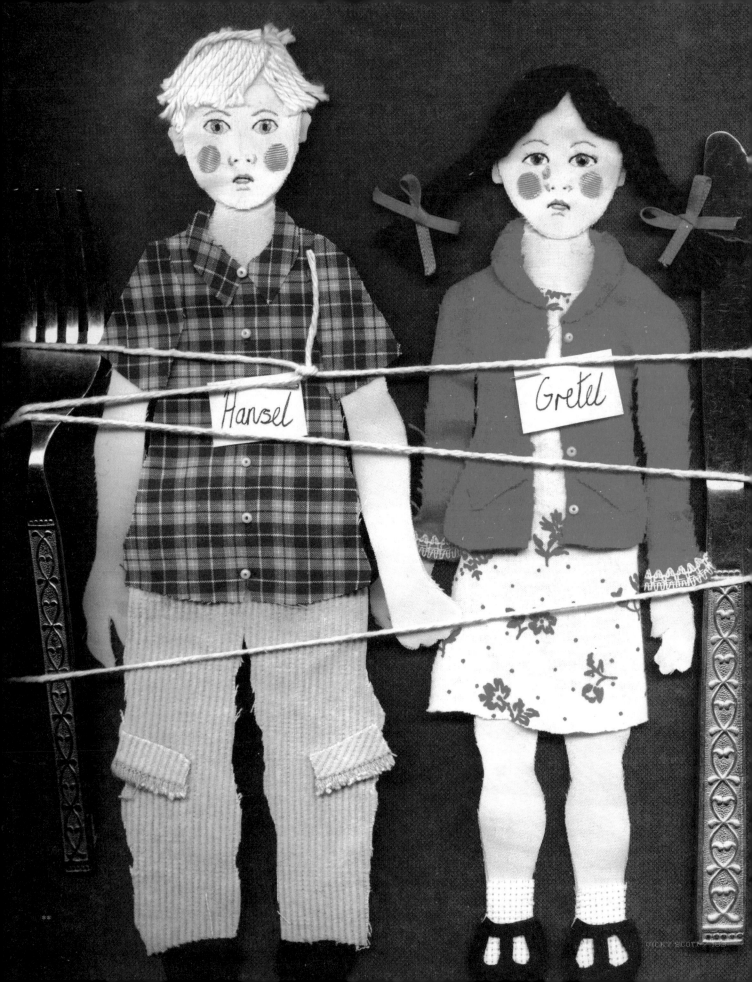

TITLE: London*

MEDIA: Embroidery, Collage, Drawing

MATERIAL: Fabric

DESCRIPTION: This piece was entered the London Transport poster design competition. Vicky has tried in this piece to include as many different forms of transport as possible and show that London's transport runs from the centre of town right the way out into more rural surrounding areas.

TITLE: Hansel And Gretal**

MEDIA: Embroidery, Collage, Drawing, Photoshop

MATERIAL: Fabric, Found objects

DESCRIPTION: The piece for Tales Magazine presents a darker side of the traditional fairytale, showing that the witch has tied the children up and is ready to eat them. Vicky produced the figures of the children as fabric dolls, with embroidered faces and woolen hair, which she thinks making the image look much more scary as their cuteness contrasts with what's going on around them.

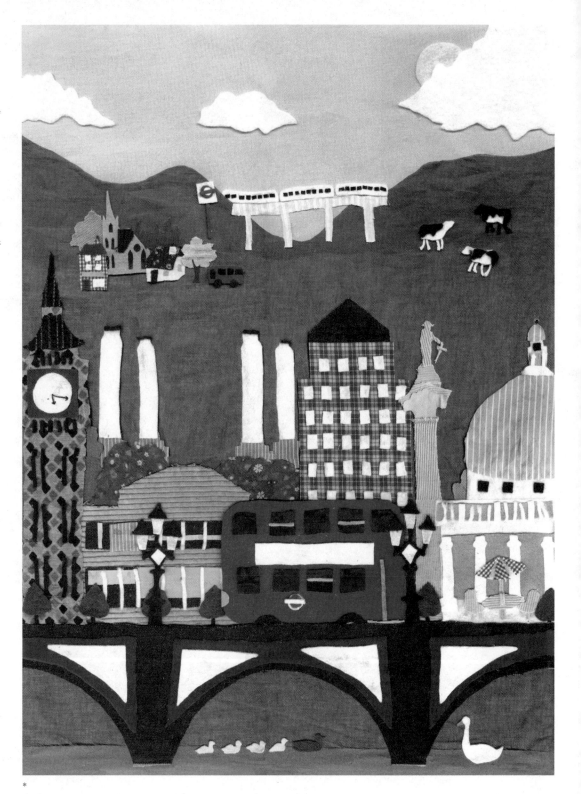

*

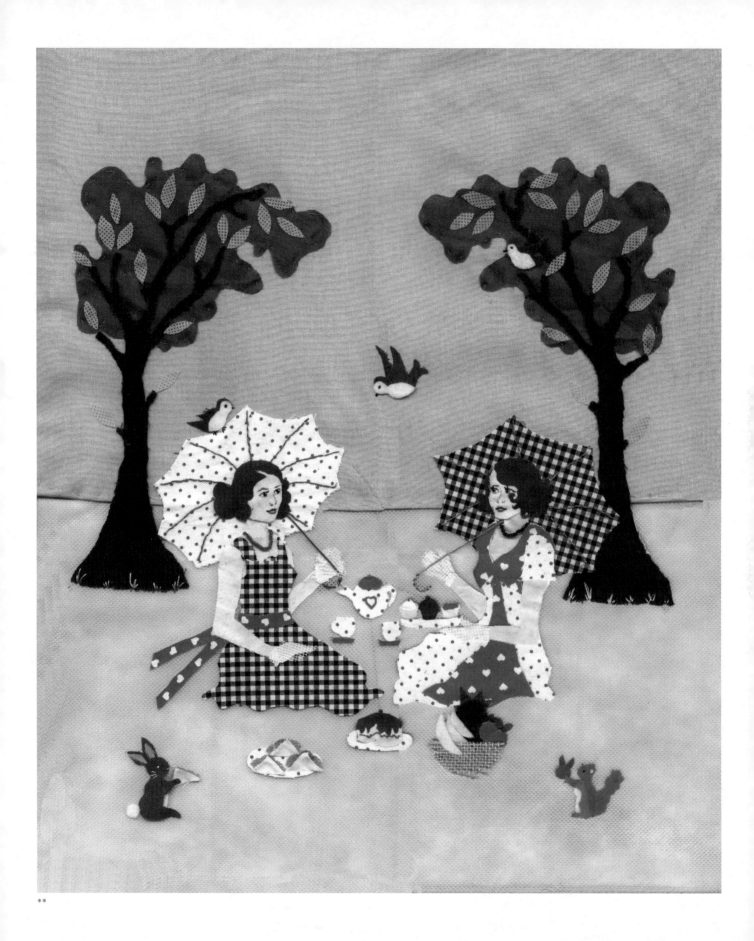

**

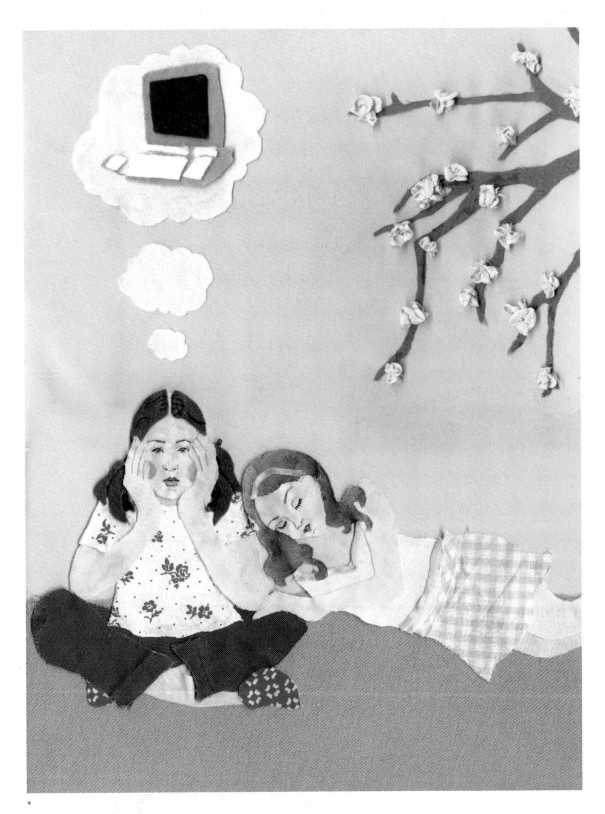

*

TITLE: Bored Kids*

MEDIA: Embroidery, Collage, Drawing

MATERIAL: Fabric

DESCRIPTION: Part of a project humourously addressing how people would cope without gadgets associated with modern city life. In this particular piece 2 teenagers are sitting in the countryside and have no idea what to do without their computers.

TITLE: Picnic**

MEDIA: Embroidery, Collage, Drawing

MATERIAL: Fabric

DESCRIPTION: 1920's inspired ladies having a relaxing picnic, surrounded by lots of cute animals.

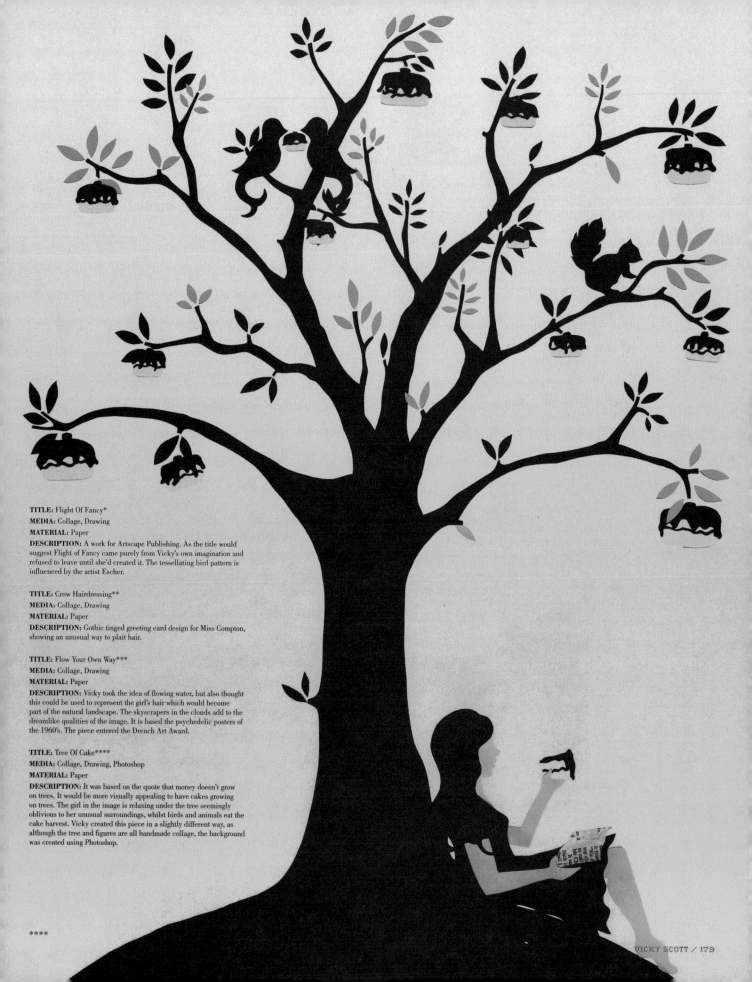

TITLE: Flight Of Fancy*

MEDIA: Collage, Drawing

MATERIAL: Paper

DESCRIPTION: A work for Artscape Publishing. As the title would suggest Flight of Fancy came purely from Vicky's own imagination and refused to leave until she'd created it. The tessellating bird pattern is influenced by the artist Escher.

TITLE: Crow Hairdressing**

MEDIA: Collage, Drawing

MATERIAL: Paper

DESCRIPTION: Gothic tinged greeting card design for Miss Compton, showing an unusual way to plait hair.

TITLE: Flow Your Own Way***

MEDIA: Collage, Drawing

MATERIAL: Paper

DESCRIPTION: Vicky took the idea of flowing water, but also thought this could be used to represent the girl's hair which would become part of the natural landscape. The skyscrapers in the clouds add to the dreamlike qualities of the image. It is based the psychedelic posters of the 1960's. The piece entered the Drench Art Award.

TITLE: Tree Of Cake****

MEDIA: Collage, Drawing, Photoshop

MATERIAL: Paper

DESCRIPTION: It was based on the quote that money doesn't grow on trees. It would be more visually appealing to have cakes growing on trees. The girl in the image is relaxing under the tree seemingly oblivious to her unusual surroundings, whilst birds and animals eat the cake harvest. Vicky created this piece in a slightly different way, as although the tree and figures are all handmade collage, the background was created using Photoshop.

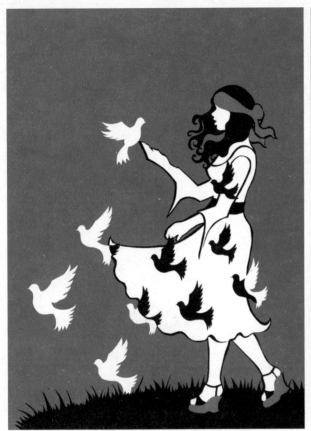

*

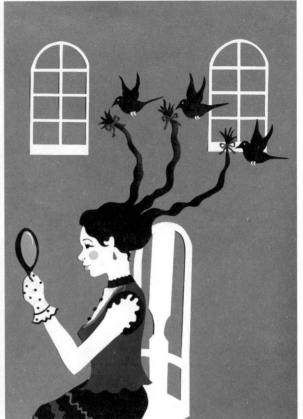

**

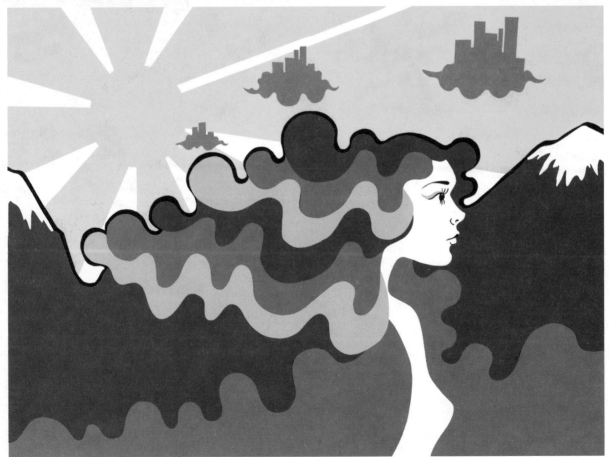

TITLE: Hot Dogs
MEDIA: Collage, Drawing
MATERIAL: Paper, Fabric
DESCRIPTION: This playful piece was based on a found image of a dog dressed up in a sausage coat. It would be a fun idea for the 2 dogs to bring their owners together. The piece is shown in The Almanac Gallery.

TITLE: Yummy Mummy*
MEDIA: Collage, Drawing
MATERIAL: Paper, Fabric
DESCRIPTION: Mother and baby greeting card design based on the phrase Yummy Mummy that is used to describe a glamorous new mum. The piece is shown in The Almanac Gallery.

TITLE: New Baby**
MEDIA: Collage, Drawing
MATERIAL: Paper
DESCRIPTION: Very cute new baby card design. The piece is shown in The Almanac Gallery.

TITLE: Heart To Heart***
MEDIA: Collage, Drawing, Photoshop
MATERIAL: Paper, Ribbon
CLIENT: The Almanac Gallery
DESCRIPTION: Romantic greeting card design, changing the dalmations spots into hearts. The piece is shown in The Almanac Gallery.

TITLE: Penguins****
MEDIA: Collage, Drawing
MATERIAL: Paper
DESCRIPTION: Cute Christmas card design for Paperchase. A gift that the baby penguins would be most keen on would be a fish, so she included this in the centre of the cracker.

*

**

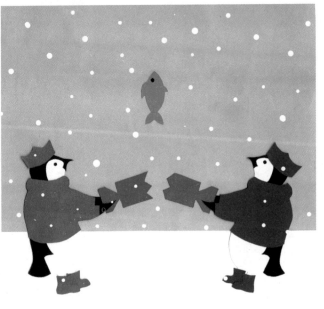

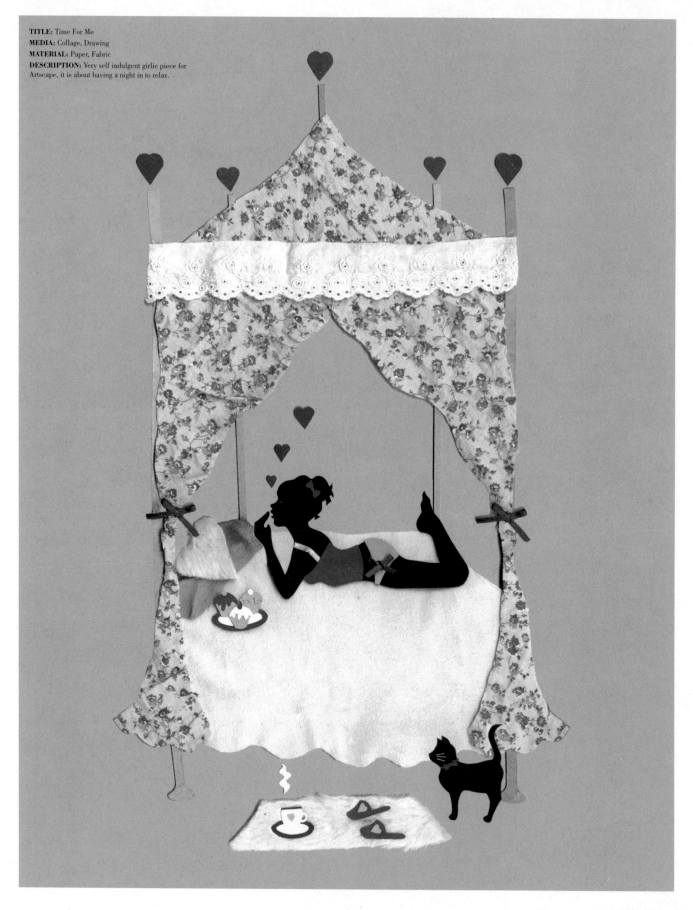

TITLE: Time For Me
MEDIA: Collage, Drawing
MATERIAL: Paper, Fabric
DESCRIPTION: Very self indulgent girlie piece for
Artscape, it is about having a night in to relax.

TITLE: Vicky
MEDIA: Embroidery, Drawing
MATERIAL: Fabric
DESCRIPTION: Self portrait in fabric.

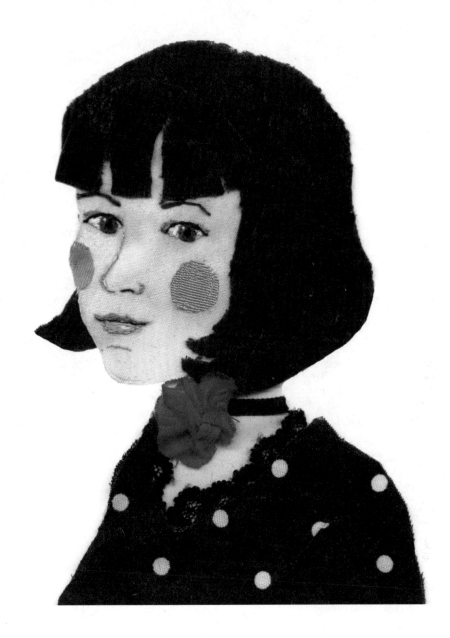

VICKY SCOTT

Kent, UK

VICKY WAS BORN IN 1982 AND GREW UP IN RICHMOND. AT THE AGE OF 5 SHE HAD DECIDED HER FUTURE CAREER AS AN ILLUSTRATOR.

IN 2004 VICKY GRADUATED FROM THE UNIVERSITY OF BRIGHTON WITH A BA HONS IN ILLUSTRATION. SINCE GRADUATION SHE HAS COMPLETED DESIGNS FOR COMPANIES INCLUDING PAPERCHASE AS WELL AS EXHIBITING AT EVENTS SUCH AS THE AFFORDABLE ARTS FAIR IN BATTERSEA AND BEING FEATURED IN THE TIMES.

HER WORK IS FASHION BASED OFTEN WITH A 1920'S FEEL. ALL VICKY'S PIECES HAVE A HANDMADE AESTHETIC BY USING A VARIETY OF MATERIALS INCLUDING CARD, PAINT AND FABRIC. MOST IMPORTANTLY HER WORK ALWAYS HAS AN UPLIFTING FEEL, WITH HER CHARACTERS ENJOYING THE SIMPLE PLEASURES IN LIFE.

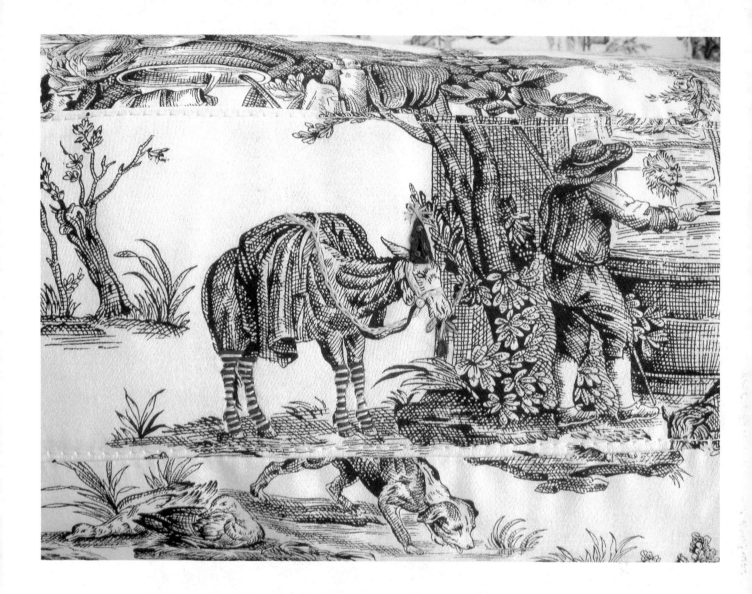

**

*

TITLE: Nother sofa*
MEDIA: Hand embroidery
MATERIAL: Cotton toile
DESCRIPTION: Hand embroidered toile upholstered as
large cushions to create a built in sofa, one of the pieces in
the series of Nother sofa.

TITLE: Toile Sofa, the second**
MEDIA: Hand embroidery
MATERIAL: Cotton upholstery
DESCRIPTION: Embroidered upholstery.

TITLE: Nother sofa
MEDIA: Hand embroidery
MATERIAL: Cotton toile
DESCRIPTION: Hand embroidered toile upholstered as large cushions to create a built in sofa.

TITLE: Commanders Palace restaurant, New Orleans
MEDIA: Hand embroidery
MATERIAL: Rayon twill
DESCRIPTION: Hand embroiderer toile panels
upholstered onto the walls of a reception area.

TITLE: Headboard
MEDIA: Hand embroidery
MATERIAL: Cotton
DESCRIPTION: Hand embroidered toile upholstered headboard.

RICHARD SAJA

New York, USA

A FEW YEARS AGO, WHILE WAKING FROM SLEEP, RICHARD STRUCK ON THE VERY SIMPLE IDEA OF EMBROIDERING OVER THE PERENNIALLY POPULAR TOILE ENJOYING YET ANOTHER MOMENT IN FASHION'S LIMELIGHT. HIS INITIAL CONCEPT WAS TO 'TATTOO,' THROUGH HAND EMBROIDERY, MAORI-INSPIRED DESIGNS ONTO THE FACES AND HANDS OF THE LORDS, LADIES, PEASANTS AND ANIMALS REPRESENTED IN A 'PLEASURES OF THE FOUR SEASONS' PRINT HE HAD FOUND IN A SHOP IN MANHATTAN'S GARMENT DISTRICT. AS SOON AS HE PUT NEEDLE TO FABRIC HE KNEW THAT TOILE PRINTS WERE A PERFECT CANVAS FOR HAND EMBROIDERY: THE BLACK LINE OF THE PRINT BEGGING TO BE MADE MORE ALIVE THROUGH THE VIBRANCY OF COLOUR, TEXTURE AND TECHNIQUE AFFORDED BY HAND EMBROIDERY. BY WEDDING TRADITIONAL TOILE PRINTS TO EMBROIDERY RICHARD FOUND HE HAD DEVELOPED SOMETHING EASILY ACCESSIBLE TO MODERN TASTES: TATTOOS ARE NOW ACCOMPANIED BY RABBIT EARS ON CHILDREN, CIGARS IN DOGS' MOUTHS, NIPPLES, GOLD CHAINS AND MOHAWKS ON MONKEYS. AND NOW, RICHARD WORKS UNDER THE NAME HISTORICALLY INACCURATE.

TITLE: Toile & Tats Line*
MEDIA: Hand embroidery
MATERIAL: Linen
DESCRIPTION: Hand embroidered embellishments over traditional toile patters.

TITLE: A Couple More Rowboats**
MEDIA: Hand embroidery
MATERIAL: Cotton toile, Linen toile
DESCRIPTION: The work is hand embroidered toile cushion.

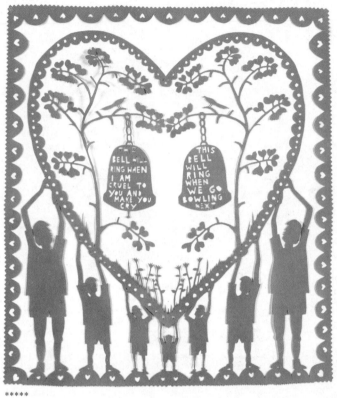

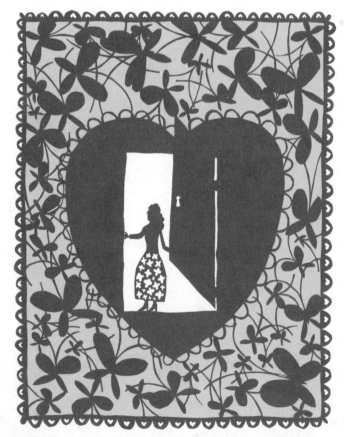

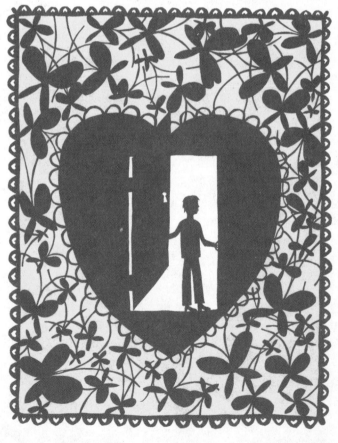

TITLE: Youreinmyhead* / MofUs.Browntreeman** /
Bird Book*** / Pink Caged Lovers P'cut**** /
MofUs.blueheartbell*****
MEDIA: Papercut with scalpel, Screenprint
MATERIAL: Paper, Ink
DESCRIPTON: -

TITLE: The Door To My Heart******
MEDIA: Papercut with scalpel, Screenprint
MATERIAL: Paper, Scalpel
DESCRIPTION: This piece was made for Habitat, originated as a papercut
and became a 2 colour screenprints. The design was cut from one single
piece of paper. It was then used as a stencil to make a coated image on a silk
screen. A background colour was printed, various different colour combina-
tions were chosen afterwards. Robert feels this is still a progressing piece of
work and will continue to develop.

*

**

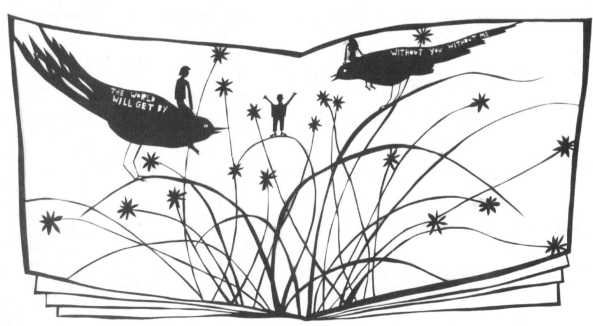

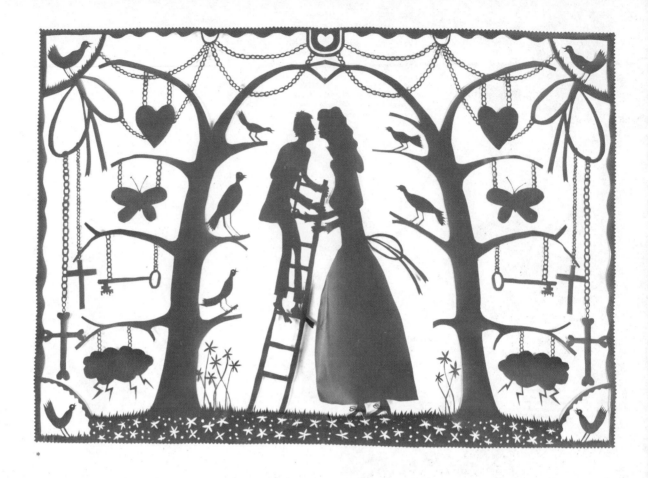

*

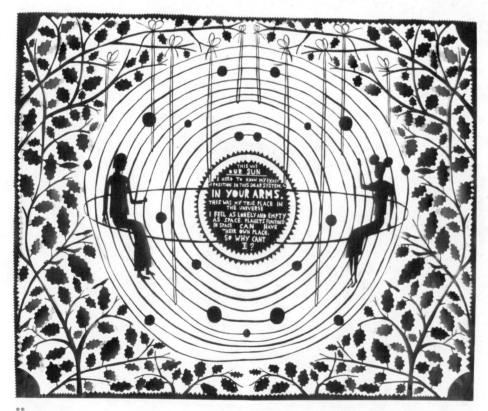

TITLE: MofUs.ladderkisswide* / MofUs.solarsystem**
MEDIA: Papercut with scalpel, Screenprint
MATERIAL: Paper
DESCRIPTION: -

**

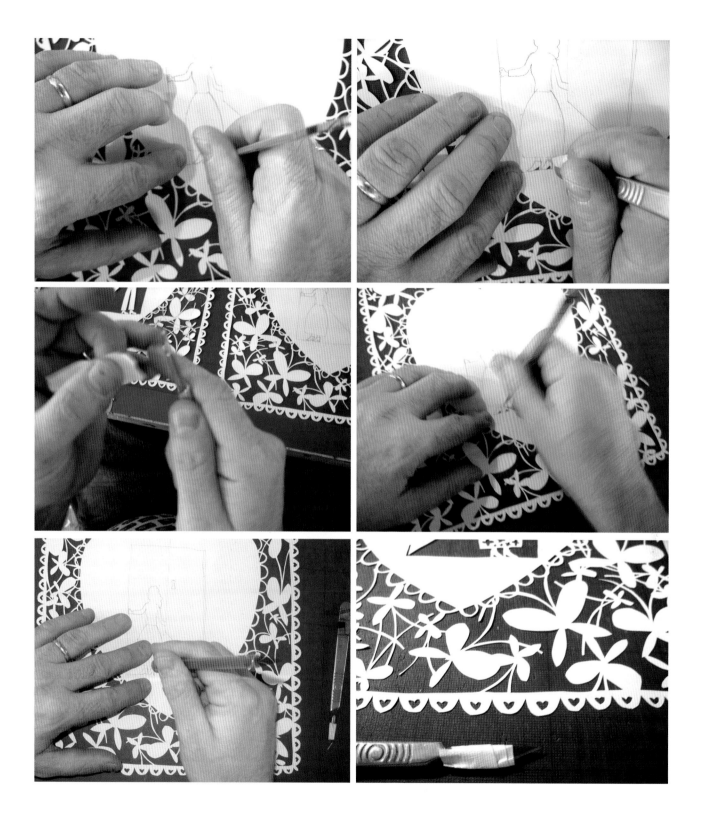

TITLE: MofUs.riseaboveitboid* /
MofUs.cloughvase** / MofUs.blueship***
MEDIA: Papercut with scalpel, Screenprint
MATERIAL: Paper, Ink
DESCRIPTION: -

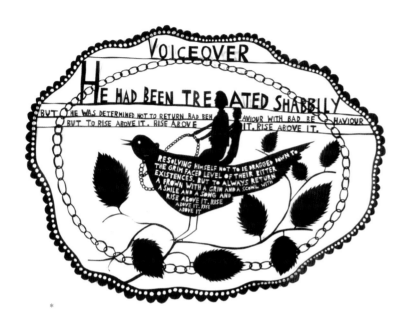

*

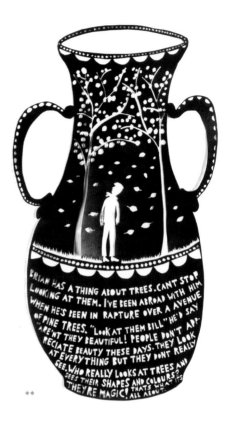

**

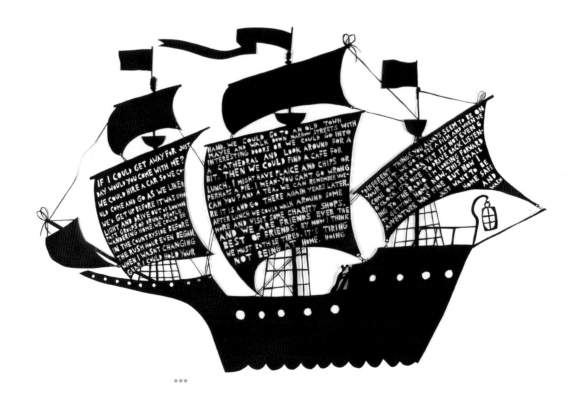

TITLE: Alphabet
MEDIA: Papercut with scalpel, Screenprint
MATERIAL: Paper
DESCRIPTION: -

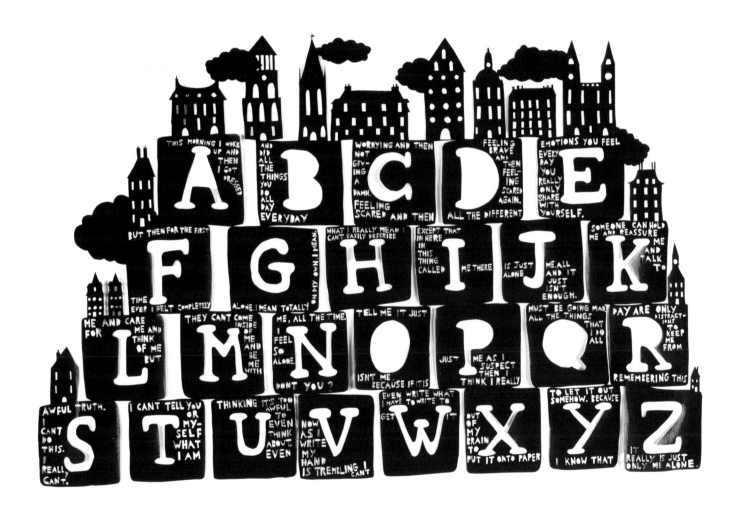

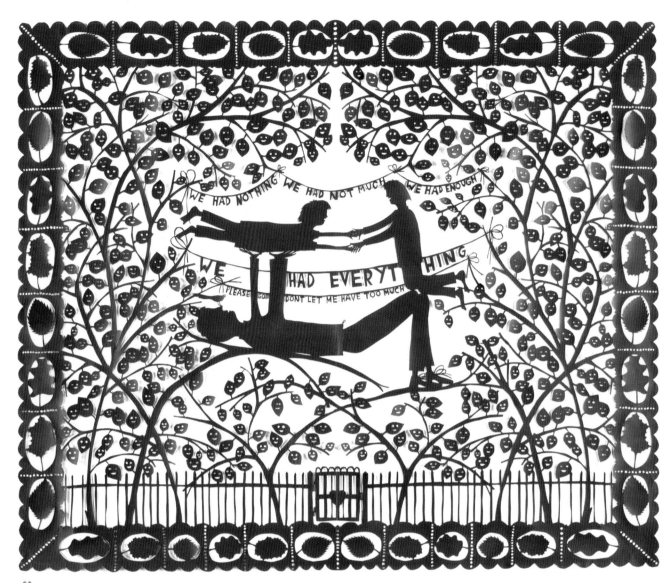

Image text: WE HAD NOTHING WE HAD NOT MUCH WE HAD ENOUGH / WE HAD EVERYTHING / PLEASE GOD DONT LET ME HAVE TOO MUCH

**

TITLE: Bird Lady* / We Had Everything**
MEDIA: Papercut with scalpel, Screenprint
MATERIAL: Paper
DESCRIPTION: -

ROBERT RYAN

London, UK

ROBERT RYAN WAS BORN IN CYPRUS IN 1962. HE LOVES DRAWING SINCE HE WAS A KID. HE IS NOW AN ILLUSTRATOR, PAPER CUTTER AS WELL AS AN ARTIST. HE GRADUATED IN THE ROYAL COLLEGE OF ART, LONDON AND HIS CLIENTS INCLUDE PAUL SMITH, VOGUE, LIBERTY, ROXY QUICKSILVER, VAROOM, PENGUIN PUBLISHING, AMELIAS MAGAZINE, MUTE RECORDS, LG COMMUNICATIONS AND MANY OTHERS.

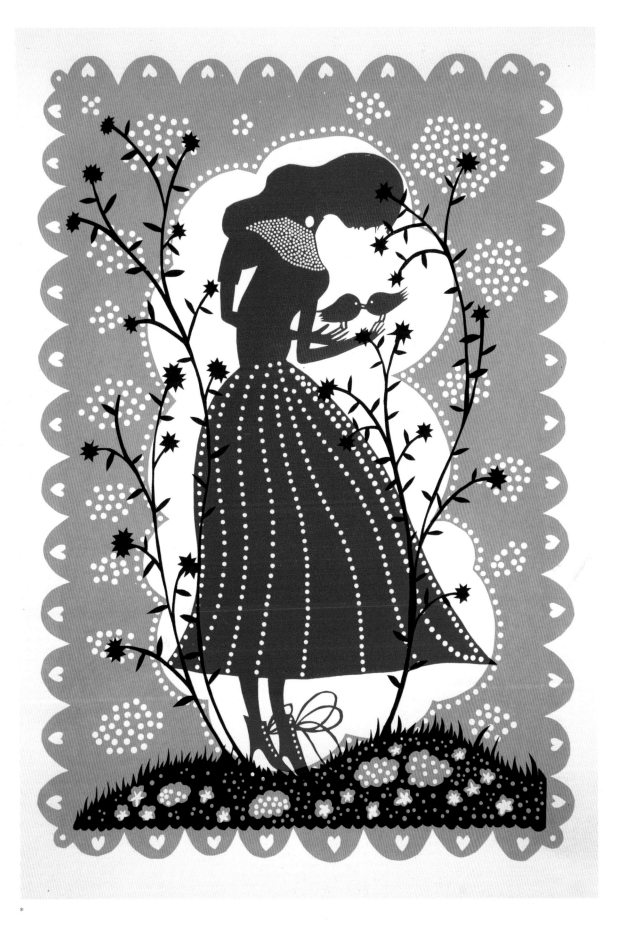

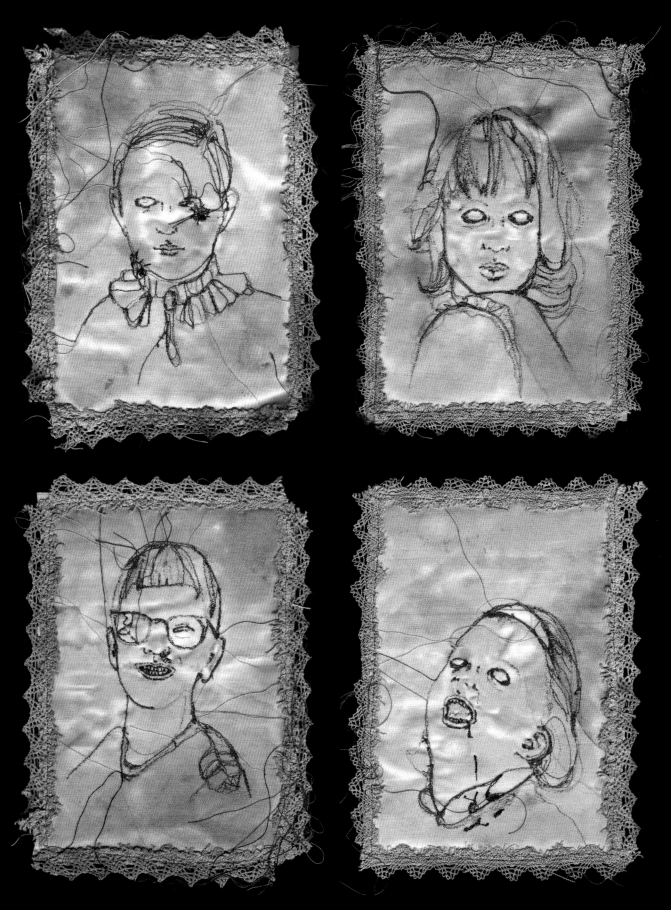

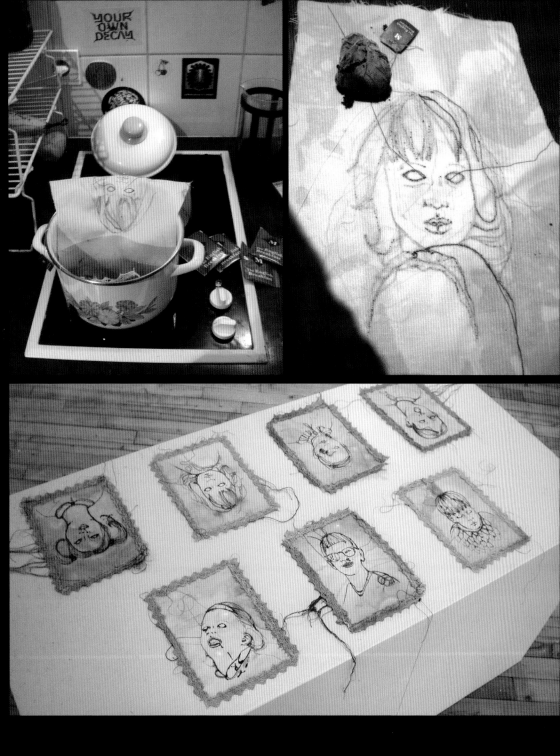

TITLE: Cafards
MEDIA: Embroidery
MATERIAL: Threads, Fabrics, Blood, Tea

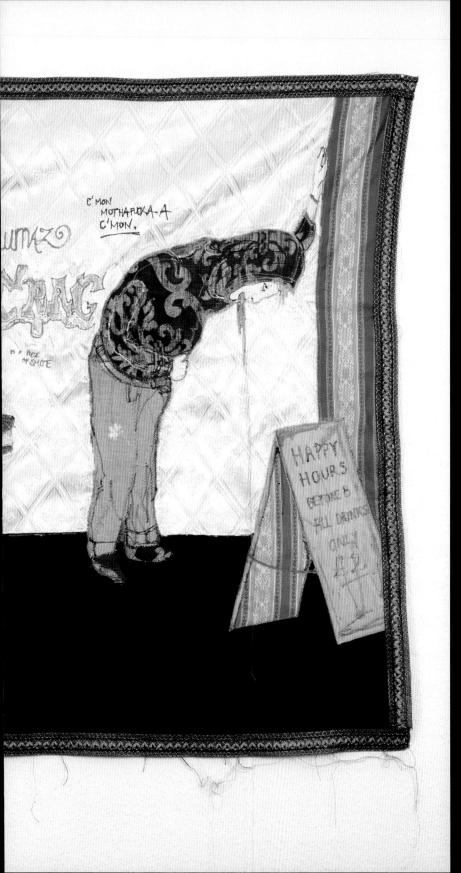

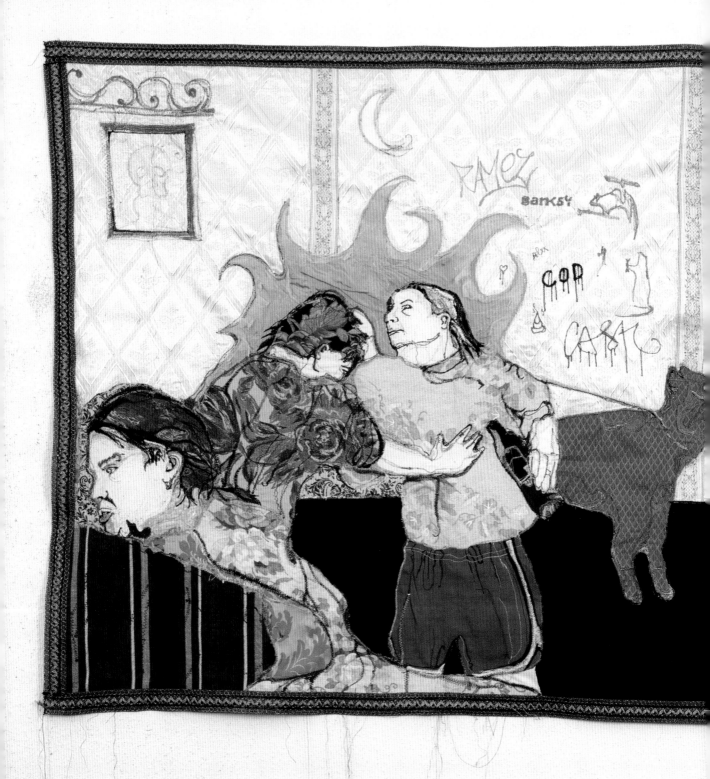

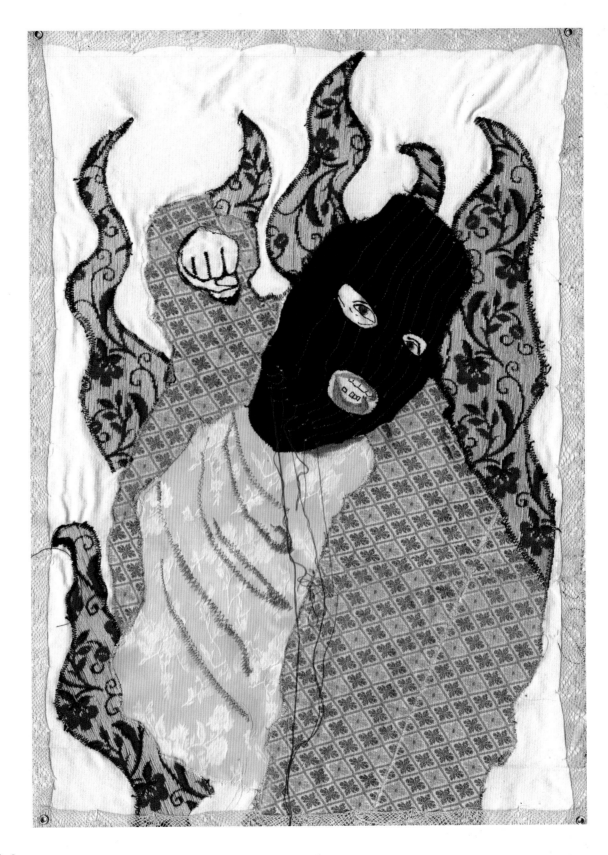

TITLE: Wrestler Number 5
MEDIA: Embroidery
MATERIAL: Threads, Fabrics
DESCRIPTION: A portrait of an English young wrestler.
The piece is shown in the Courtesy galerie Taché-Levy (B).

TITLE: Pisseuses*
MEDIA: Embroidery
MATERIAL: Threads, Fabrics
DESCRIPTION: Les Pisseuses is about 90 cm round. It represents girls pissing outside, in an industrial area. The piece is shown in the Courtesy Galerie Taché-Levy, Brussels.

TITLE: Fingerboy**
MEDIA: Embroidery
MATERIAL: Threads, Fabrics
DESCRIPTION: A scene from the serial portrait about backyard wrestling in England. The piece is shown in the Courtesy galerie Villa Grisebach gallery (D).

TITLE: Red Warrior***
MEDIA: Embroidery
MATERIAL: Threads, Fabrics
DESCRIPTION: A scene from the serial portrait about backyard wrestling in England. The piece is shown in the Courtesy galerie Frank Elbaz.

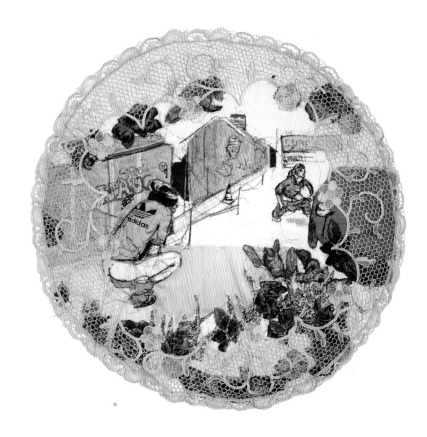

*

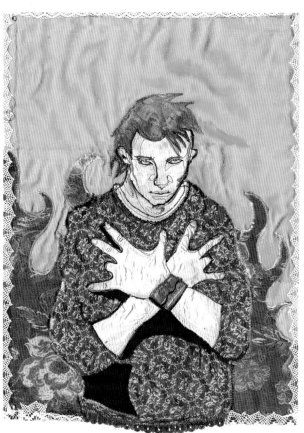

**

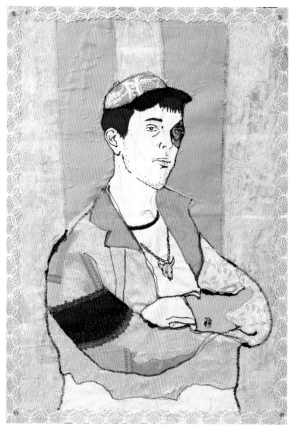

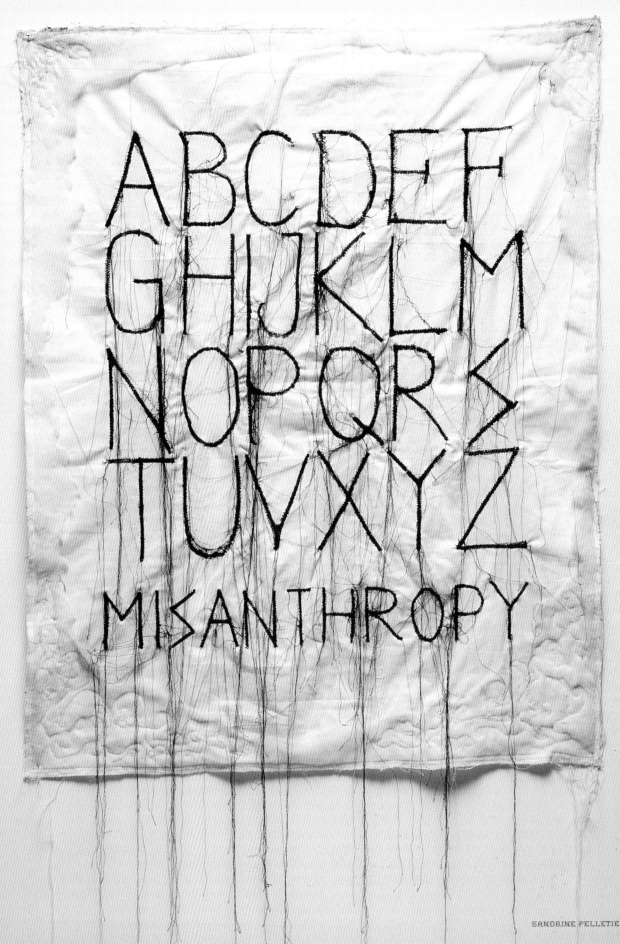

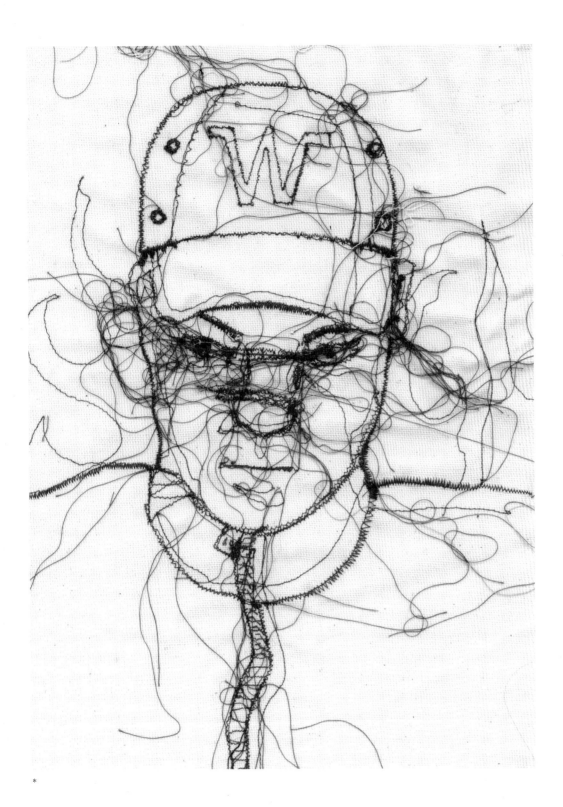

*

TITLE: WBack*

MEDIA: Embroidery

MATERIAL: Threads, Fabrics

DESCRIPTION: It is a portrait of an English young wrestler for Courtesy galerie Frank Elbaz. Here it's a digital scan of the thread from the back of the embroidery, more abstract, remaining scares, blood and veins. It is part of Sandrine's graduation job about backyard wrestling 'Wild Boyz' and it was shown in the Centre Georges Pompidou in Paris in 2003.

TITLE: Misanthropy**

MEDIA: Embroidery

MATERIAL: Threads, Fabrics

DESCRIPTION: Misanthropy is inspired from 'abécédaire.' An 'abécédaire' is done with love and care. Normally, people receive one for a communion, a wedding or a baby's birth. Here, this misanthropic abécédaire is not finished, there are missing letters and in the corners, little skulls are represented.

SANDRINE PELLETIER

Lausanne, Switzerland

SANDRINE PELLETIER IS A SWISS GRAPHIC ARTIST. SHE WAS BORN IN 1976 AND NOW LIVES AND
WORKS IN LAUSANNE AND PARIS. GRADUATED FROM ECAL, SWITZERLAND, IN 2002, SANDRINE
BEGAN TO WEAVE THE BEGINNING OF A CAREER, WITH EXHIBITIONS IN LAUSANNE, PARIS, LYONS,
BRUSSELS, LONDON, MILAN AND TOKYO UNDER HER BELT.

HER UNIVERSE CAN BE DEFINED AS GRAPHIC WEAVING, HALFWAY BETWEEN FETISHISM, GOTHIC
AND THE MACABRE: RAW, ORGANIC IMAGES, CRUSTY AND ACIDIC, WOVEN ON WORN WALLPAPER
OF A HAM-PINK COLOUR. HER WORK IS MAINLY EMBROIDERY, BUT ALSO HAS DIFFERENT SORTS
OF TEXTILE COLLAGE SUCH AS LACE, LEATHER OR WOOL.

SHE IS NOW WORKING AS A FREELANCE ILLUSTRATOR FOR BRANDS AND INTERNATIONAL MAGA-
ZINES, AND WOULD LIKE TO EVOLVE IN A SORT OF CRAFTED SHOWBIZ, FULL OF HUMOUR AND
SELF-MOCKERY. SHE LIKES CATS, DECADENT FETISH PARTIES, AND DRINKING PASTIS AND
GRILLING SARDINES ON SUNDAYS.

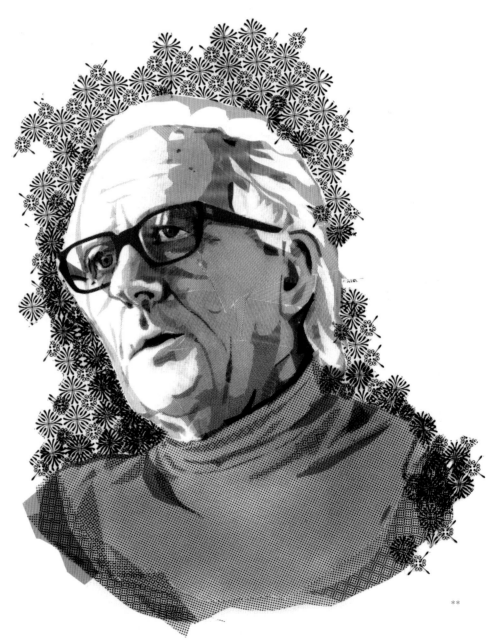

TITLE: Employee*
MEDIA: Meat collage, Digital scan
MATERIAL: Ham, Toast, Mustard
DESCRIPTION: The artwork became the cover of Yummy
magazine (FR), the first magazine dedicated to junk food.
Sandrine had the idea of doing a portrait of a McDonald's
employee of the month, so they can expose them sometimes
in McDonald's restaurants.

TITLE: René**
MEDIA: Letraset stickers collage
MATERIAL: Letraset lines, Dots stickers
DESCRIPTION: This is the work for CitizenK. It illustrates
an article about French politician and ecologist René
Dumont. The technique is almost the same as bank note
illustration, for the result. It is made with old letraset lines
and dots stickers, which are used before the computer went
out the market.

**

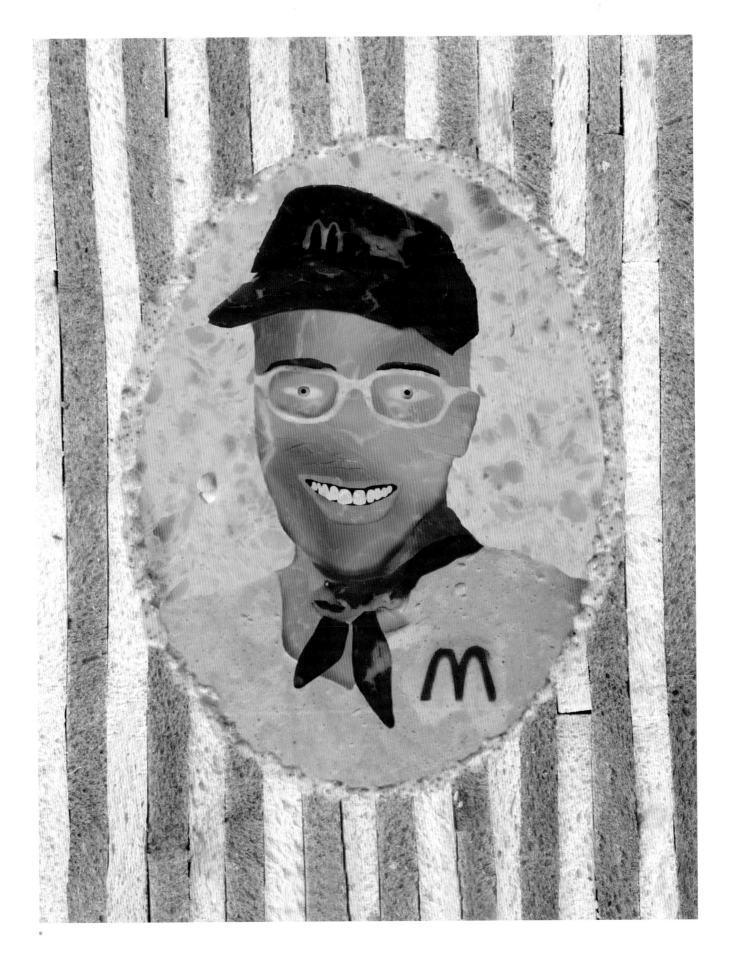

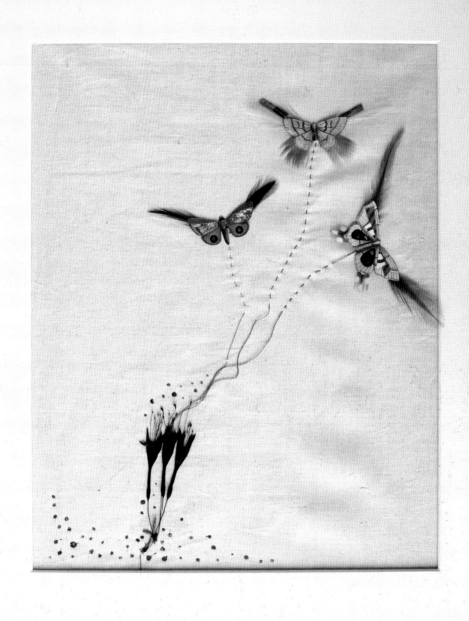

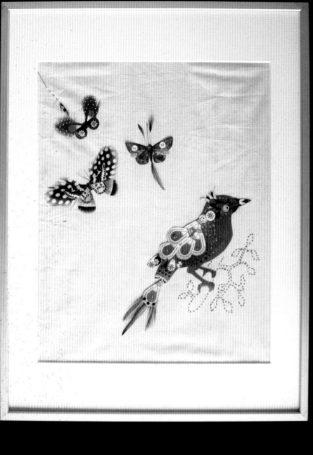
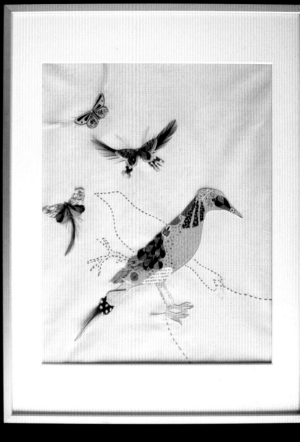

TITLE: Bazaar Time

MEDIA: Embroidery

MATERIAL: Thread, Cloth, Buttons

DESCRIPTION: Carolina started working on this series of embroideries when she was doing her MA at Central St. Martins, since then she'd carry on working in her spare time. She feels particularly attached to these pieces as she has great memories of the time when she works on those. It has always been a personal project hence Carolina never had a brief or a deadline, and often that's when one does the most honest and original work. It's not her favourite thing she's done, but it's probably the one that reflects her the most.

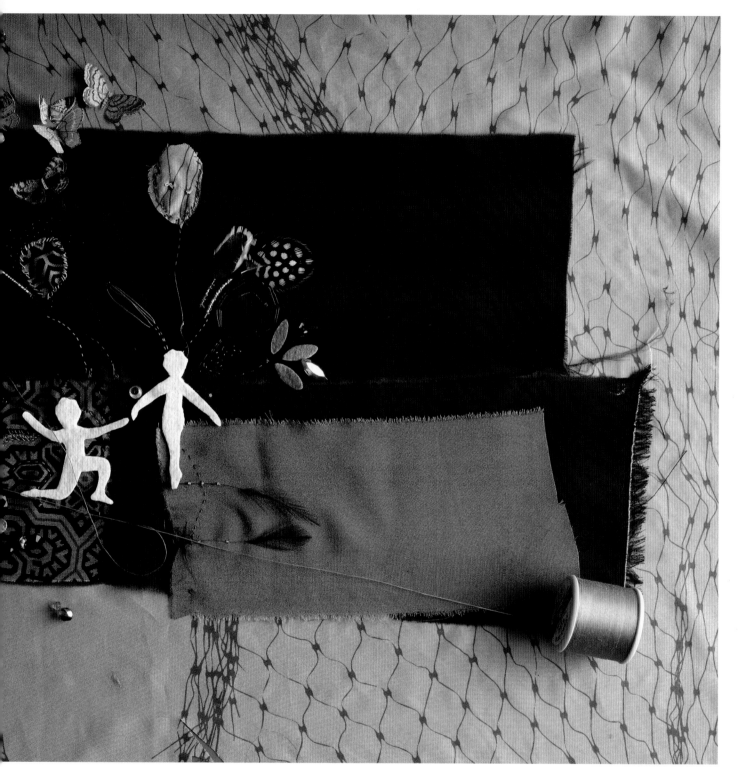

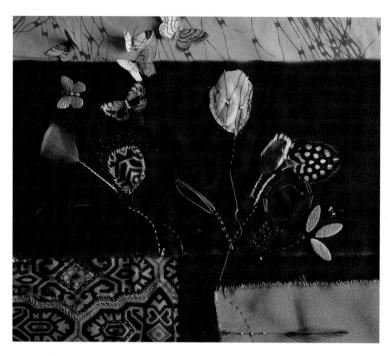

TITLE: Bazaar Time
MEDIA: Embroidery
MATERIAL: Thread, Cloth, Buttons
DESCRIPTION: Carolina started working on this series of embroideries when she was doing her MA at Central St. Martins, since then she'd carry on working in her spare time. She feels particularly attached to these pieces as she has great memories of the time when she works on those. It has always been a personal project hence Carolina never had a brief or a deadline, and often that's when one does the most honest and original work. It's not her favourite thing she's done, but it's probably the one that reflects her the most.

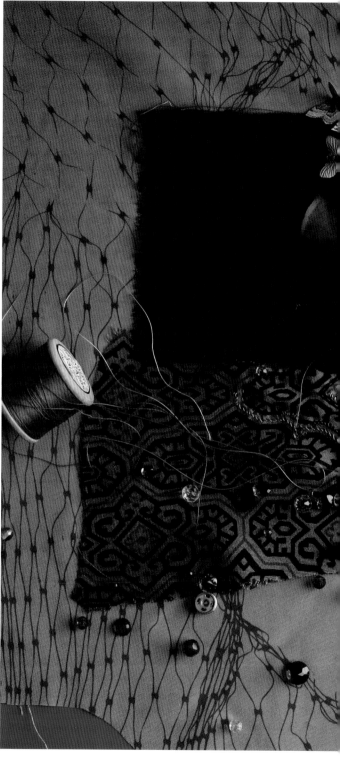

TITLE: Bazaar Time
MEDIA: Embroidery
MATERIAL: Thread, Cloth, Buttons
DESCRIPTION: Carolina started working on this series of embroideries when she was doing her MA at Central St. Martins, since then she'd carry on working in her spare time. She feels particularly attached to these pieces as she has great memories of the time when she works on those. It has always been a personal project hence Carolina never had a brief or a deadline, and often that's when one does the most honest and original work. It's not her favourite thing she's done, but it's probably the one that reflects her the most.

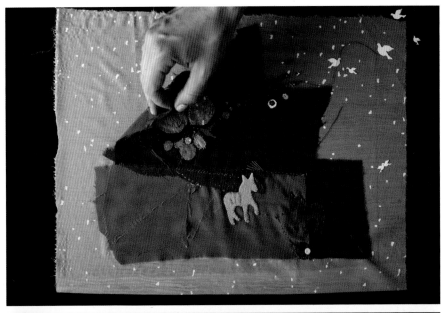

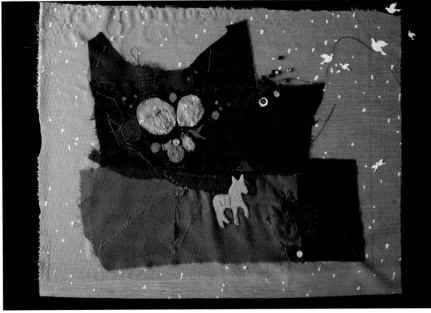

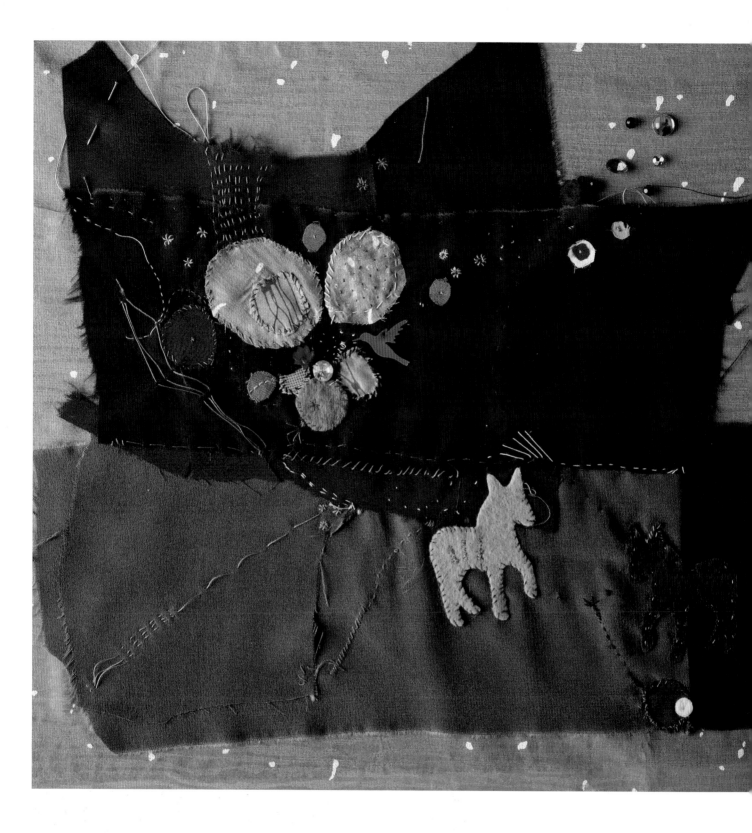

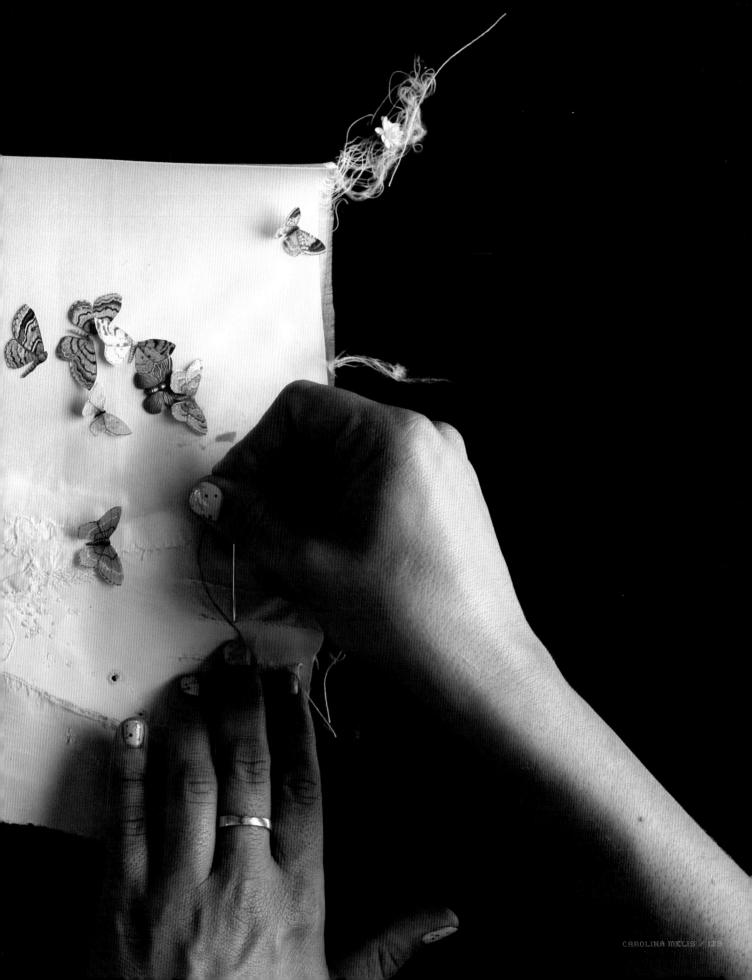

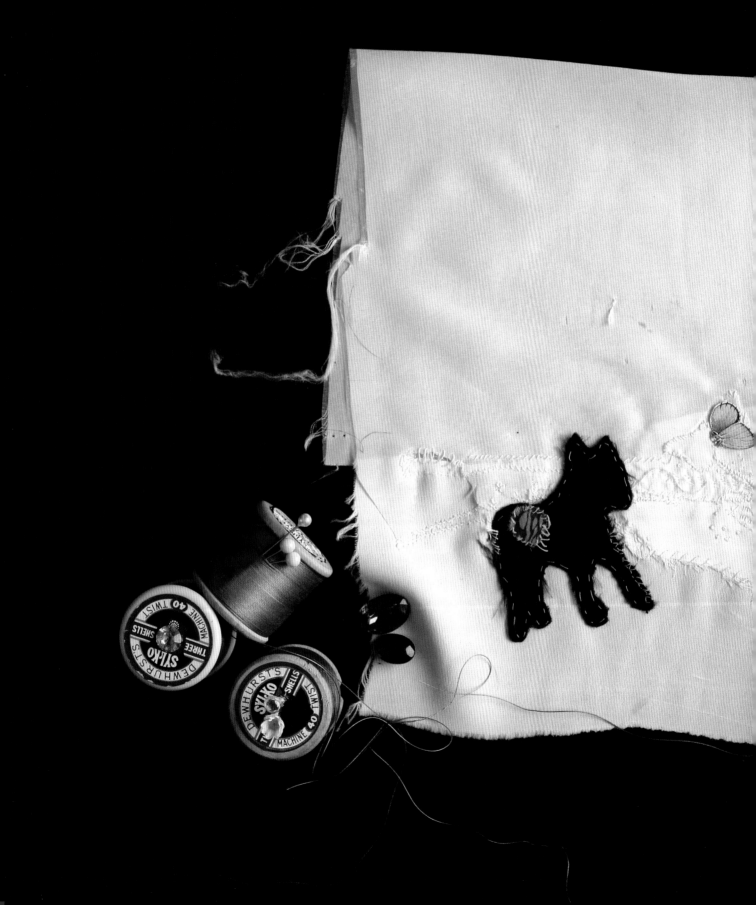

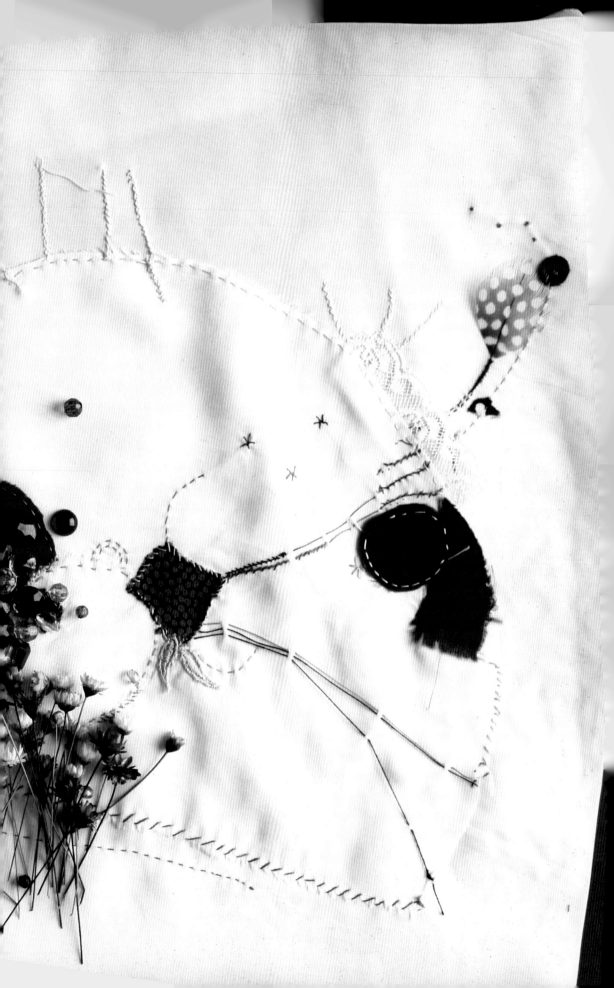

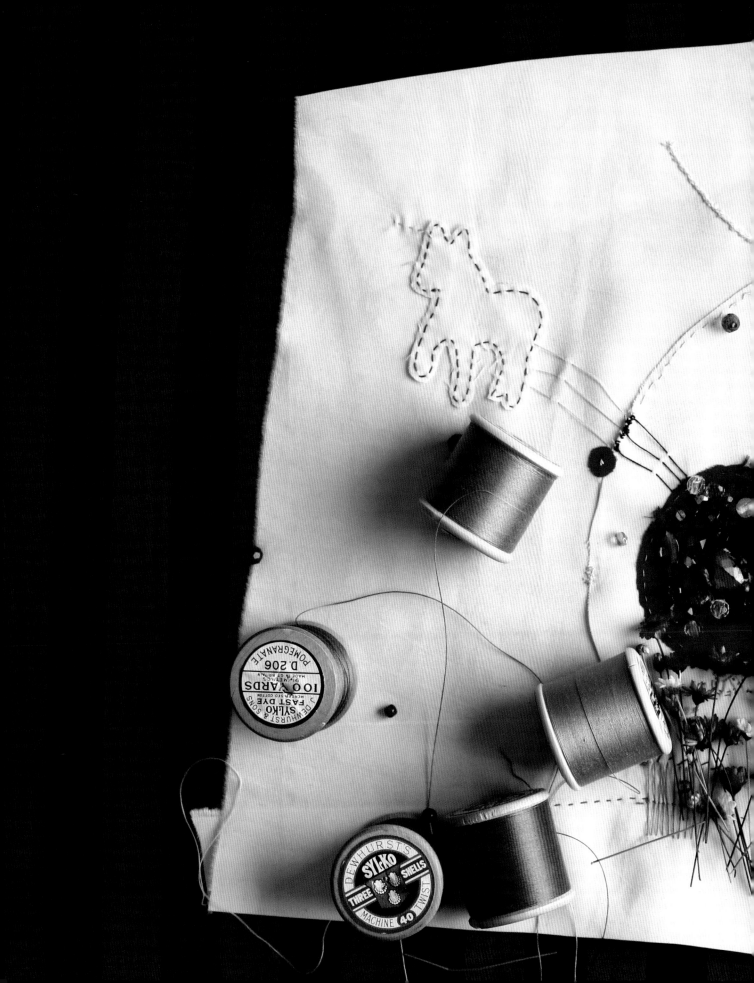

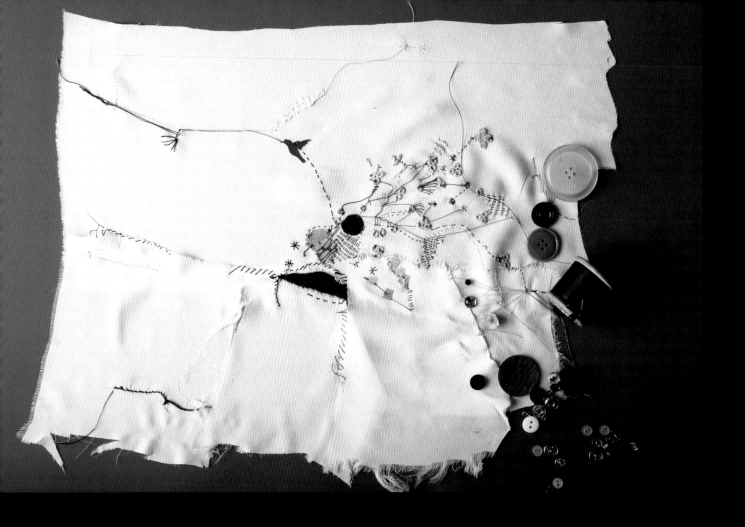

TITLE: Bazaar Time
MEDIA: Embroidery
MATERIAL: Thread, Cloth, Buttons
DESCRIPTION: Carolina started working on this series of embroideries when
she was doing her MA at Central St. Martins, since then she'd carry on working
in her spare time. She feels particularly attached to these pieces as she has great
memories of the time when she works on those. It has always been a personal
project hence Carolina never had a brief or a deadline, and often that's when one
does the most honest and original work. It's not her favourite thing she's done, but
it's probably the one that reflects her the most.

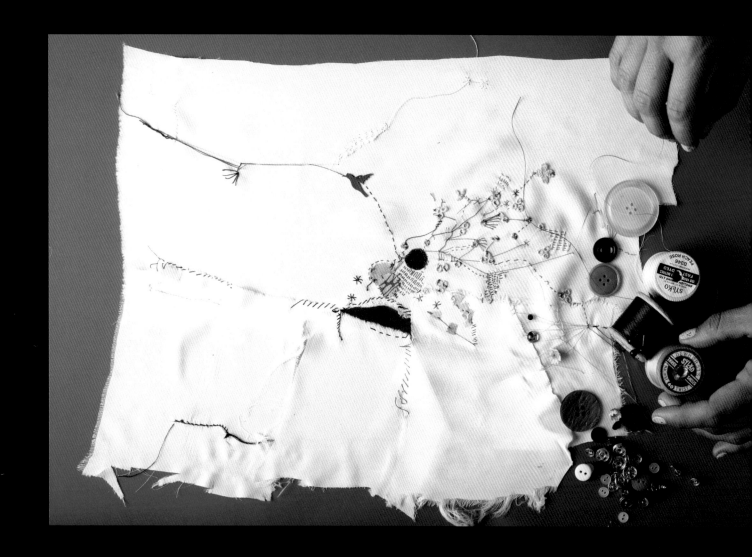

CAROLINA MELIS

London, UK

ORIGINALLY FROM SARDINIA, CAROLINA MOVED TO THE UK TO CONTINUE HER TRAINING IN
DANCE AND CHOREOGRAPHY STUDY AT LONDON CONTEMPORARY DANCE SCHOOL AND
DARTINGTON COLLEGE OF ARTS.

HER CHOREOGRAPHIC PRACTICE DEVELOPED AN INTEREST IN SCREEN-BASED MOVEMENT
THAT LED TO AN MA IN COMMUNICATION DESIGN AT CENTRAL ST. MARTINS SPECIALIZING IN
ANIMATION AND ILLUSTRATION. IN 2004 CAROLINA WON AN ANIMATE! COMMISSION
(CHANNEL 4 AND ACE) FOR THE FILM AS THE CROW FLIES AND HAS RECENTLY DIRECTED A
NEW MUSIC VIDEO THE HAPPY SEA, COLLEEN (LEAF, UK).

CAROLINA IS ALSO KNOWN INTERNATIONALLY FOR HER ILLUSTRATION WORK, WHICH HAS
BEEN FEATURED IN DESIGN AND FASHION CONTEXTS AS WELL AS GALLERY SPACES. HER
ANIMATED WORK, GREATLY INFORMED BY HER BACKGROUND IN CHOREOGRAPHY, EXPLORES
IDEAS OF DELICACY, ORGANIC DEVELOPMENT, LIFE-CYCLES AND LIVING RELATIONSHIPS,
YIELDING ELEGANTLY TRAGIC PIECES WITH A SUBTLE ROMANCE.

CAROLINA MELIS IS REPRESENTED BY NEXUS PRODUCTIONS AND ARE CURRENTLY WORKING
ON FURTHER COMMERCIAL AND MUSIC VIDEO PROJECTS.

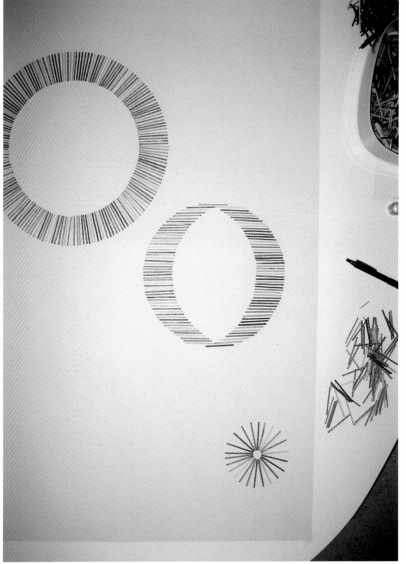

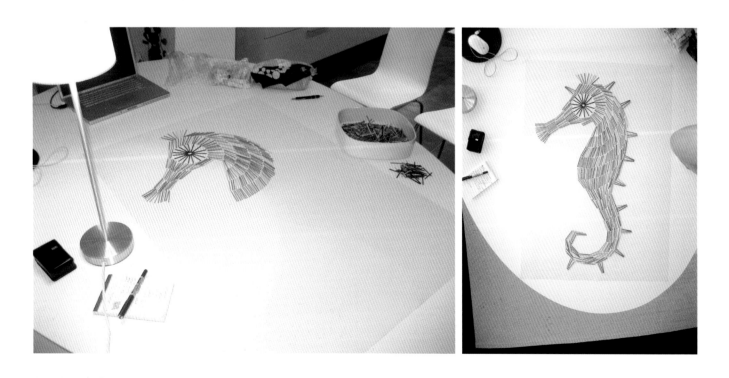

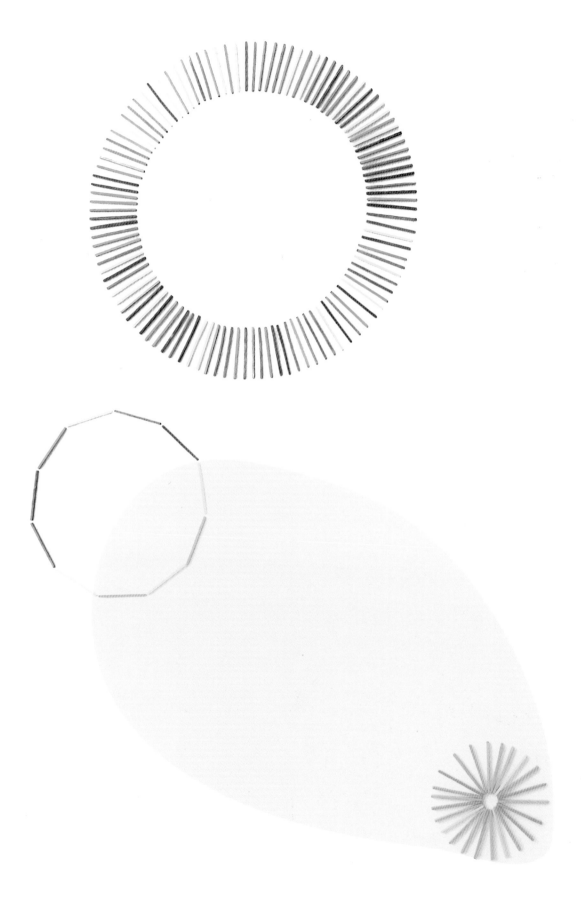

JOHANNA LUNDBERG

Stockholm, Sweden

JOHANNA LUNDBERG WAS A SWEDISH STUDENT AT THE
LONDON COLLEGE OF COMMUNICATION DOING GRAPHIC
DESIGN/ILLUSTRATION. SHE HAS BEEN DOING INTERNSHIPS
AT GH AVISUALAGENCY IN NEW YORK, SYRUP HELSINKI IN
FINLAND AND AT NEUE GESTALTUNG IN BERLIN.

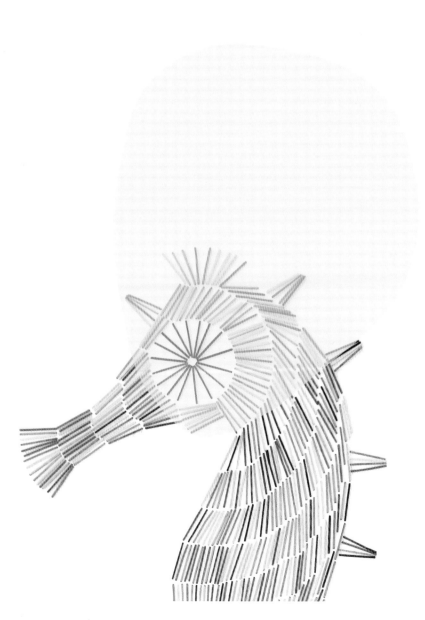

TITLE: Living In A Bubble

MEDIA: Collage, Photography, Computer illustrating

MATERIAL: Coloured wooden matches, Paper

DESCRIPTION: Johanna first created patterns with coloured
wooden matches by laying them flat on a large paper. She then
photographed it and added vector illustration on top.

Finding herself in the place where Johanna grew up and left
a long time ago, she thought of some key words that could
describe it to an audience – Family, Animals, Forest, Happy
and Playful. Johanna then used them as a starting point and
created a series of illustrations that is made out of coloured
wooden matches. The seahorse illustration comes from her
father's seahorse-tattoo. They lived quite isolated and picking
strawberries in her grandmother's garden is a strong memory.
The colour represents her childhood happiness. The vector
image (bubble) is added on top to give more layers and
dimensions, and to give the feeling of protection.

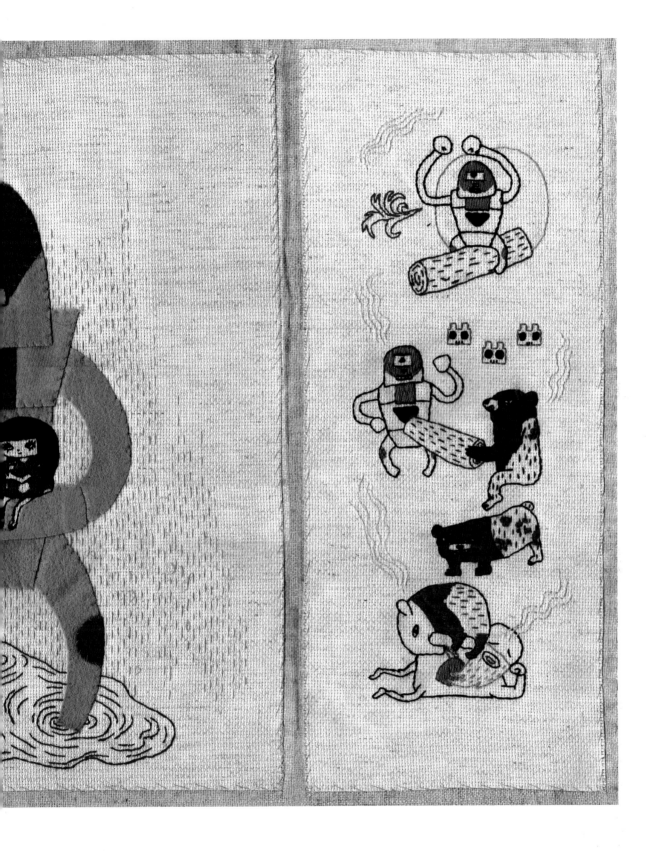

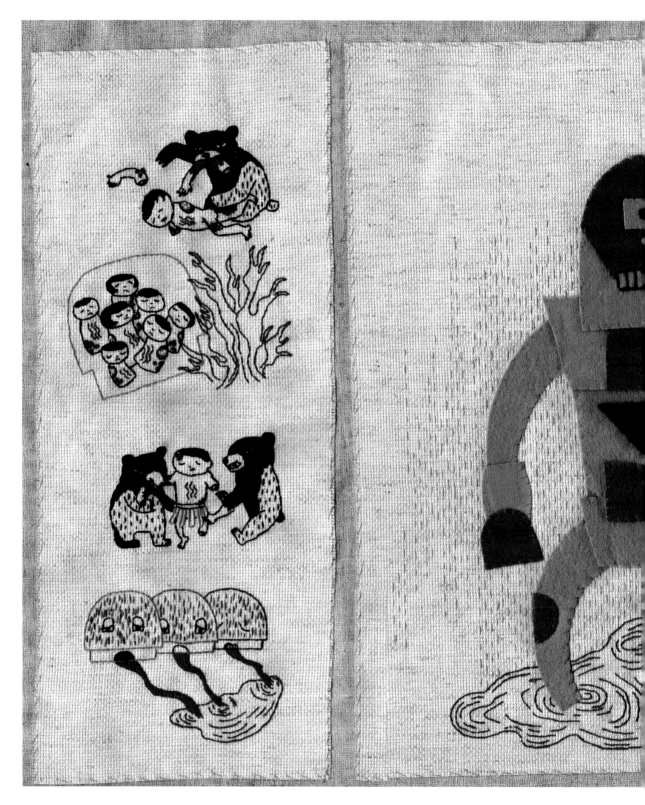

TITLE: YaShita Tribe TROYY Blanket

MEDIA: Embroidery

MATERIAL: Cloth, Thread

DESCRIPTION: This embroidery piece is made for a show at Flux Factory called 'Grizzly proof.' Aya created an imaginary tribe called Yashita that were cursed by the spirits of the Black Bear. This blanket shows the story of the curse and also the story of a saver TROYY.

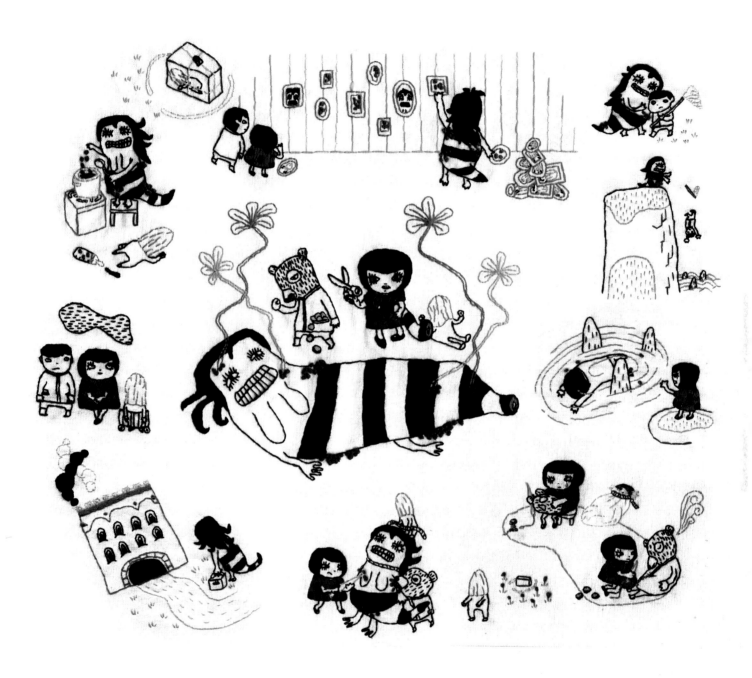

TITLE: (Previous Page) Jojo* / Ghost Brother** / Evil Nanny*** /
(This Page) Nana**** / Three Children And An Evil Nanny*****

MEDIA: Embroidery

MATERIAL: Cloth, Thread, Wall paper covered with stencil

DESCRIPTION: This is made for a show called 'Cute & Scary' in the Flux
Factory gallery. The embroidery pieces tell a story about the evil nanny
taking over the house of three children by killing them, and their revenge.
The evil nanny killed the oldest child of the three, Jojo, by pushing him
from the cliff. The youngest child is killed by the evil nanny with poisoned
milk. The second child Nana planned to take revenge on the evil nanny
because she kills her brothers. Jojo comes back when Nana sawed his
body to her favourite position in front of her teddy bear. The Ghost Brother
comes back when his sister decides to take revenge. The children succeed
and evil Nanny is killed in the end.

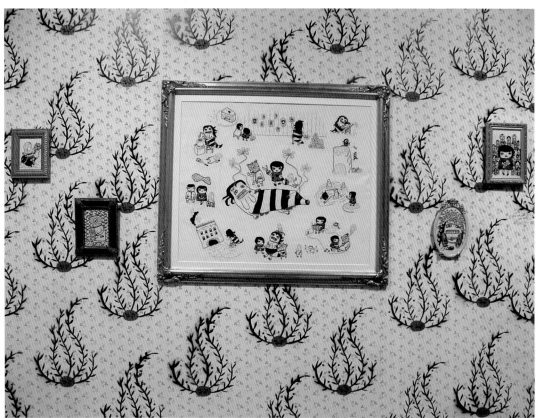

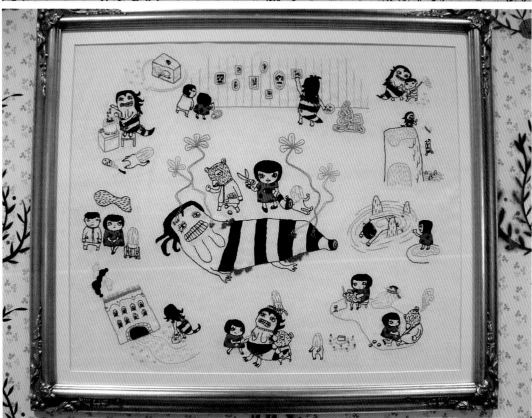

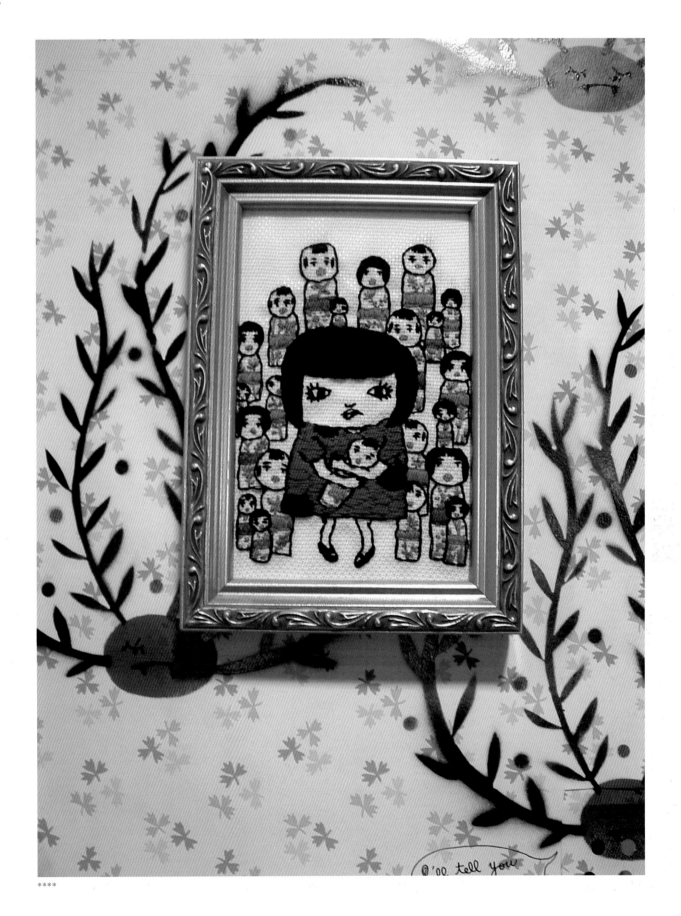

©'00 tell you

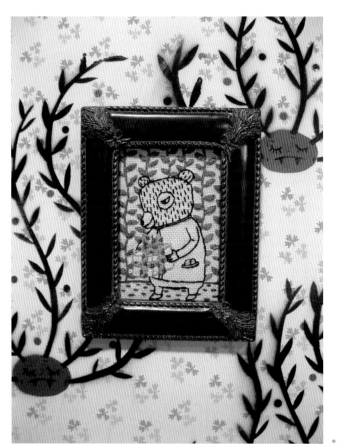

AYA KAKEDA

New York, USA

AYA WAS BORN AND RAISED IN TOKYO JAPAN. SHE NOW
WORKS AND LIVES IN BROOKLYN, NEW YORK. SHE LIKES CATS,
SEALS, RECEIVING POSTCARDS AND SHE HAS EVER-CHANG-
ING WEEKLY OBSESSIONS, NOW IT'S THE FRENCH LANGUAGE
AND STAR NOSED MOLE. SHE ALSO ELABORATES LOTS OF
THEORIES ABOUT LOT OF THINGS. WHEN SHE DOESN'T INDULGE
IN HER OBSESSIONS SHE PAINTS AND DRAWS, AND CREATES
HER OWN WHIMSICAL NARRATIVES.

*

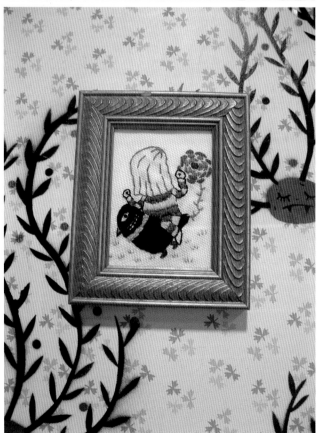

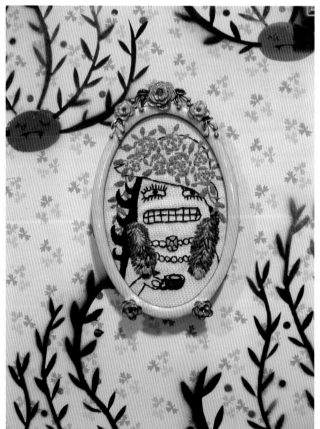

** ***

TITLE: Dear Friend (Left page)

MEDIA: Drawing, Stitching

MATERIAL: Ink, Pen, Thread on Paper

DESCRIPTION: In the past couple of years, Caroline started to do some drawings with ink washes and pen while still incorporating a little bit of the collaging and sewing. She felt like there was a certain detail and intimacy that could be achieved in a drawing rather than a large stitched piece.

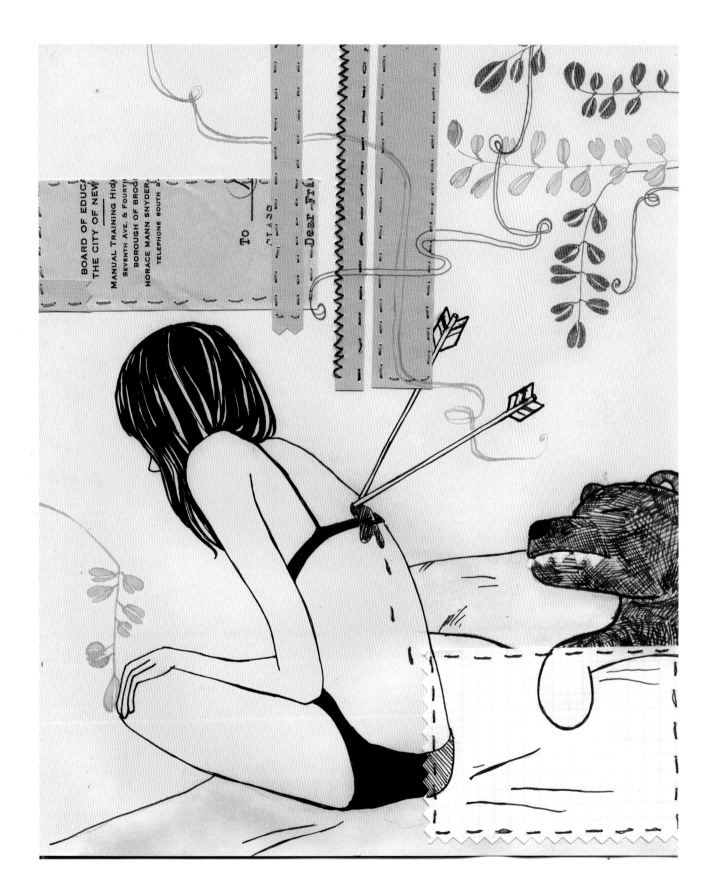

TITLE: I Wood For You
MEDIA: Painting, Stitching
MATERIAL: Acrylic, Fabric, Thread
DESCRIPTION: With this piece, Caroline wanted to use thread as more of a drawing tool. She needed to give the piece some depth beyond the two prominent figures, so she decided to use subtle embroidery. Once again, in this piece the girl wears a form of disguise in her 'native American' headwear.

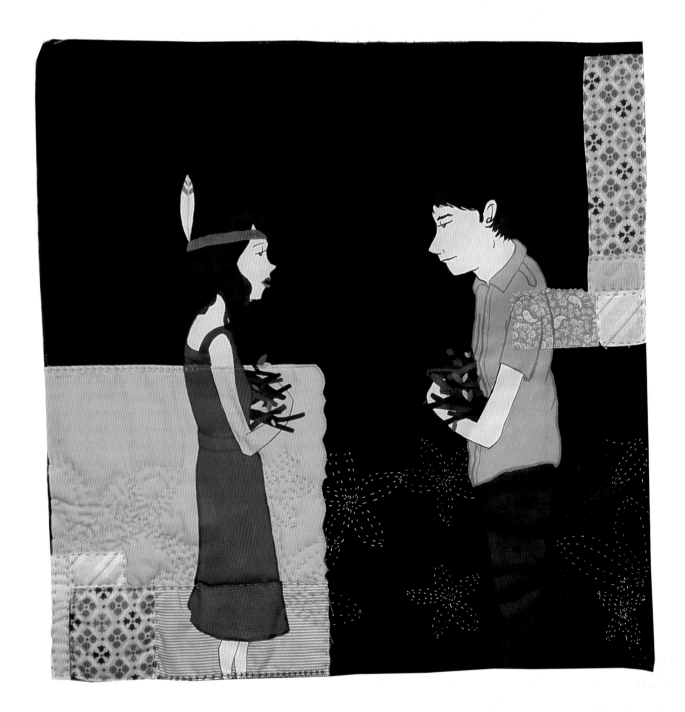

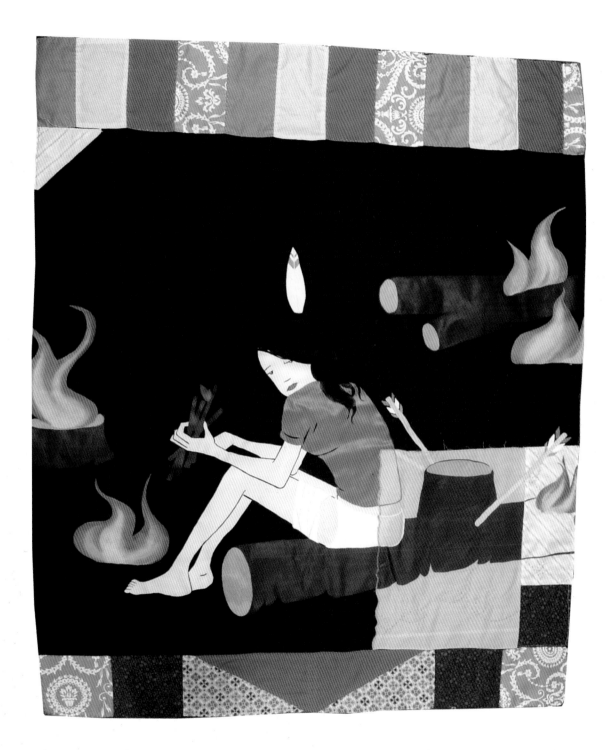

TITLE: Weight On Words
MEDIA: Painting, Stitching
MATERIAL: Acrylic, Fabric, Thread

DESCRIPTION: This is a piece from the show 'Hey There Lonely Girl.' Again
Caroline used the theme of summer camp flags/banners, but this one has a different
composition in how she laid out the patchwork. She wanted to play with the patch-
work outside of the normal, grid-like way. She wanted the dynamic of the patchwork
toss play off of the girls and the activity of the girls in the piece.

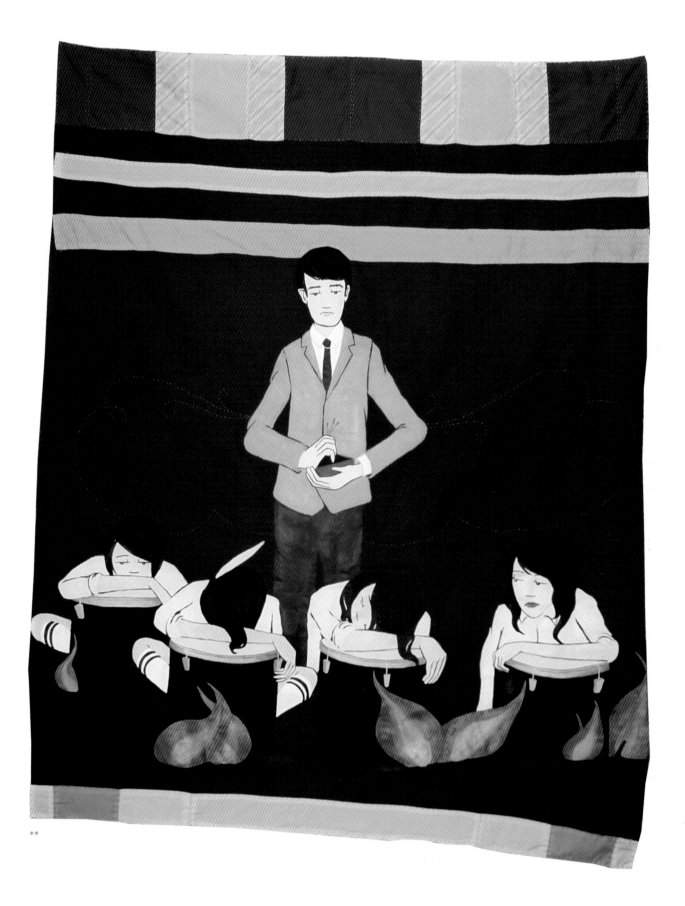

**

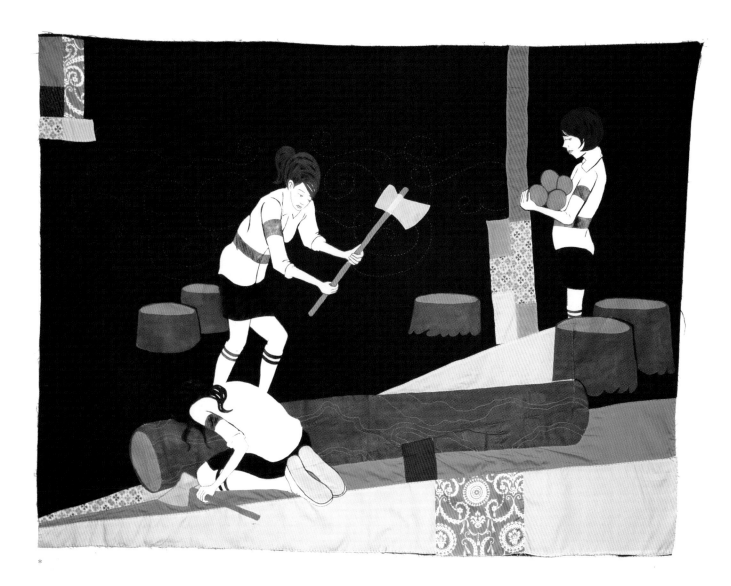

*

TITLE: Erase Me And I'll Reappear *

MEDIA: Painting, Stitching

MATERIAL: Acrylic, Fabric, Thread

DESCRIPTION: This is a piece for a 2-person show at New Image Art titled 'Hey There Lonely Girl.' In this series of paintings Caroline incorporated the colour blocking used in quilting and the theme of childhood summer camp flags and banners. These paintings play with the idea of multiple identities and/or personalities, and create characters in disguise. Caroline used the theme of summer camp flags/banner and played with the patchwork outside of the normal, grid-like way.

TITLE: Travel To A Different Beat**

MEDIA: Painting, Stitching

MATERIAL: Acrylic, Fabric, Thread

DESCRIPTION: This is also a piece for 'Hey There, Lonely Girl.' Her new set of paintings feature a 'gang' of girls exploring themes of camaraderie, as well as the idea that each girl is perhaps one of many personalities in a single person. Quilting is used to evoke nostalgia of traditional American handicrafts, and she explores the theme of summer camp flags to show the different 'camps' of emotions every person.

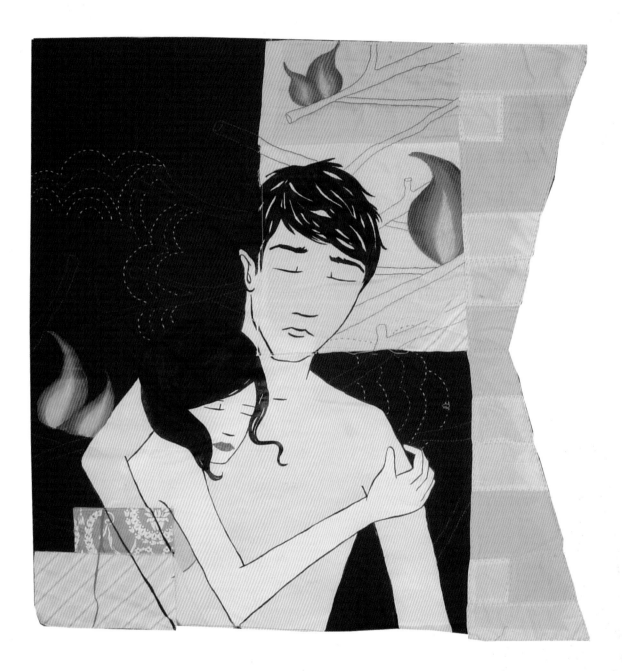

TITLE: What I Thought It Was, It Isn't Anymore
MEDIA: Painting, Stitching
MATERIAL: Acrylic, Fabric, Thread
DESCRIPTION: This piece was the start of a new series of paintings that had to do with nautical signaling flags. Although the way the newer pieces don't look like this one, this was just a start. Caroline likes the idea of communication that are related to these flags, for instance this flag represents the letter 'a' and could represent the distress/maneuvering signal of 'Diver Down' or 'Keep Clear.' She incorporated colour blocking and quilting of the old quilts with the actual colour block of the signaling flags.

TITLE: I Learned That With You*
MEDIA: Drawing, Stitching
MATERIAL: Acrylic, Fabric, Thread
DESCRIPTION: In the past couple of years, Caroline started to do some drawings with ink washes and pen while still incorporating a little bit of the collaging and sewing. She felt like there was a certain detail and intimacy that could be achieved in a drawing rather than a large stitched piece.

TITLE: I Swallow Your Sorrow**
MEDIA: Drawing, Stitching
MATERIAL: Acrylic, Fabric, Thread
DESCRIPTION: Usually when Caroline portrays a woman half naked, it's never really to evoke a sexual feeling, although sometimes it definitely seems so. She likes the seeming vulnerability of someone when they are naked, when everything is stripped away. Sort of like, what you see is what you get. Although the vulnerability is there, she feels like there is an empowerment, not in a sexual empowerment sort of way, but in an honest, self-actualizing way.

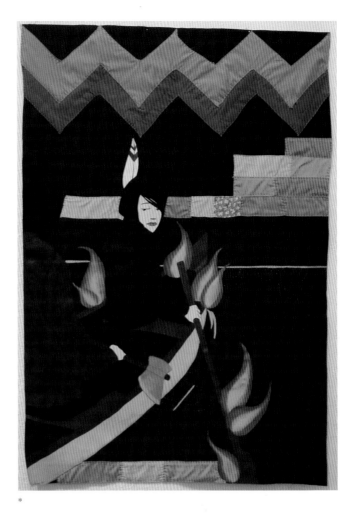

*

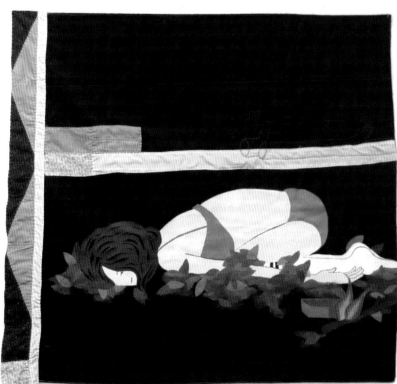

**

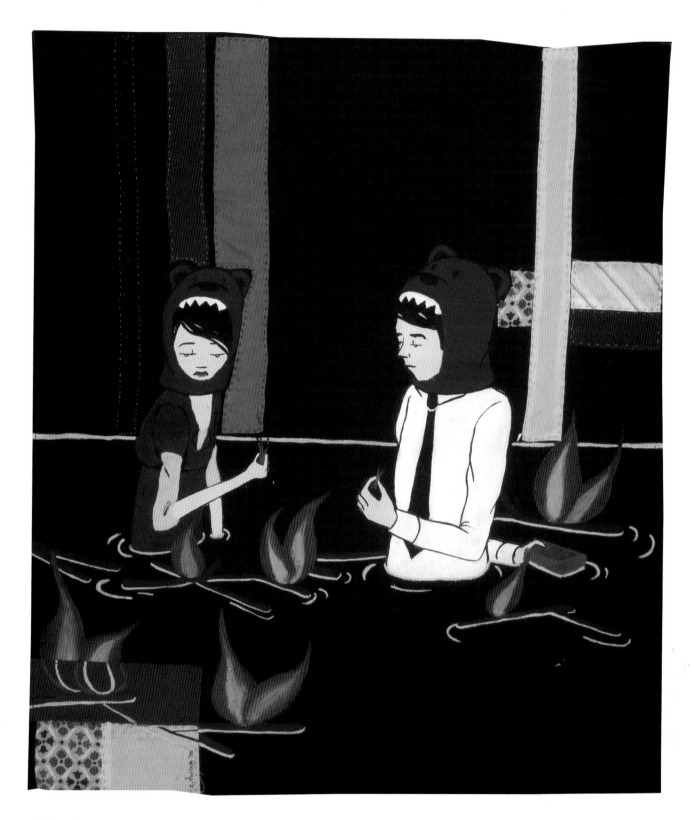

TITLE: Guilty Crush
MEDIA: Drawing, Stitching
MATERIAL: Acrylic, Fabric, Thread
DESCRIPTION: This piece is mainly about an accountability of
your actions after the 'blame game' in a relationship is played.

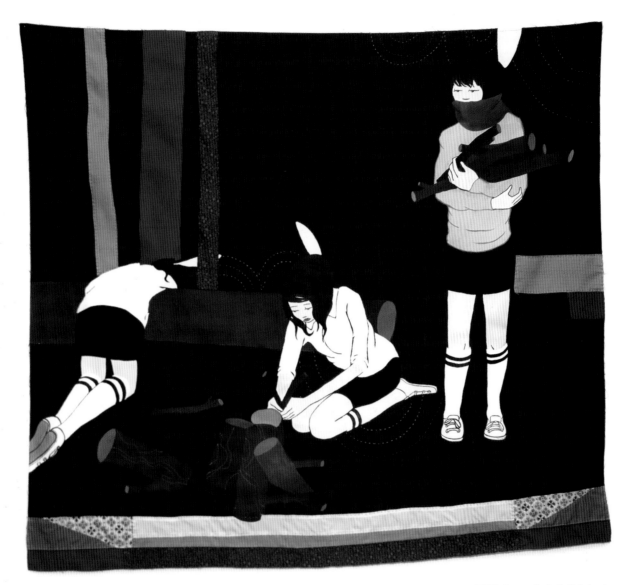

CAROLINE HWANG

New York, USA

CAROLINE HWANG WAS BORN IN MINNEAPOLIS, MINNESOTA, GREW UP IN
SOUTHERN CALIFORNIA AND EARNED HER BACHELOR'S DEGREE AT ART CEN-
TER COLLEGE OF DESIGN. SHE CURRENTLY RESIDES IN BROOKLYN, NEW YORK.
HWANG'S WORK IS INFLUENCED AS MUCH BY HER GRANDMOTHER'S CROCHETING
AND KNITTING AS IT IS BY CRAFTS, GRAPHIC ARTS, QUILTING, FILMS AND MUSIC,
AMONG OTHER THINGS. SHE COLLAGES TOGETHER FABRIC, THREAD, AND PAINT
TO CREATE IMAGES THAT COMMUNICATE RAW HUMAN EMOTION, SELF-REFLEC-
TION, AND THE DYNAMICS AND DIFFICULTY OF ALL RELATIONSHIPS.

SHE HAS BEEN FEATURED IN PAPER MAGAZINE AND SWINDLE QUARTERLY AND
HAS DONE ILLUSTRATIONS FOR THE NEW YORK TIMES, BUST MAGAZINE, AND
HOW DESIGN. HER WORK HAS MOST RECENTLY BEEN SHOWN AT CLEMENTINE
GALLERY (NEW YORK), NEW IMAGE GALLERY (LOS ANGELES), MOTEL GALLERY
(PORTLAND) AND 96 GILLESPIE (LONDON).

TITLE: Compensating for the Underfunctioner
MEDIA: Painting, Stitching
MATERIAL: Acrylic, Fabric, Thread
DESCRIPTION: In the same theme of summer camp
flags, except Caroline tried to use the patchwork in a
more 'dynamic' way rather than the stringent grided way
that most quilts are made.

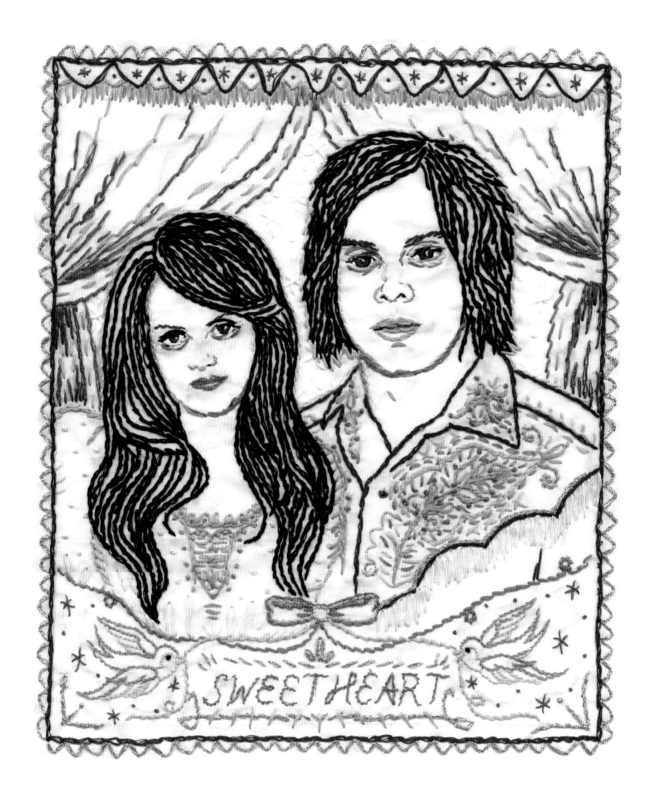

SWEETHEART

TITLE: The White Stripes
MEDIA: Hand embroidery
MATERIAL: Cotton panel
DESCRIPTION: The work is made for Venus to accompany an interview
with the White Stripes and the release of their album, Elephant.

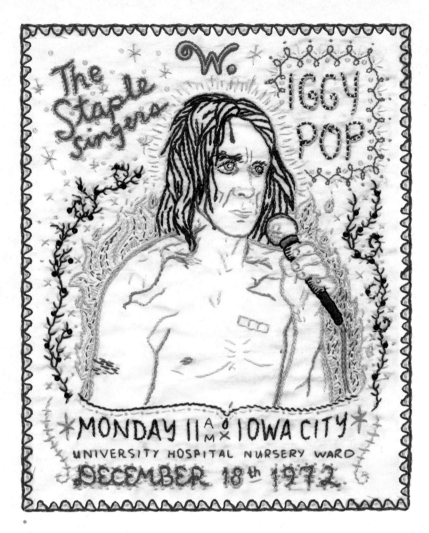

TITLE: Iggy Pop*
MEDIA: Hand embroidery
MATERIAL: Cotton panel
CLIENT: Nylon
DESCRIPTION: This piece was an open assignment from Nylon magazine where they invited artists to create their 'dream bill concert poster' featuring any lineup, at any venue at any point in history. Jenny chose The Staple Singers opening for Iggy Pop in the nursery ward where she was born at the time of her birth.

TITLE: Roger Miller** / La Chingona***
MEDIA: Hand embroidery
MATERIAL: Cotton panel
DESCRIPTION: -

*

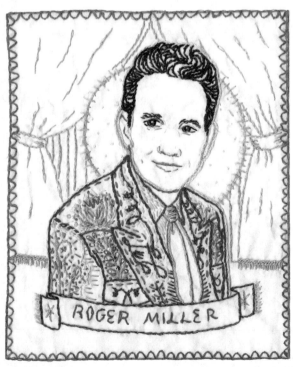

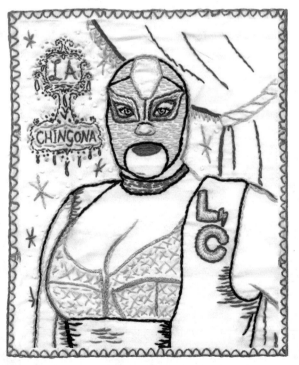

**

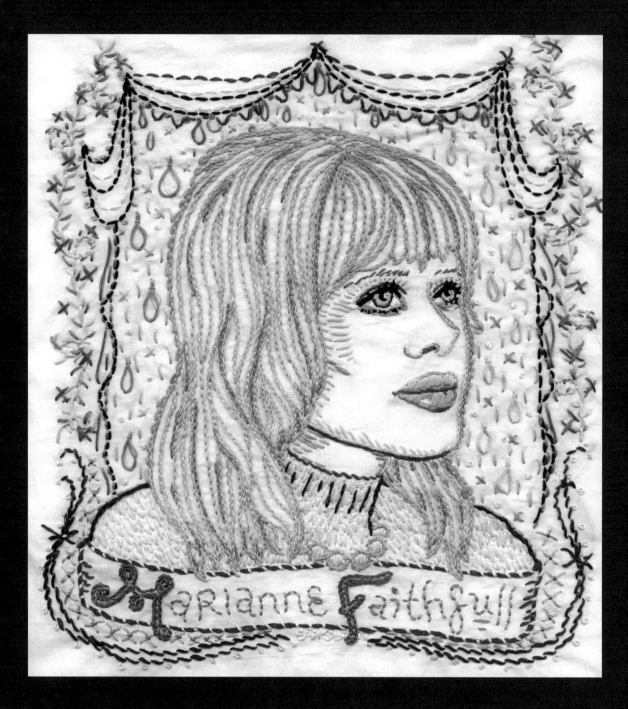

TITLE: Marianne Faithfull
MEDIA: Hand embroidery
MATERIAL: Cotton panel
DESCRIPTION: The work is made for Venus.

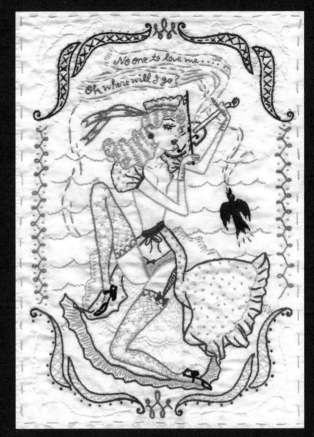

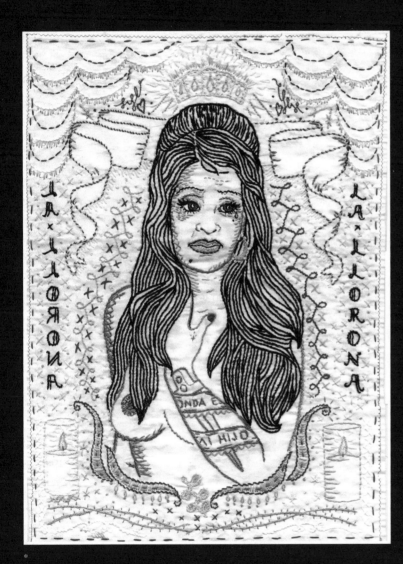

TITLE: La Llorona*
MEDIA: Hand embroidery
MATERIAL: Cotton panel
DESCRIPTION: -

TITLE: Blue Lass**
MEDIA: Hand embroidery
MATERIAL: Cotton panel
DESCRIPTION: This work was a collaboration
with artist Dame Darcy. Jenny asked Dame to
produce an illustration for her to embroider.

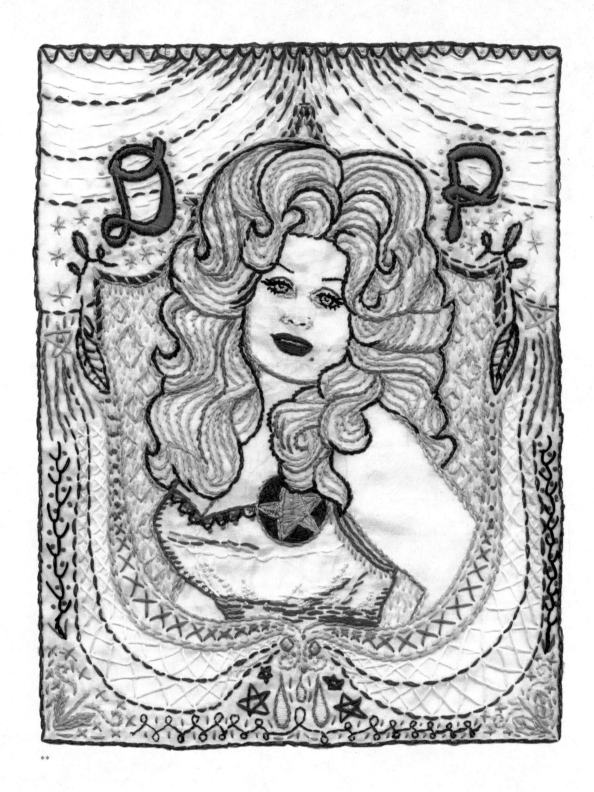

**

TITLE: Dirty Face, Crowning Glory* /
Dolly Parton (aka Blue Dolly)**
MEDIA: Hand embroidery
MATERIAL: Cotton panel
DESCRIPTION: -

JENNY HART

Austin, USA

JENNY HART (B. 1972) IS AN ARTIST BASED IN AUSTIN, TEXAS WHOSE WORKS IN EMBROI-
DERY HAVE BEEN PUBLISHED AND EXHIBITED INTERNATIONALLY. SHE IS ALSO THE FOUNDER
SUBLIME STITCHING, A PIONEERING DESIGN COMPANY LAUNCHED IN 2001 TO REVITALIZE THE
CRAFT OF HAND EMBROIDERY.

JENNY'S WORK HAS APPEARED IN PUBLICATIONS SUCH AS SPIN, ROLLING STONE, NYLON, THE
FACE, BUST AND JUXTAPOZ. SHE IS THE AUTHOR OF TWO TITLES FOR CHRONICLE BOOKS (SAN
FRANCISCO) AND HER DESIGN WORK WON PRINT MAGAZINE'S REGIONAL DESIGN
ANNUAL AWARD (2005). JENNY HAS COLLABORATED WITH THE FLAMING LIPS AND THE
DECEMBERISTS, AND HER WORK IS IN THE COLLECTIONS OF CARRIE FISHER, TRACEY ULLMAN
AND ELIZABETH TAYLOR.

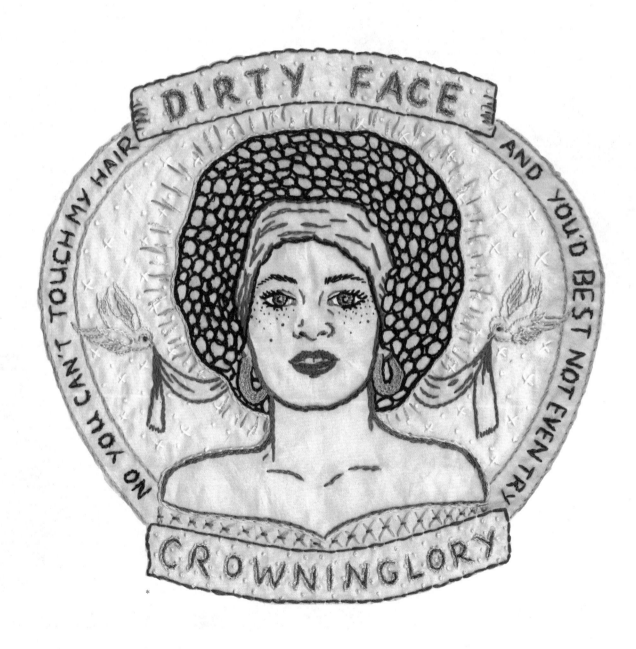

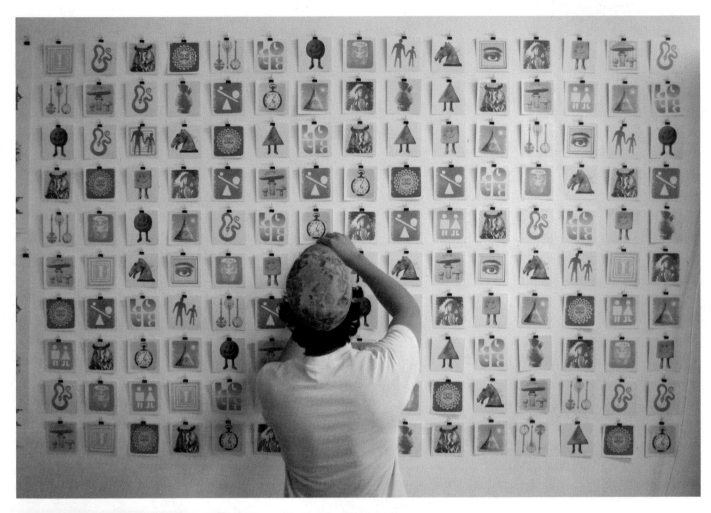

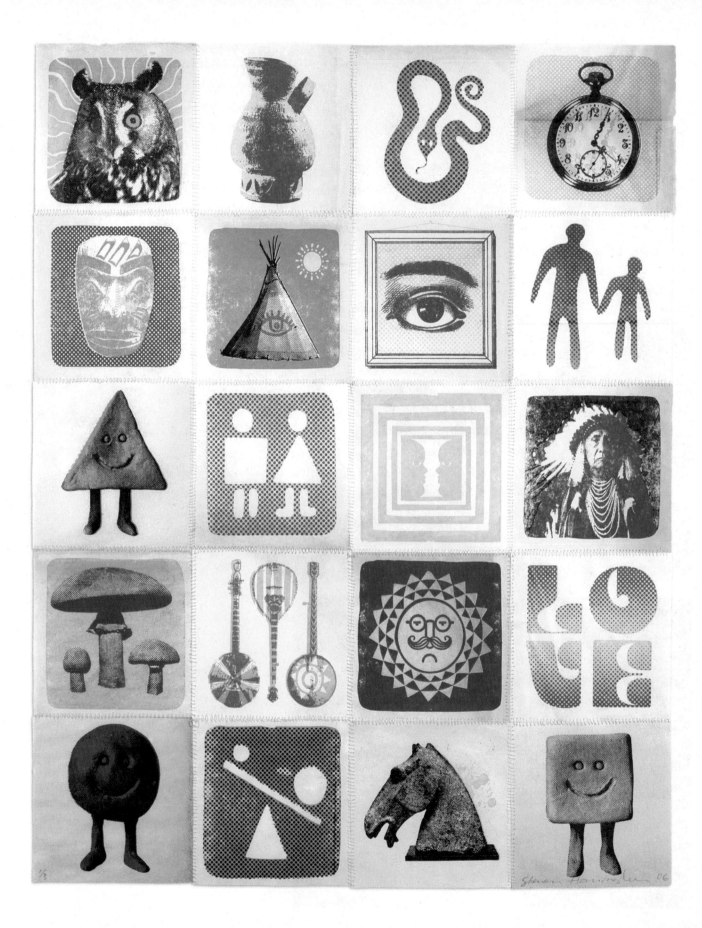

TITLE: Community
MEDIA: Silkscreen, Hand sewn, Collage
MATERIAL: Aged paper, Screenprint
DESCRIPTION: A triptych describing community for 'Thank You,' a personal art show held at Art Prostitute Gallery in Denton, TX.

1/1 Steven Harrington 06

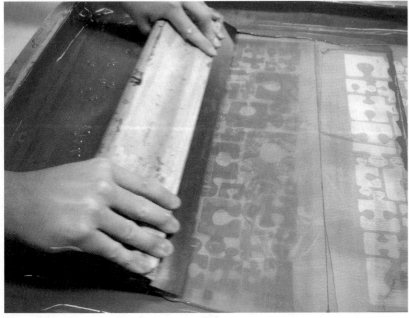

TITLE: Somehow, We All Seem Connected
MEDIA: Silkscreen, Collage
MATERIAL: Paper
DESCRIPTION: A puzzle kite created for 'Thank You,' a personal art show held at Art Prostitute Gallery in Denton, TX.

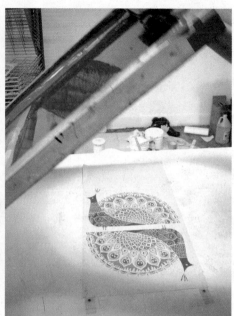

TITLE: Peacock
MEDIA: Silkscreen, Collage
MATERIAL: Paper
DESCRIPTION: A peacock kite created for 'Thank You,'
a personal art show held at Art Prostitute Gallery in Denton, TX.

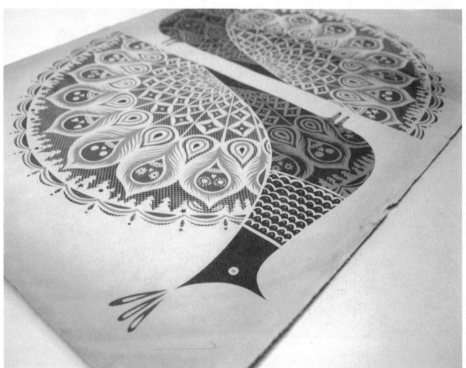

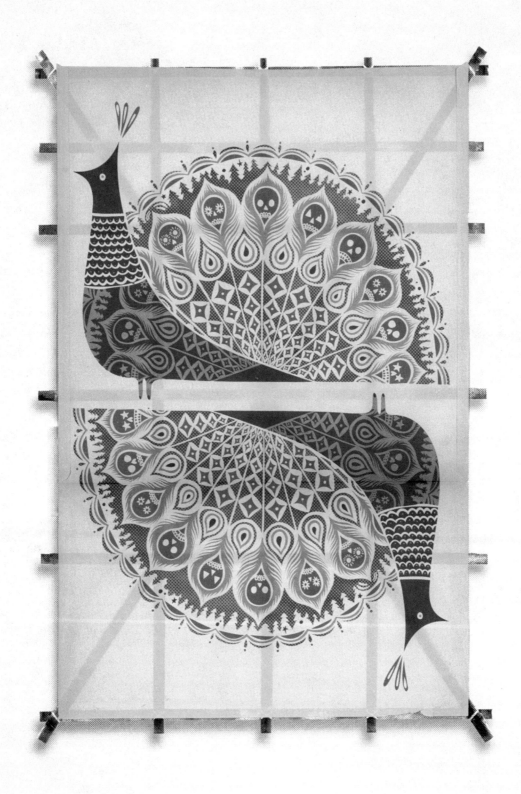

1/1 Steven Harrington 06

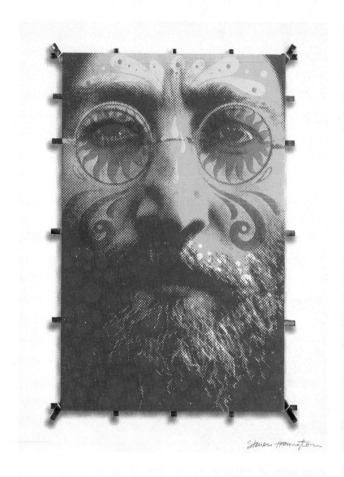

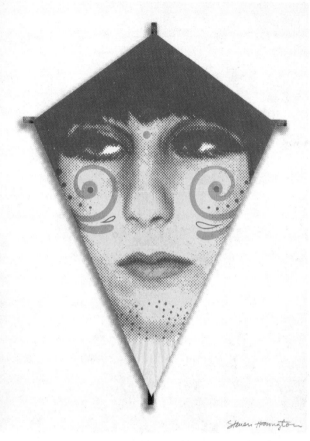

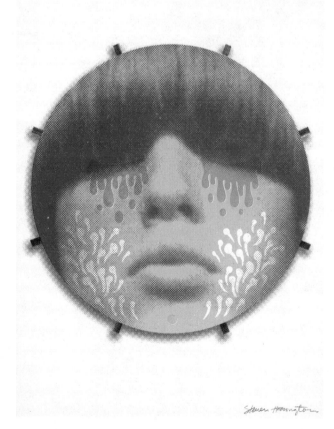

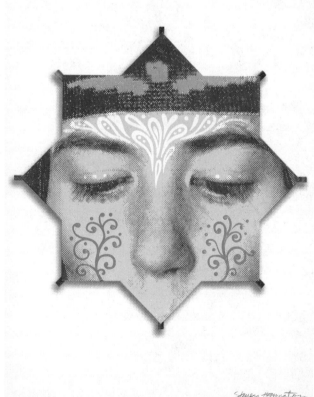

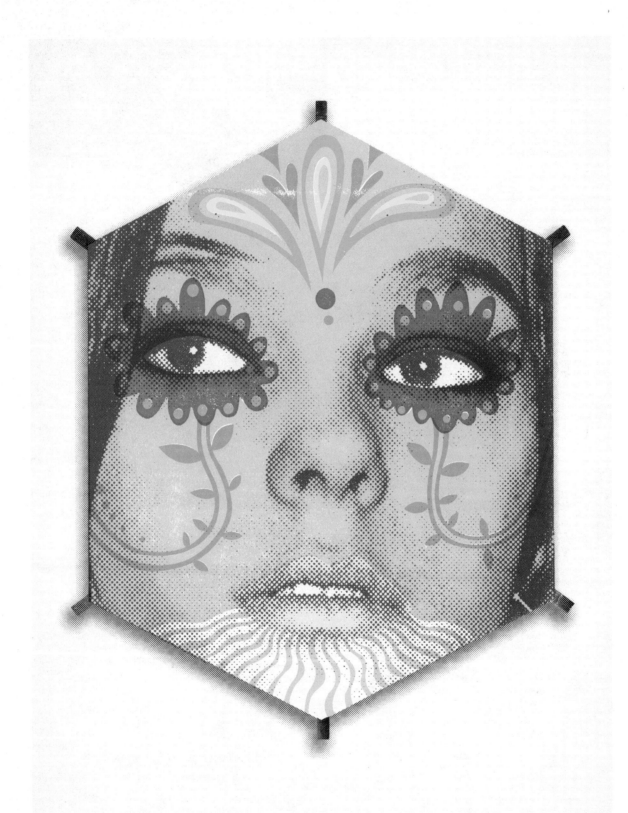

Steven Harrington

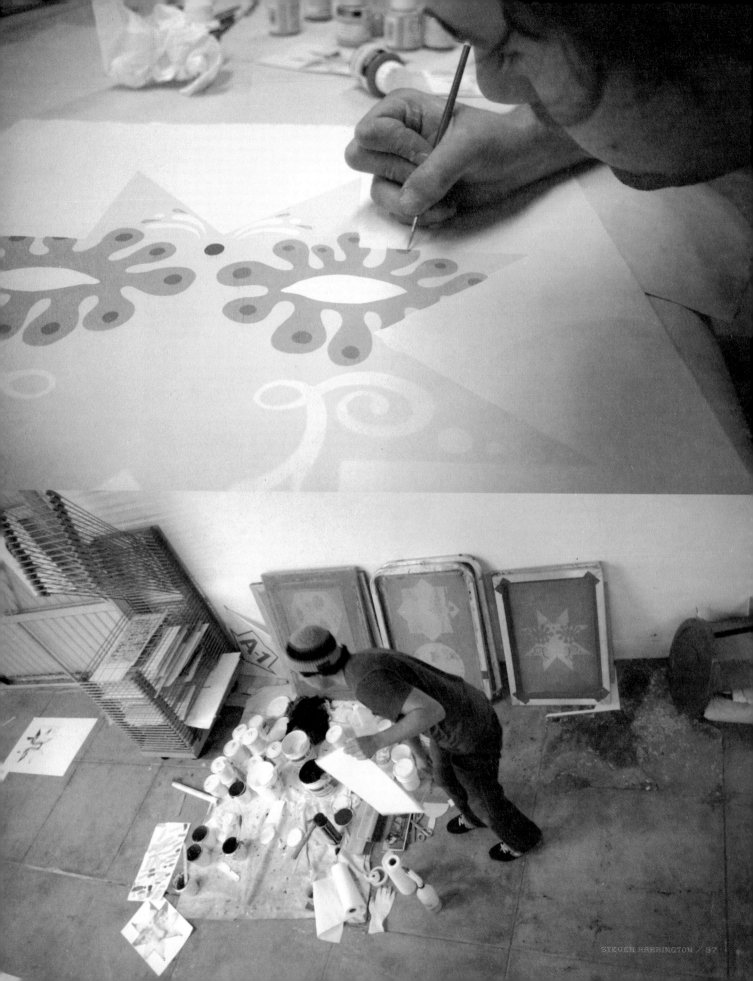

STEVEN HARRINGTON / 87

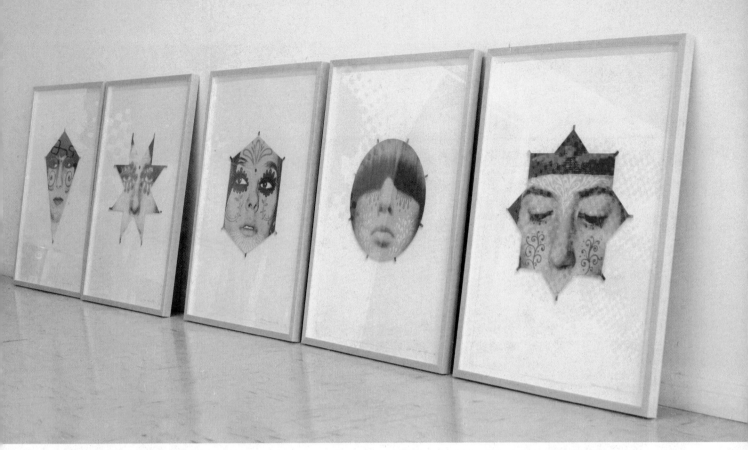

TITLE: Faces
MEDIA: Silkscreen, Collage
MATERIAL: Paper
DESCRIPTION: A series of six kites created for 'Thank You,' a personal art show held at Art Prostitute Gallery in Denton, TX.

STEVEN HARRINGTON

Los Angeles, USA

STEVEN HARRINGTON LIVES AND WORKS IN LOS ANGELES, CA. ASIDE FROM OWNING AND OPERATING NATIONAL FOREST DESIGN WITH FELLOW ARTIST JUSTIN KRIETEMEYER, HE STILL FINDS TIME TO WORK ON BOTH COMMISSIONED AND SELF-INSPIRED ART PROJECTS OF HIS OWN.

INFLUENCED BY IMAGES, FASHION AND GRAPHICS DISCOVERED IN TIME LIFE ENCYCLOPEDIAS FROM 1965-1972, THRIFT STORES, AND THE MOODY BLUES, HIS ART MIGHT BE TERMED CONTEXTUAL OBJECTIVISM. THAT IS, HE VIEWS EACH PIECE HE CREATES AS A TANGIBLE OBJECT THAT IS PART AND PARCEL OF A LARGER CONTEXT; THE OBJECT HELPS DEFINE THE CONTEXT AND THE CONTEXT HELPS DEFINE THE OBJECT. WHATEVER FEEL OR MEANING THE OBSERVER TAKES AWAY FROM THE PIECE BELONGS TO THE OBSERVER. NOTHING IS SHOVED DOWN HIS OR HER THROAT. DISCOVERY IS THE KEY.

SOME OF HIS MOST RECENT PROJECTS INCLUDE A FOUR BOARD SERIES FOR BURTON SNOWBOARDS, CONTRIBUTIONS TO THE FRENCH CLOTHING LINE SIXPACK, AND A SERIES OF SILKSCREEN PRINTS BASED ON THE IDEA OF 'COMMUNITY.' HE HAS EXHIBITED WORK IN LOS ANGELES, NEW YORK, DALLAS, SAN FRANCISCO, CHICAGO, PHILADELPHIA, MONTREAL, TOKYO, MELBOURNE AND BARCELONA.

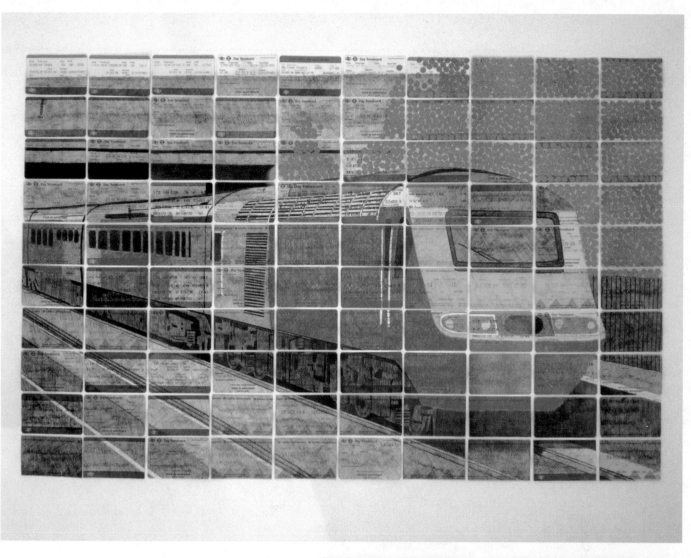

TITLE: Traintravel

MEDIA: Collage

MATERIAL: Train tickets, Black biro, Green sticker labels

DESCRIPTION: A train drawn directly onto train tickets
using black biro and green sticker labels.

TITLE: YCN Commendation Certificate

MEDIA: Sticker labels collage

MATERIAL: Certificate of commendation for the YCN annual awards scheme, Workbook style stickers

DESCRIPTION: Certificate of commendation for the Young Creative Network (YCN) annual awards scheme. The YCN logo was created into a grid where the receiver could create their own certificate with the provided sticker labels making each certificate individual. Using workbook style stickers.

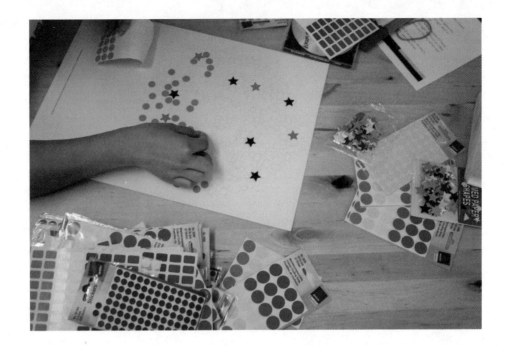

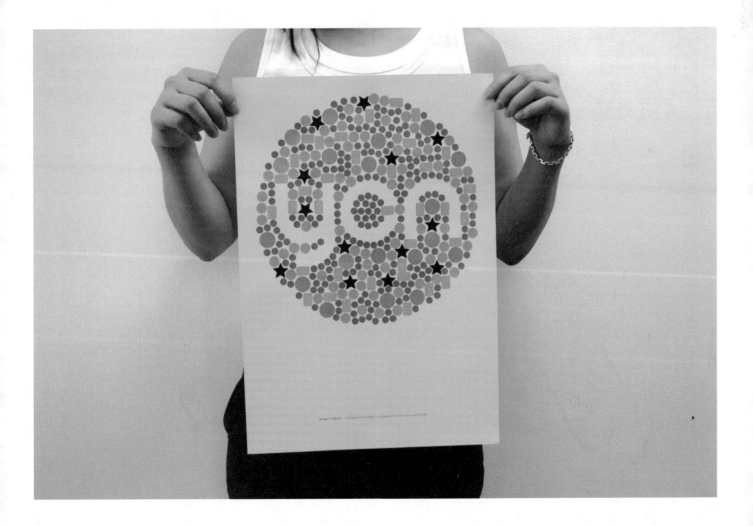

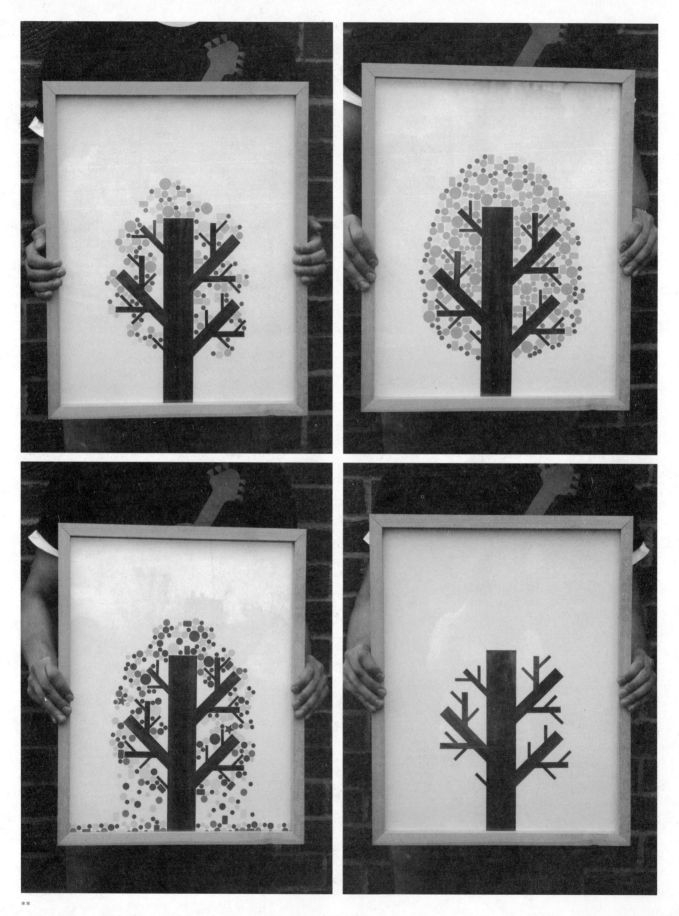

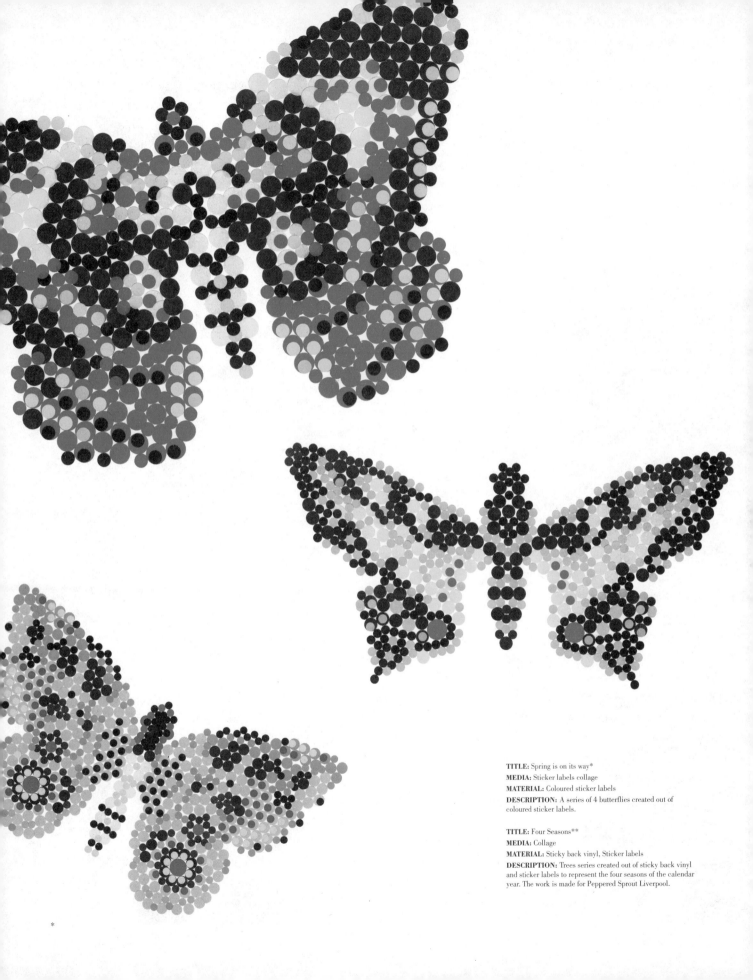

TITLE: Spring is on its way*
MEDIA: Sticker labels collage
MATERIAL: Coloured sticker labels
DESCRIPTION: A series of 4 butterflies created out of coloured sticker labels.

TITLE: Four Seasons**
MEDIA: Collage
MATERIAL: Sticky back vinyl, Sticker labels
DESCRIPTION: Trees series created out of sticky back vinyl and sticker labels to represent the four seasons of the calendar year. The work is made for Peppered Sprout Liverpool.

*

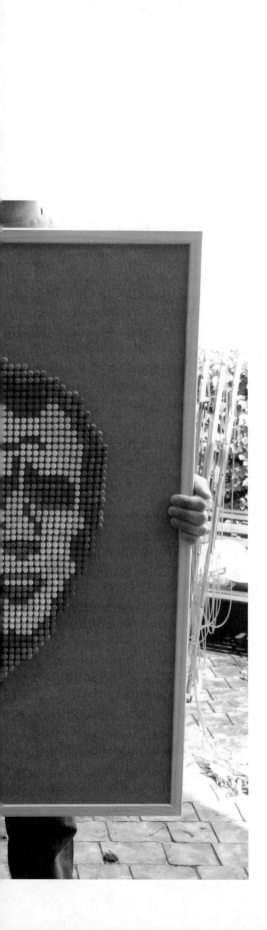

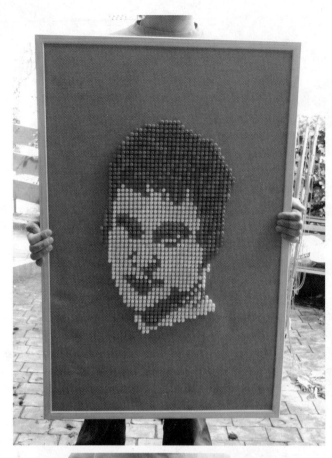

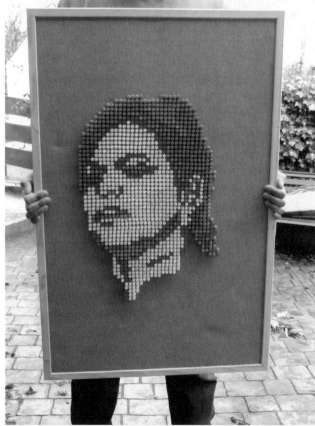

TITLE: Pinheads
MEDIA: Collage
MATERIAL: Coloured pushpins, Corkboard
DESCRIPTION: 4 portraits of famous people known for saying ridiculous statements. Portrait of George W. Bush, Katie Price, Lee Ryan and Jade Goody created out of coloured pushpins on corkboard.

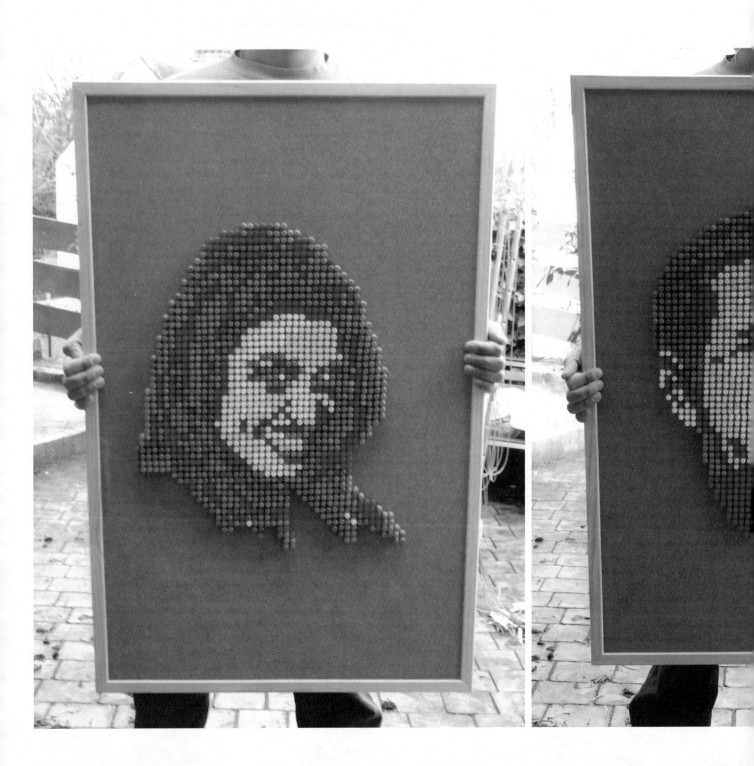

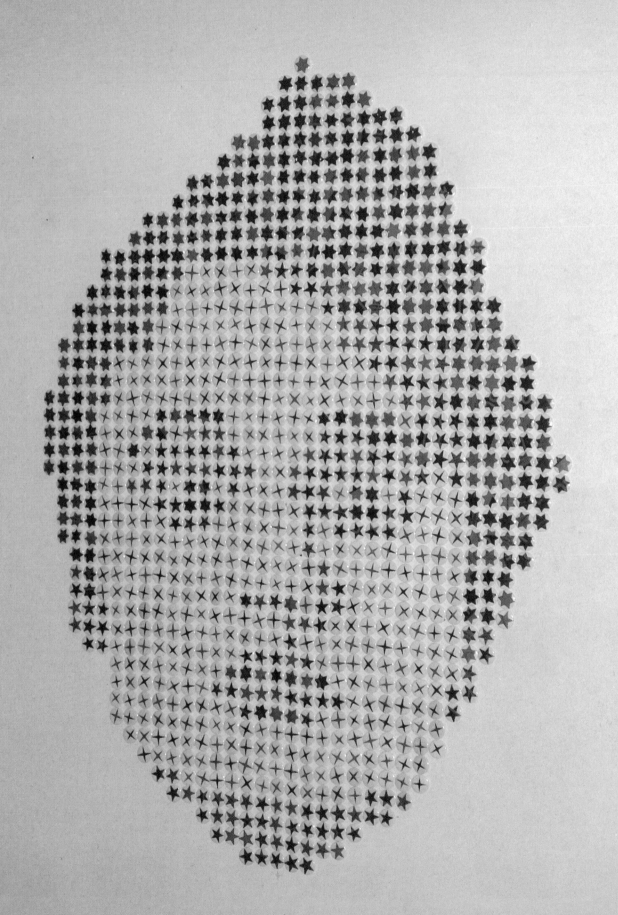

MELVIN GALAPON / 89

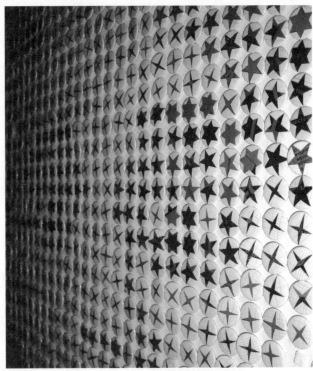

TITLE: Rock and Roll Star
MEDIA: Collage
MATERIAL: Pin badges, Cut card, Graph paper
DESCRIPTION: Portrait of Pete Doherty created out of pin badges with a star decorating each. The work is exhibition in 'Stuck On Me' at the Notting Hill Arts Club.

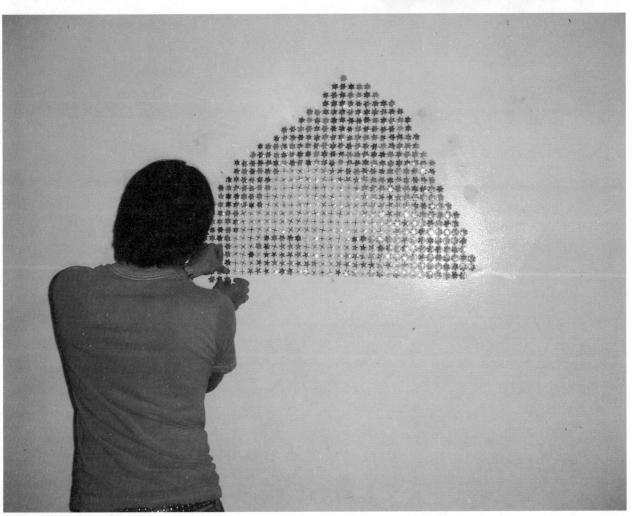

TITLE: Airmail
MEDIA: Drawing collage
MATERIAL: Envelopes, Acrylic, Black fine liner pen
DESCRIPTION: A series of 6 illustrations with the delivery vehicle drawn directly onto envelopes using acrylic and black fine liner pen.

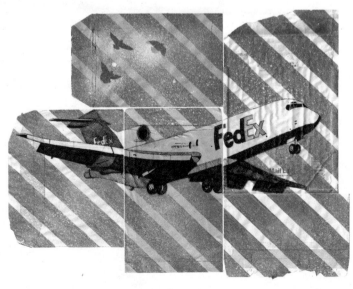

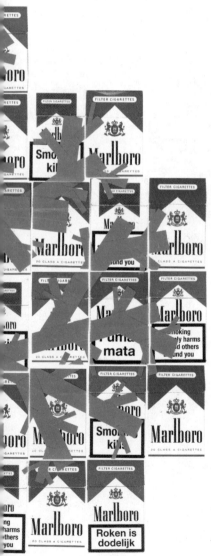

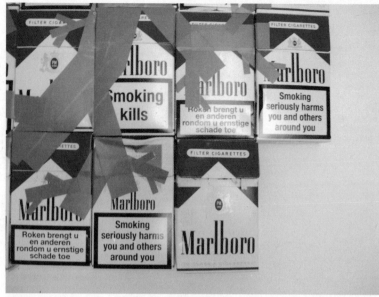

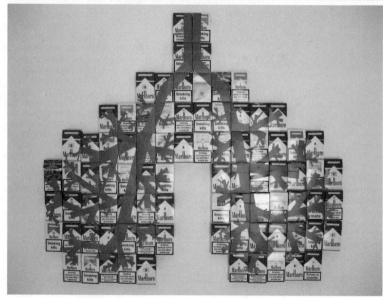

TITLE: Smoking Lungs
MEDIA: Collage
MATERIAL: Cigarette packets, Blue electrical insulation tape
DESCRIPTION: The work is made for Howies. It's a pair of lungs created onto multiple cigarette packets using blue electrical insulation tape and then scanned.

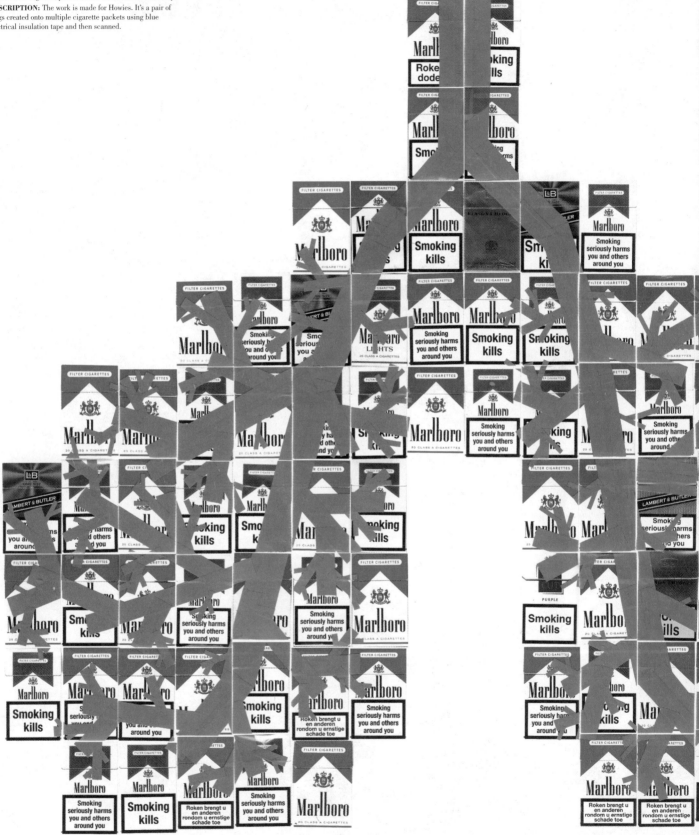

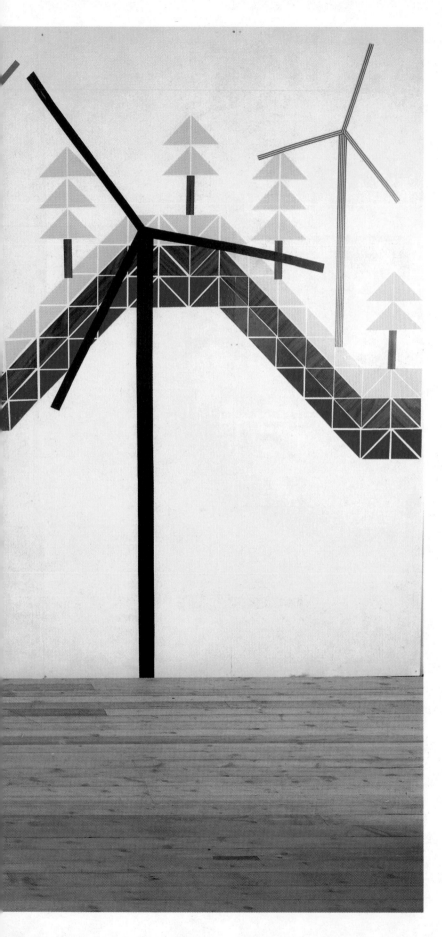

MELVIN GALAPON

London, UK

ORIGINALLY FROM THE NORTH WEST OF ENGLAND AND NOW LIVING IN LONDON, YOU CAN OFTEN FIND MELVIN WANDERING THE STREETS WITH HIS SKETCHBOOK IN HIS BACK POCKET AND HIS TRUSTY IPOD SHUFFLE TO KEEP HIM COMPANY. MELVIN'S ABILITY AT GETTING EASILY BORED OCCASSIONALLY IS EVIDENT IN HIS WORK, WHICH MAKES HIM FLOAT BETWEEN DIFFERENT TECHNIQUES AND MATERIALS.

APART FROM THE OCCASIONAL SENSE OF BOREDOM THAT KEEPS HIM STRIVING TO FIND THE NEW INTERESTING THING FOR THAT WEEK, HE HAS ALSO DEVELOPED AN INTEREST IN STICKY BACK VINYL THAT SOMETIMES APPEARS IN HIS WORK DEPENDING ON HIS MOOD. HE'S APPEARED IN THE SEMI-PERMAMENT BOOK 2006, FEATURED IN RIOT MAGAZINE AUSTRALIA, WON THE HOWIES ART THINK SPRING 2006 COMPETITION, HAS EXHIBITED WORK AT THE MAGMA BOOKSHOP IN LONDON AND IS ALSO CURRENTLY STUDYING MA COMMUNICATION DESIGN AT CENTRAL ST. MARTINS.

CLIENTS INCLUDE: KILIMANJARO MAGAZINE, YCN, HOWIES, NEW YORK TIMES, THE GUARDIAN, WALLPAPER AND NO-ONE BOUTIQUE.

TITLE: Climate Change
MEDIA: Collage
MATERIAL: Triangular sticky back vinyl in various colours and effects, Electrical insulation tape
DESCRIPTION: A large-scale backdrop of a landscape filled with colourful windmills for Howies. Created out of triangular sticky back vinyl in green, wood effect and red colours with the windmills created out of electrical insulation tape.

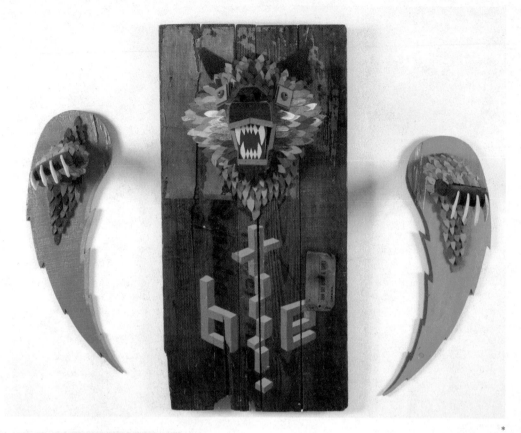

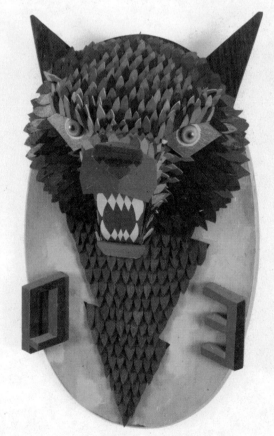

TITLE: Bite The Earth* / OE*

MEDIA: Wall sculpture

MATERIAL: Mixed media

DESCRIPTION: A cluster of cultural icons and seemingly familiar imagery stemming from Americana is, in fact, merely a series of paradoxes. Viewers are confronted with cryptic symbols from overlapping sources, both traditional and contemporary, which intrigue and provoke.

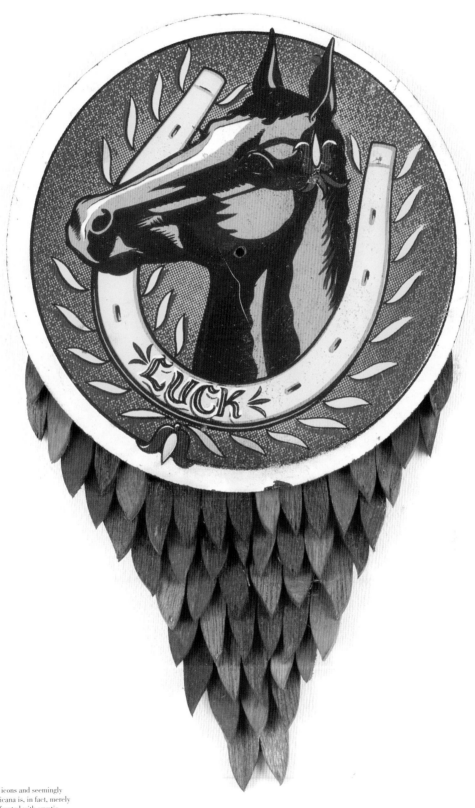

TITLE: Luck
MEDIA: Wall sculpture
MATERIAL: Mixed media
DESCRIPTION: A cluster of cultural icons and seemingly familiar imagery stemming from Americana is, in fact, merely a series of paradoxes. Viewers are confronted with cryptic symbols from overlapping sources, both traditional and contemporary, which intrigue and provoke.

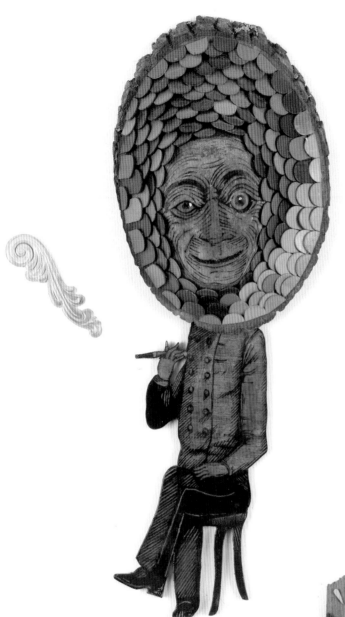

*

TITLE: Untitled (Smoker)* / Yer Boy**

MEDIA: Wall sculpture

MATERIAL: Mixed media

DESCRIPTION: A cluster of cultural icons and seemingly familiar imagery stemming from Americana is, in fact, merely a series of paradoxes. Viewers are confronted with cryptic symbols from overlapping sources, both traditional and contemporary, which intrigue and provoke.

**

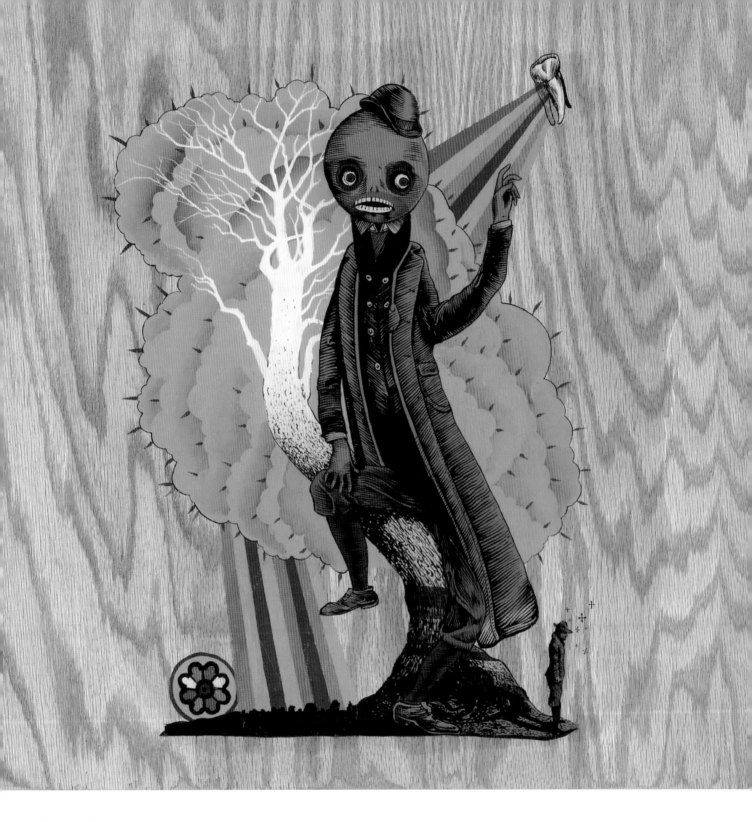

TITLE: Spare Me O'er

MEDIA: *Painting*

MATERIAL: Wood, House paint, Shoe polish

DESCRIPTION: A cluster of cultural icons and seemingly familiar imagery stemming from Americana is, in fact, merely a series of paradoxes. Viewers are confronted with cryptic symbols from overlapping sources, both traditional and contemporary, which intrigue and provoke.

TITLE: Coal Chute Ghost* / Coke Oven Soldier** /
H.D.B.*** / Triangle Shirt Guard**** / Hard Done By
Factories*****
MEDIA: Wall sculpture
MATERIAL: Mixed media
DESCRIPTION: A cluster of cultural icons and seemingly
familiar imagery stemming from Americana is, in fact,
merely a series of paradoxes. Viewers are confronted with
cryptic symbols from overlapping sources, both traditional
and contemporary, which intrigue and provoke.

TITLE: Hard Done By Factories*****
MEDIA: Installation
MATERIAL: Mixed media
DESCRIPTION: (Same as above)

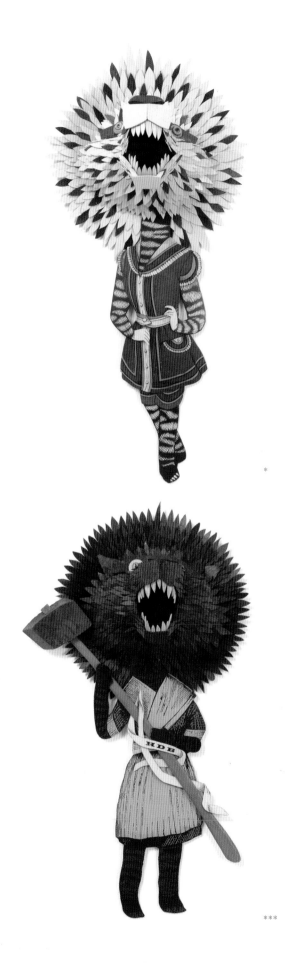

*

**

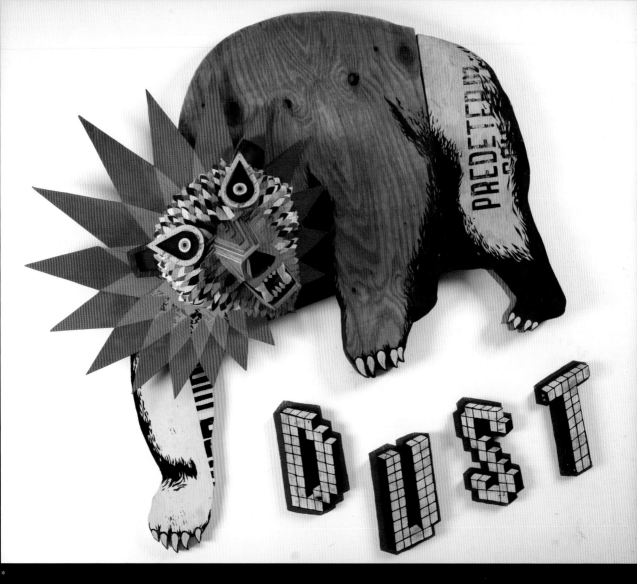

TITLE: Always to Dust*
MEDIA: Wall sculpture
MATERIAL: Mixed media
DESCRIPTION: A cluster of cultural icons and seemingly familiar imagery stemming from Americana is, in fact, merely a series of paradoxes. Viewers are confronted with cryptic symbols from overlapping sources, both traditional and contemporary, which intrigue and provoke.

TITLE: Unknown**
MEDIA: Wall sculpture
MATERIAL: Mixed media
DESCRIPTION: -

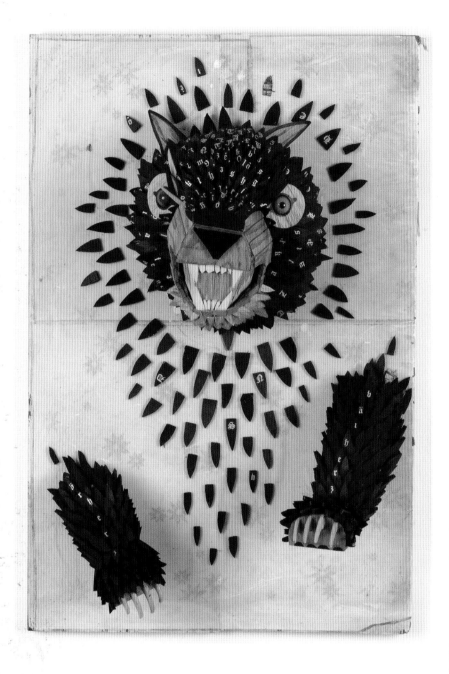

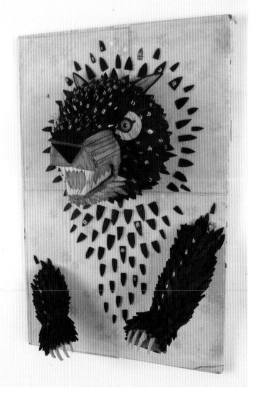

TITLE: Bragging Party
MEDIA: Wall sculpture
MATERIAL: Wood, Found object
DESCRIPTION: A cluster of cultural icons and seemingly familiar imagery stemming from Americana is, in fact, merely a series of paradoxes. Viewers are confronted with cryptic symbols from overlapping sources, both traditional and contemporary, which intrigue and provoke.

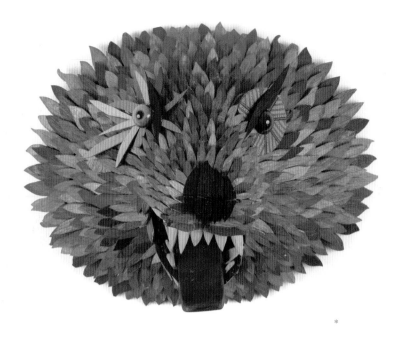

*

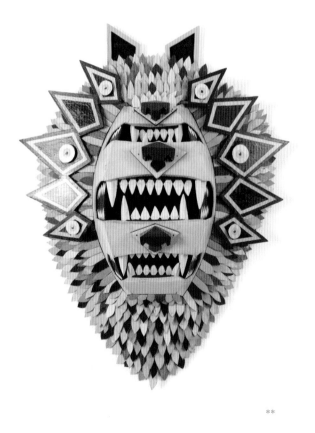

**

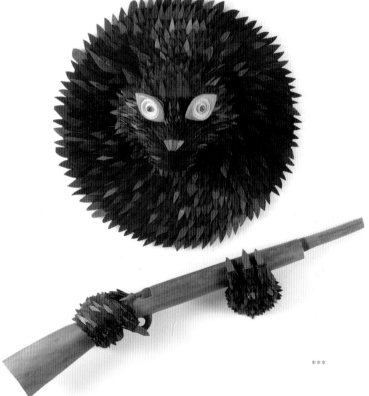

TITLE: Bear Head* / Three Into One** / Goon Eater Ghost***

MEDIA: Wall sculpture

MATERIAL: Mixed media

DESCRIPTION: A cluster of cultural icons and seemingly familiar imagery stemming from Americana is, in fact, merely a series of paradoxes. Viewers are confronted with cryptic symbols from overlapping sources, both traditional and contemporary, which intrigue and provoke.

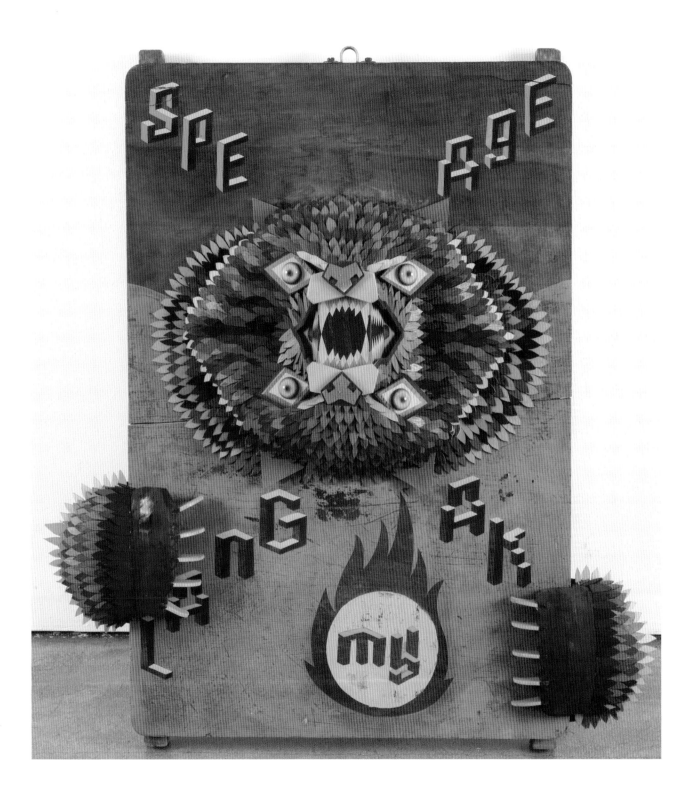

TITLE: Speak My Language

MEDIA: Wall sculpture

MATERIAL: Mixed media

DESCRIPTION: A cluster of cultural icons and seemingly familiar
imagery stemming from Americana is, in fact, merely a series of paradoxes.
Viewers are confronted with cryptic symbols from overlapping sources,
both traditional and contemporary, which intrigue and provoke.

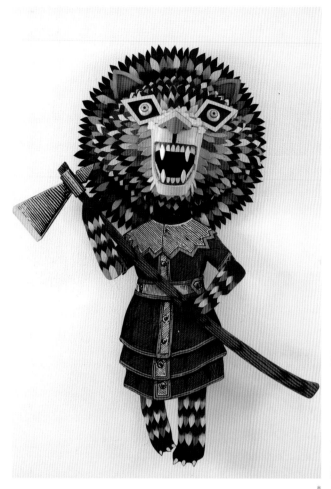

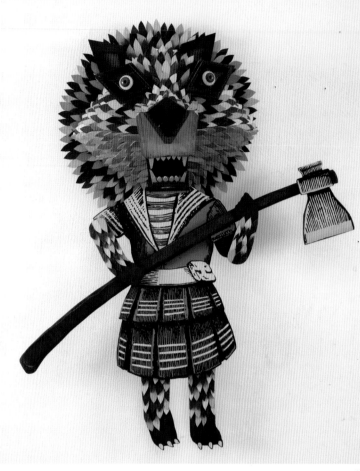

* **

TITLE: Ghost of the White Rose* / Ghosts of Local Absurdists 138**
MEDIA: Wall sculpture
MATERIAL: Mixed media
DESCRIPTION: A cluster of cultural icons and seemingly familiar imagery stemming from Americana is, in fact, merely a series of paradoxes. Viewers are confronted with cryptic symbols from overlapping sources, both traditional and contemporary, which intrigue and provoke.

AJ FOSIK

Denver, USA

AJ FOSIK'S ECLECTIC HANDMADE AND INTRICATELY DESIGNED WOOD ANIMAL SCULPTURES AND PAINTINGS, COMBINED WITH CRYPTIC SYMBOLS, INTRIGUE AND PROVOKE. FOSIK CREATES AN EXPERIENCE THAT AT FIRST GLANCE EVOKES A QUESTIONING OF FAMILIAR CONCEPTS AND THEN PUSHES THE VIEWER TO LOOK AND THINK DEEPER. INSPIRED BY SUBVERSIVE CULTURAL INFLUENCES, WHICH SHIFT COMPLACENCY, HE CREATES PIECES THAT SUSPEND COMFORT WHILE AT THE SAME TIME OFFER RECOGNIZABLE SYMBOLS AND IMAGES. IN THIS DYNAMIC TENSION THE ART AND THE VIEWER HOPEFULLY COME TOGETHER IN AN EXPANDED DEFINITION OF CULTURE AND ASSUMPTION.

AJ FOSIK STUDIED ILLUSTRATION AT PARSONS SCHOOL OF DESIGN AND GRADUATED IN 2003. FOSIK'S WORK HAS BEEN PUBLISHED IN SWINDLE MAGAZINE, NY ARTS, WOOSTER COLLECTIVE, IDEAL DIGITAL, AND JUXTAPOZ MAGAZINE.

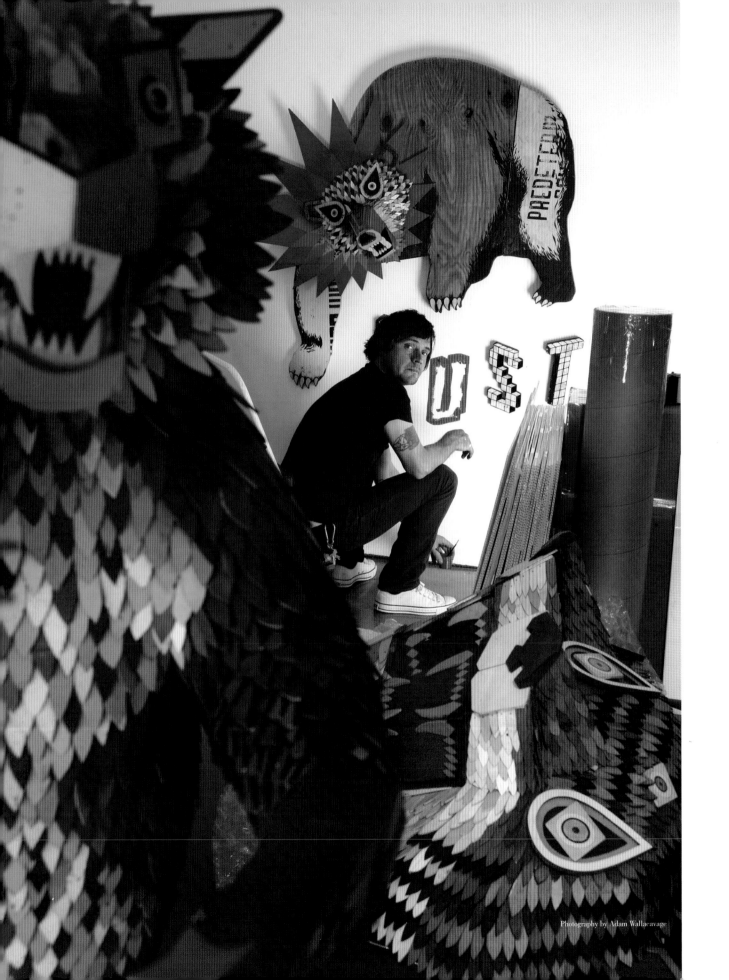

Photography by Adam Wallacavage

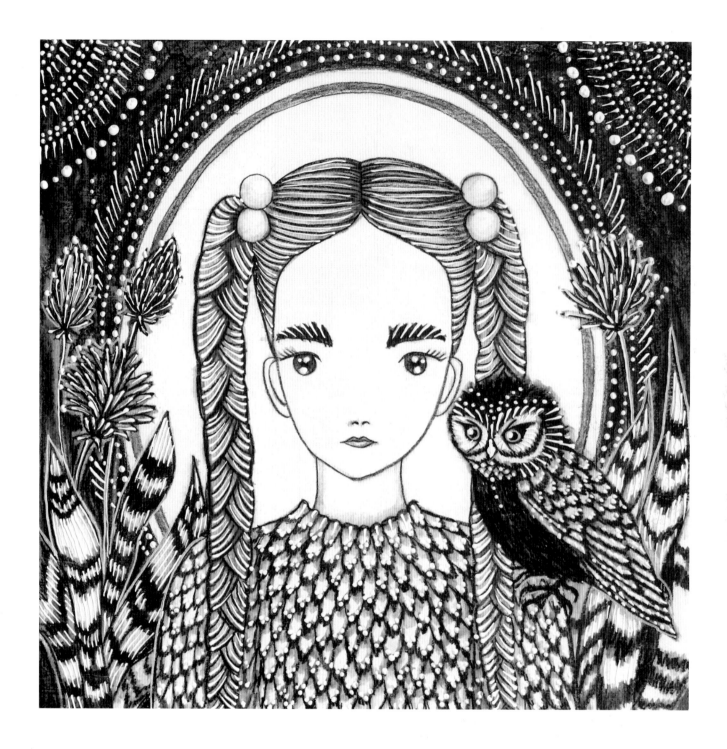

TITLE: Sweet Companion
MEDIA: Water colour, Acrylic
MATERIAL: Paper, Wood panel
DESCRIPTION: This series of 'Porcelain Girls'
are inspired by the artist's grandmother's porcelains.

TITLE: We Told You So* / New Birth** / Among You***
MEDIA: Water colour, Acrylic
MATERIAL: Paper, Wood panel
DESCRIPTION: This series of 'Porcelain Girls' are inspired by the artist's grandmother's porcelains.

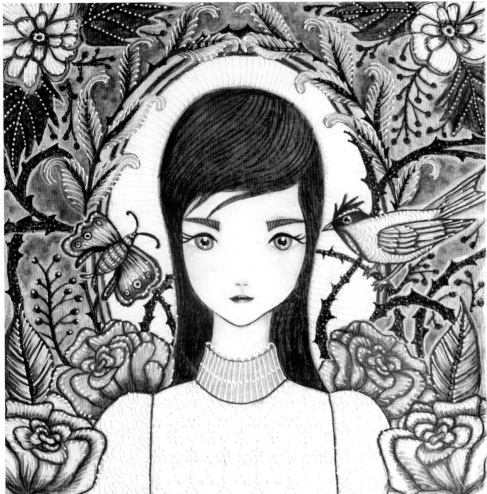

*

** ***

*

TITLE: No Me Preguntes Si Te Quiero* / Tú Solo Tú** / Poco A Poco***
MEDIA: Spray paint, Acrylic
MATERIAL: Wood
DESCRIPTION: This dyptic was created for the artist's personal art exhibition 'No Me Quieras Matar Corazon' at the Iguapop Gallery. Pieces were inspired in folk love songs lyrics from Latin America.

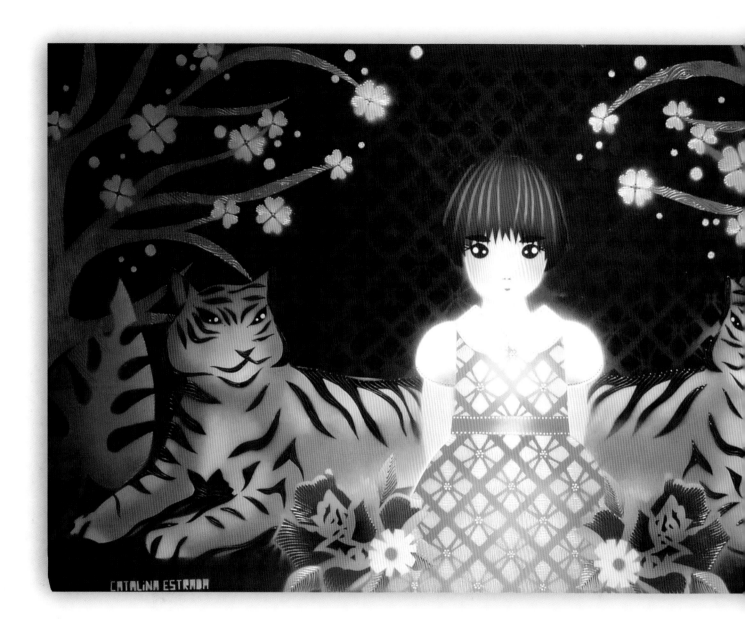

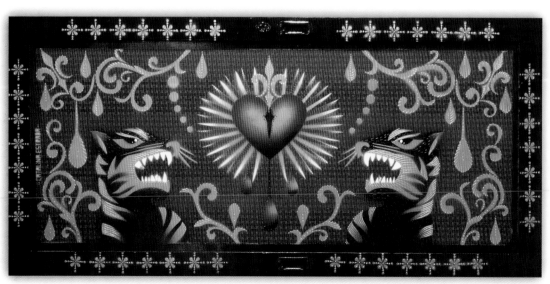

TITLE: Amor Se Escribe Con Llanto
MEDIA: Spray paint, Acrylic
MATERIAL: Wood
DESCRIPTION: This dyptic was created for the artist's personal art exhibition 'No Me Quieras Matar Corazon' at the Iguapop Gallery. Pieces were inspired in folk love songs lyrics from Latin America.

TITLE: Dime Porqué

MEDIA: Spray paint, Acrylic

MATERIAL: Wood panel

DESCRIPTION: These 2 pieces were created for the artist's personal art exhibition 'No Me Quieras Matar Corazon' at the Iguapop Gallery. Pieces were inspired in folk love songs lyrics from Latin America.

TITLE: Bambi
MEDIA: Spray paint, Acrylic
MATERIAL: Wood panel
DESCRIPTION: This piece was created for 'We Make Money Not Art' Group Exhibition at Iguapop Gallery to celebrate its 3rd anniversary.

TITLE: Strange Wind* / White Little Dress** / Red Flowers***
MEDIA: Lithography* / Lithography** / Lithography, Collage***
MATERIAL: Japanese paper on wood boxes with front glass
DESCRIPTION: These 3 pieces are small fragments of a personal story.
The white dress on the second work was a gift the artist received from a
Colombian great artist, Jose Antonio Suarez.

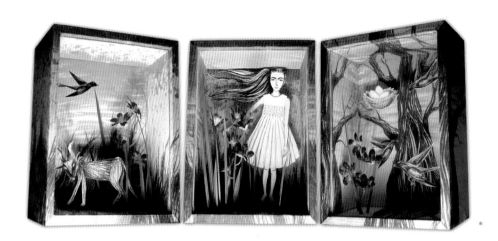

*

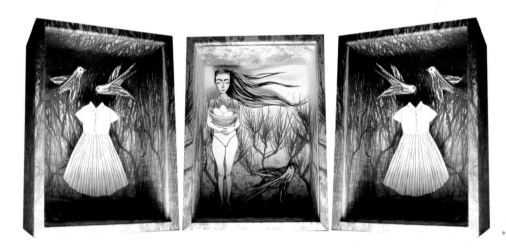

**

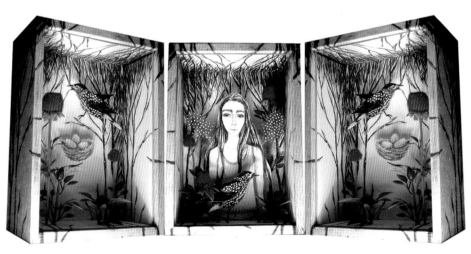

CATALINA ESTRADA

Barcelona, Spain

BORN AND RAISED IN COLOMBIA, AND LIVING IN BARCELONA SINCE 1999, CATALINA
BRINGS ALL THE COLOURS AND POWER OF LATIN-AMERICAN FOLKLORE AND REFINES
IT WITH A SUBTLE TOUCH OF EUROPEAN SOPHISTICATION. HER ABILITY FOR CREATING
FASCINATING ILLUSIVE WORLDS, FULL OF COLOURS, NATURE, AND ENCHANTING CHAR-
ACTERS, BURSTS IN ALL OF HER WORKS: ART, GRAPHIC DESIGN AND ILLUSTRATION.

PRESENTED AS A FRESH AND NEW DESIGN TALENT BY COMMUNICATION ARTS AND
COMPUTER ARTS MAGAZINES, HER WORK HAS ALSO BEEN FEATURED BY DIE
GESTALTEN VERLAG, SWINDLE, DPI, PPAPER AND GRAPHIC MAGAZINE. SOME OF HER
CLIENTS INCLUDE: COCA-COLA, PAUL SMITH, NIKE, MOTOROLA, CUSTO-BARCELONA,
SALOMON, CHRONICLE BOOKS, AMONG OTHERS.

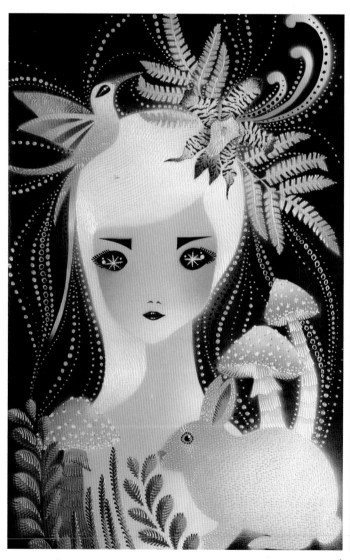 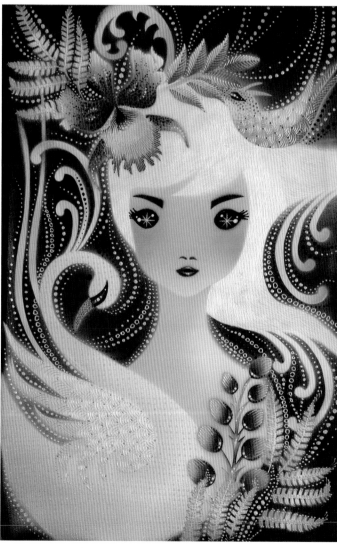

* **

TITLE: Keferstenia* / Cattleya**
MEDIA: Spray paint, Acrylic
MATERIAL: Canvas
DESCRIPTION: These 2 pieces were created for Jonathan LeVine
Gallery's '16th Annual Swap Meet,' Group Show.

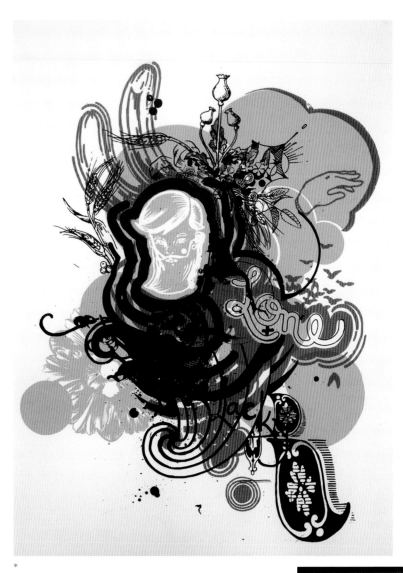

TITLE: Lone*
MEDIA: Silkscreen
MATERIAL: Paper
DESCRIPTION: 3 colour silkscreen print on paper, edition of 10" x 30" and 22" x 30".

TITLE: Landscape**
MEDIA: Drawing, Collage
MATERIAL: Ink, Inkjet print, Enamel, Log pieces, Felt, Plexiglass, Frame
DESCRIPTION: This work is mixed media collage consisting of different landscape drawings. Materials include ink painting, drawing, Inkjet and enamel mounted on log pieces in 18" x 22" x 3" and collaged together with felt and plexiglass mounted on the inside of a frame.

The drawings are extracted from landscape sketches created during a cross-country trip in 2006. Different geographies and stylistic renderings are forced together to create a new environment.

*

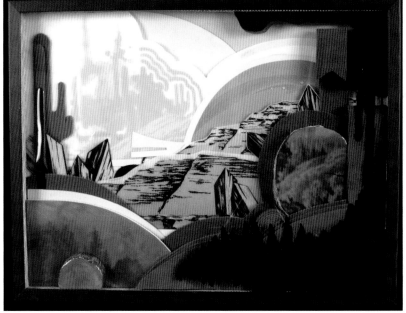

**

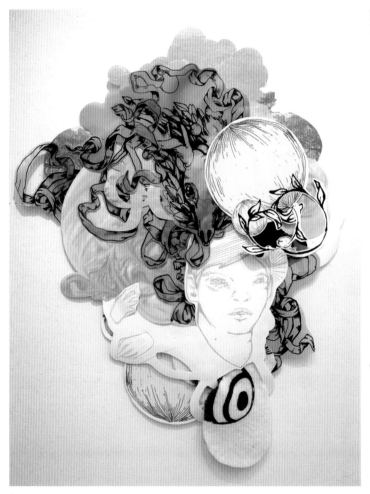

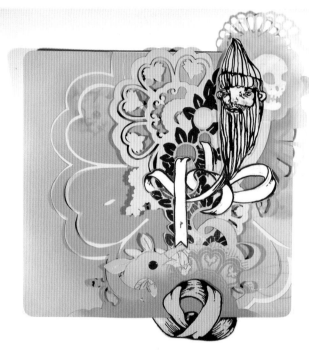

**

*

TITLE: Fauna*

MEDIA: Drawing, Silkscreen, Paper cutting

MATERIAL: Paper, Handmade felt

DESCRIPTION: Drawing, silkscreen and inkjet print on papers and handmade felt in approximate dimensions of 32" x 48" x 4".

A portrait collage that reveals a darker edge to otherwise sweet content (also with a digital image of cake frosting).

TITLE: Gnome**

MEDIA: Paper Cutting, Ink drawing collage

MATERIAL: Paper, Ink

DESCRIPTION: This piece combines a drawing and silkscreen on double sided vellum. Cut papers contain archival inkjet prints and enamel paint.

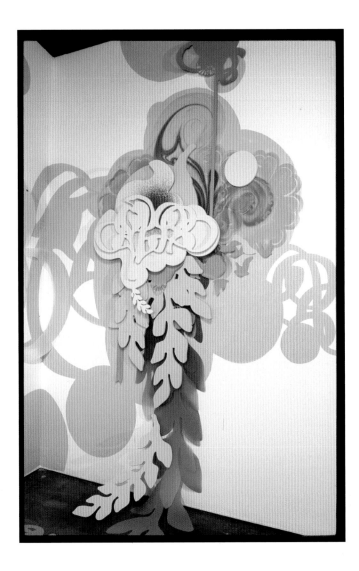

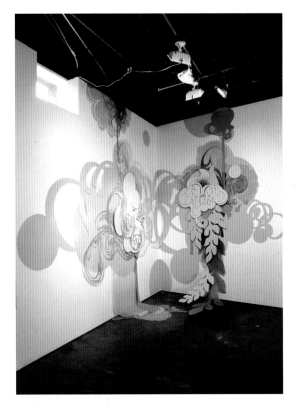

TITLE: Dear Flies, Love Spider

MEDIA: CNC router cut foam, Painting, Silkscreen

MATERIAL: Foam, Wood, Plastic, Vellum

DESCRIPTION: These are installation views from a solo exhibit at the Marcia Wood Gallery in Atlanta, GA. Installation collage combining drawing and painting on foam, wood, plastic and vellum in approximate dimensions of 6 x 12 x 3 feet.

Stephanie thinks of this work as the work of excess and combines digital photographs of frosting with the ornamental edges of calligraphic font. She wanted to take the language out of these things and reduce them to formal elements. With these elements, she responded to the space intuitively to create a more personal moment.

The piece was titled by Parker Noon of the band 'The Low Low's.' It was exhibited in the same show as 'Wolves Eat Dogs' that Parker also titled.

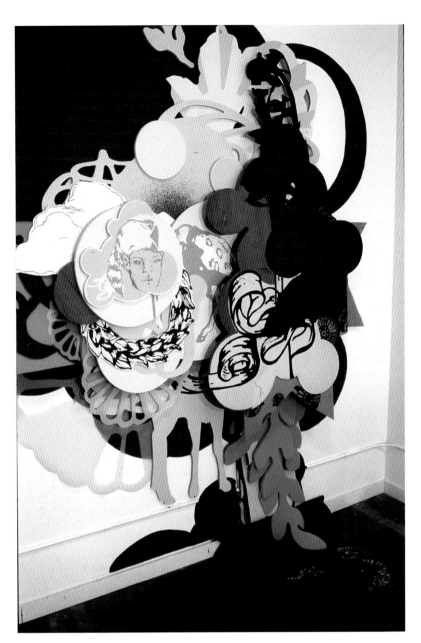

TITLE: Wolves Eat Dogs

MEDIA: Digitally cut foam shapes with surface painting

MATERIAL: Foam, Wood, Plastic, Vellum

DESCRIPTION: These are installation views from the Marcia Wood Gallery. Installation collage combines drawing and painting on foam, wood, plastic and vellum in approximate dimensions of 10 x 13 x 3 feet.

This installation was created during a period of transition. The installation reflects a sort of chaos of the time. She was looking to create a beauty through chaos, a lack of grounding, a movement and animal presence merging with the logic of order.

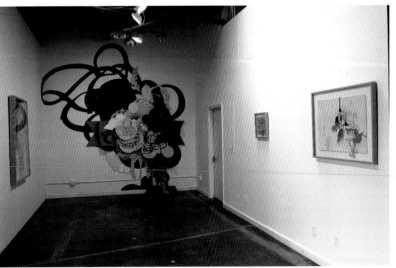

TITLE: Pushing Drift*
MEDIA: Painting, Silkscreen, Collage installation
MATERIAL: Felt, Foam, Sculpted paint, Paper, Enamel coating
DESCRIPTION: These are installation views from exhibit in the Indiana University Museum of Art in Bloomnington, U.S.A. Complete installation dimensions are approximately 8 x 13 x 3 feet.

Using several pieces from Stephanie's 'Spool' exhibit. She tried to give elements of the decorative a commanding presence juxtaposed with static renderings of a more animal, or carnal presence.

TITLE: Song**
MEDIA: Inkjet, Painting
MATERIAL: Vellum, Paper
DESCRIPTION: Collaged inkjet prints on double-sided vellum and paper. Dimensions are approximately 36" x 48" x 3". Spills of enamel paint soil the otherwise decorative surface to create the beast. The artist wanted both the bear and the vellum to be simultaneously decorative and aggressive.

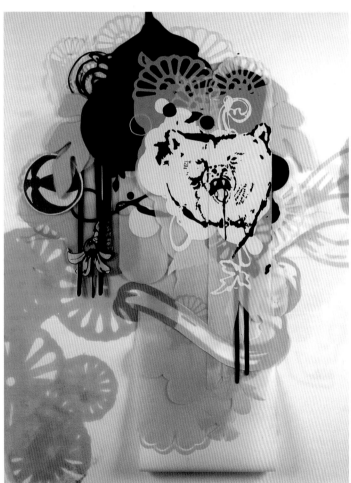

**

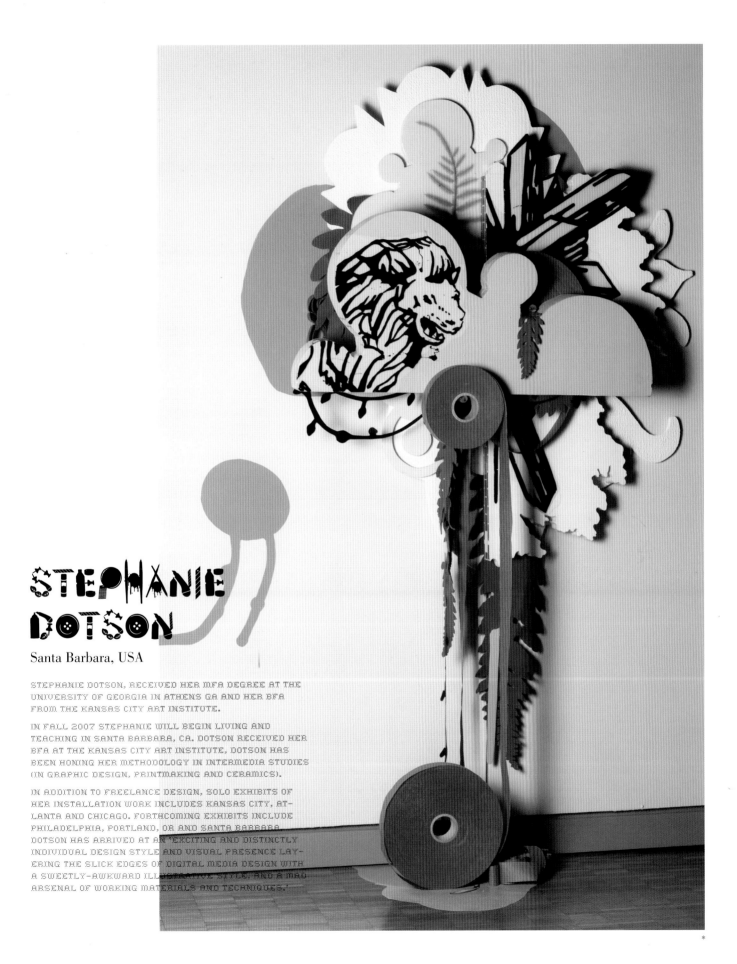

STEPHANIE DOTSON

Santa Barbara, USA

STEPHANIE DOTSON, RECEIVED HER MFA DEGREE AT THE
UNIVERSITY OF GEORGIA IN ATHENS GA AND HER BFA
FROM THE KANSAS CITY ART INSTITUTE.

IN FALL 2007 STEPHANIE WILL BEGIN LIVING AND
TEACHING IN SANTA BARBARA, CA. DOTSON RECEIVED HER
BFA AT THE KANSAS CITY ART INSTITUTE. DOTSON HAS
BEEN HONING HER METHODOLOGY IN INTERMEDIA STUDIES
(IN GRAPHIC DESIGN, PRINTMAKING AND CERAMICS).

IN ADDITION TO FREELANCE DESIGN, SOLO EXHIBITS OF
HER INSTALLATION WORK INCLUDES KANSAS CITY, AT-
LANTA AND CHICAGO. FORTHCOMING EXHIBITS INCLUDE
PHILADELPHIA, PORTLAND, OR AND SANTA BARBARA.
DOTSON HAS ARRIVED AT AN "EXCITING AND DISTINCTLY
INDIVIDUAL DESIGN STYLE AND VISUAL PRESENCE LAY-
ERING THE SLICK EDGES OF DIGITAL MEDIA DESIGN WITH
A SWEETLY-AWKWARD ILLUSTRATIVE STYLE, AND A MAD
ARSENAL OF WORKING MATERIALS AND TECHNIQUES."

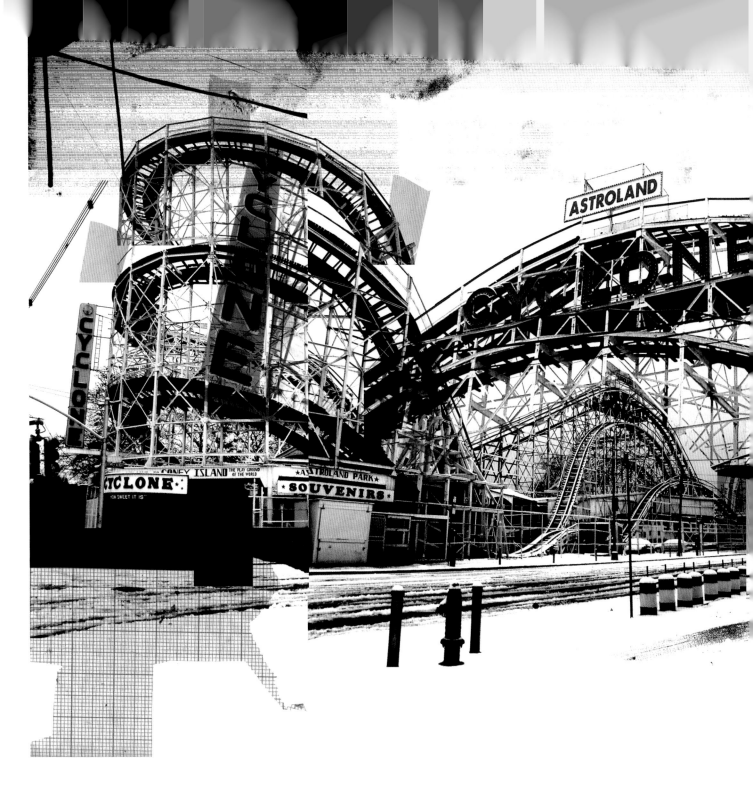

TITLE: Coney Island Cyclone
MEDIA: Mixed media
MATERIAL: Scalpel, Paper, Photography, Ink, Photoshop, Collage
DESCRIPTION: Illustration on the subject 'If You Could Do Anything Tomorrow What Would It Be?' featured in 'If You Could,' published in 2006.

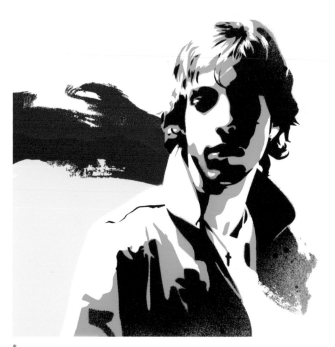

TITLE: James Morrison*
MEDIA: Mixed media
MATERIAL: Scalpel, Paper, Spray paint, Illustrator, Photoshop, Ink
DESCRIPTION: Illustration for Big Issue to accompany a review of 'Undiscovered' by James Morrison.

TITLE: Grinderman**
MEDIA: Mixed media
MATERIAL: Scalpel, Paper, Spray paint, Illustrator, Photoshop, Ink
DESCRIPTION: Illustration for Observer Music Monthly.

*

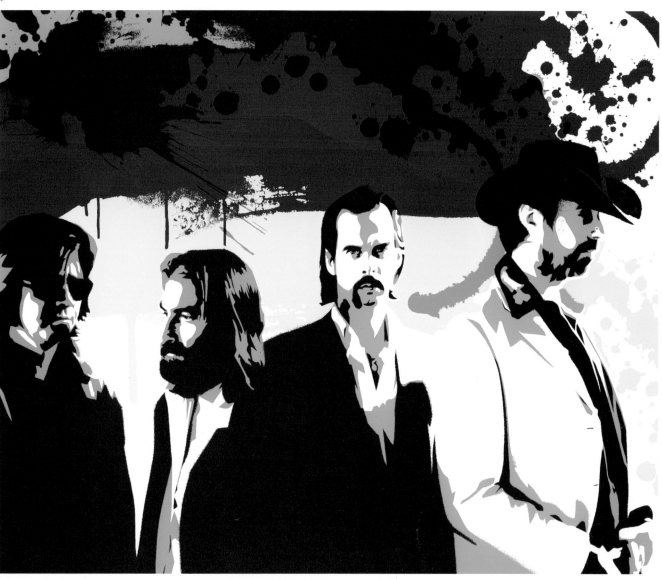

**

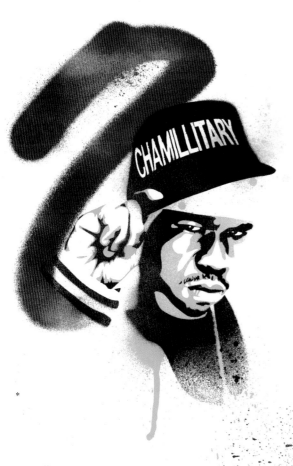

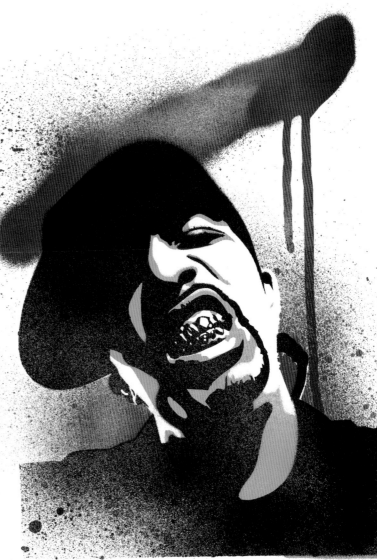

TITLE: Chamillionaire*
MEDIA: Mixed media
MATERIAL: Scalpel, Paper, Spray paint, Illustrator
DESCRIPTION: Illustration to accompany an article on Houston Rap in Vibe Magazine in 2007.

TITLE: Lil Flip**
MEDIA: Mixed media
MATERIAL: Scalpel, Paper, Spray paint, Illustrator
DESCRIPTION: Illustration to accompany an article on Houston Rap in Vibe Magazine in 2007.

*

**

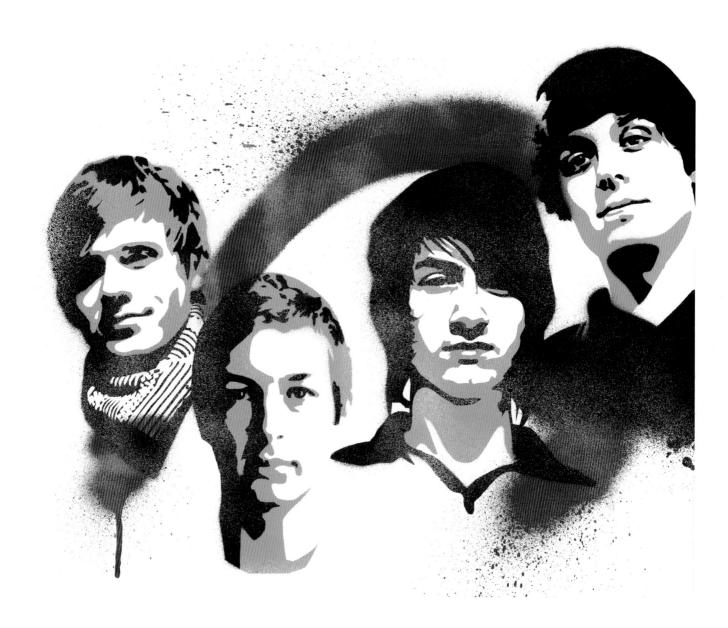

TITLE: The Arctic Monkeys
MEDIA: Mixed media
MATERIAL: Scalpel, Paper, Spray paint, Illustrator,
Photoshop, Ink
DESCRIPTION: Illustration for the Observer Music
Monthly Review section.

TITLE: CMYK Girl*
MEDIA: Mixed media
MATERIAL: Scalpel, Paper, Spray paint, Illustrator, Photoshop, Ink, Silkscreen
DESCRIPTION: Illustration produced for Art Department 10th anniversary brochure.

TITLE: Prince**
MEDIA: Mixed media
MATERIAL: Scalpel, Paper, Spray paint, Illustrator, Photoshop, Ink
DESCRIPTION: Illustration for the Observer Music Monthly Review section.

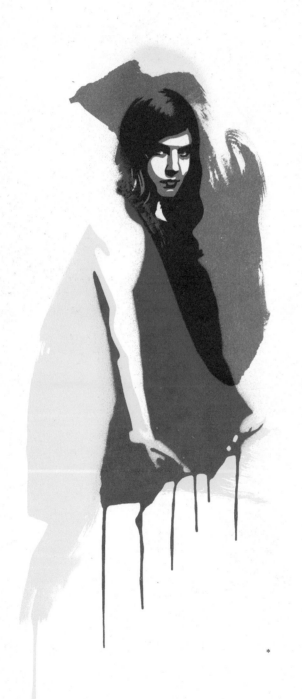

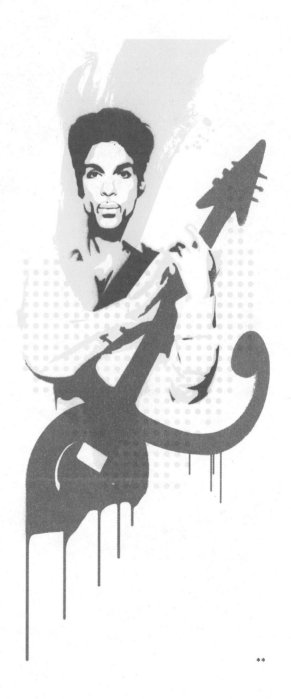

*

**

TITLE: Learn To Play Guitar*
MEDIA: Mixed media
MATERIAL: Scalpel, Paper, Spray paint, Illustrator, Photoshop, Ink
DESCRIPTION: Illustration on the subject 'If You Could Do Anything Tomorrow What Would It Be?' featured in 'If You Could,' published 2007.

TITLE: CMYKboy**
MEDIA: Mixed media
MATERIAL: Scalpel, Paper, Spray paint, Illustrator, Photoshop, Ink, Silkscreen
DESCRIPTION: T-Shirt design for Japanese T-Shirt company Graniph in 2005.

**

MILES DONOVAN

London, UK

PEEPSHOW CO-FOUNDER MILES DONOVAN
HAS PRODUCED HUNDREDS OF ILLUSTRA-
TIONS FOR A DIVERSE RANGE OF WORLD-
WIDE CLIENTS INCLUDING THE NEW YORK
TIMES, THE OBSERVER, BILLBOARD AND
INTERVIEW AND HAS CONTRIBUTED TO
MARKETING CAMPAIGNS FOR CUERVO,
ROLLING ROCK, AIRTRAN, TARGET AND
J RECORDS.

HIS WORK IS EXTENSIVELY FEATURED
IN PUBLICATIONS INCLUDING 'ILLUSIVE,'
'THE FUNDAMENTALS OF ILLUSTRATION,'
'PEN AND MOUSE' AND 'DIGITAL ILLUS-
TRATION.' HE HAS EXHIBITED IN LONDON
AND NEW YORK AND WAS FEATURED IN
'PICTURE THIS' AN EXHIBITION OF CON-
TEMPORARY ILLUSTRATION SPONSORED
BY THE BRITISH COUNCIL THAT TOURED
THE WORLD IN 2002-2003.

WITH 'PEEPSHOW' MILES HAS WORKED
ON DESIGN, ART DIRECTION AND MOV-
ING IMAGE PROJECTS FOR NIKE, CHAN-
NEL FOUR, COCA-COLA, TOYOTA, DIESEL,
ROUNDHOUSE STUDIOS AND THE VICTORIA
& ALBERT MUSEUM. MILES WORKS FROM
PEEPSHOW HQ IN EAST LONDON AND IS
REPRESENTED BY ART DEPARTMENT IN
NEW YORK.

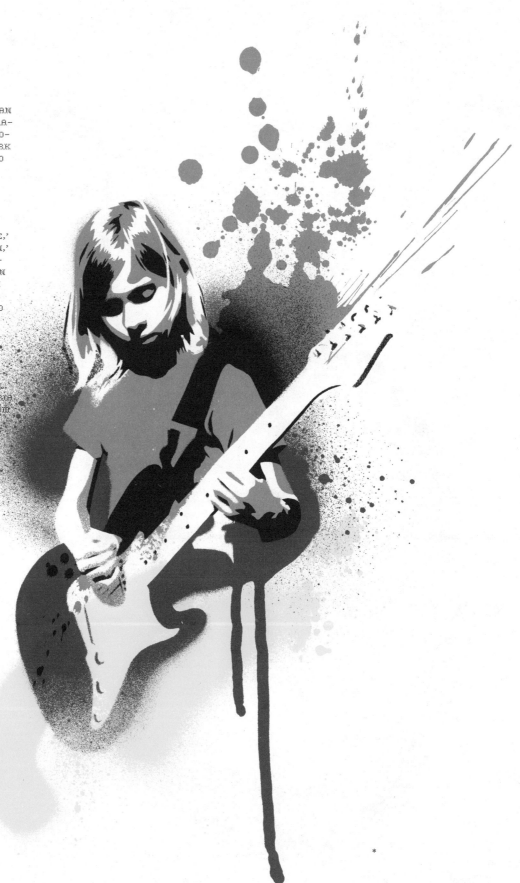

TITLE: Bird* / Banana**
MEDIA: Pyrography, Painting
MATERIAL: Wood plaque, Gouache
DESCRIPTION: This ongoing series depicts suave looking men in sweaters holding yellow objects.

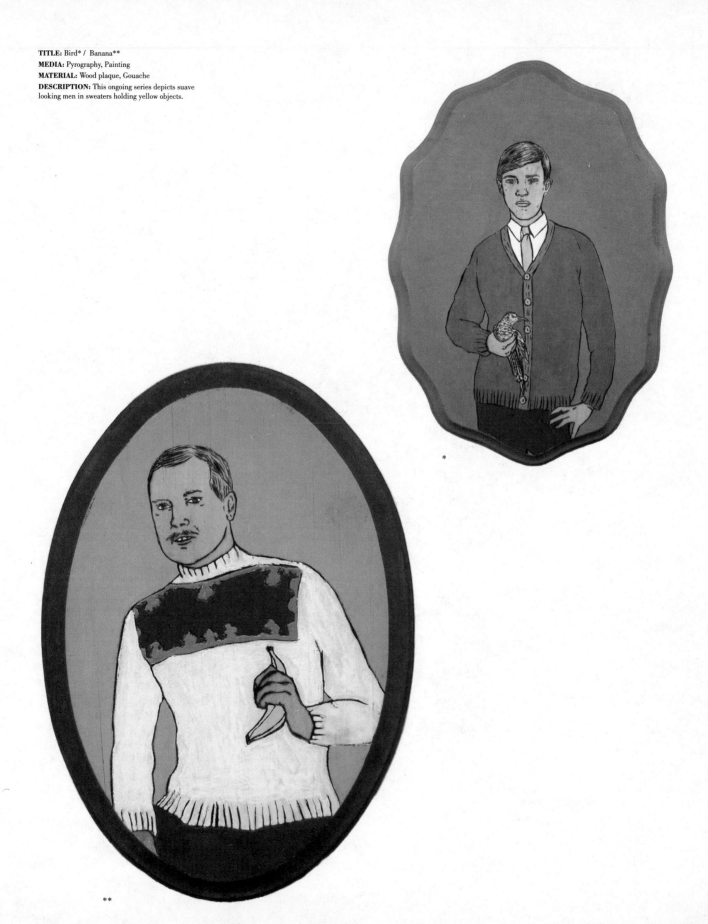

*

**

TITLE: Untitled Dog*
MEDIA: Pyrography, Painting
MATERIAL: Wood, Acrylic
DESCRIPTION: This is a work in progress and possibly the beginning of a series that will feature a variety of dog breeds.

TITLE: Knit baby**
MEDIA: Pyrography, Painting
MATERIAL: Wood, Gouache
DESCRIPTION: 'Knit Baby' was originally devised as a sketch for an article in BUST magazine.

*

**

TITLE: Battle Scenes (Bugs* / Birds** / Beasts***)
MEDIA: Pyrography
MATERIAL: Panel
DESCRIPTION: 'Battle scenes' is a triptych in which various surreal combinations of people, nature and technology have come into conflict.

*

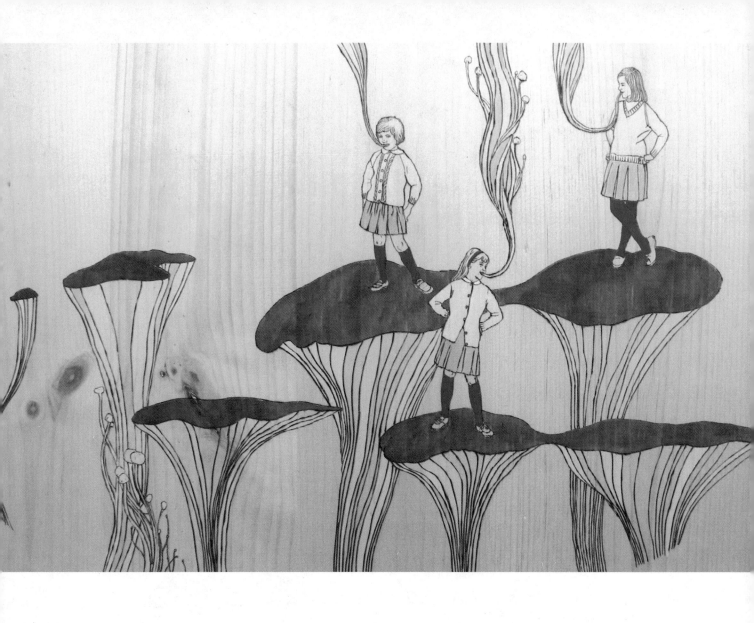

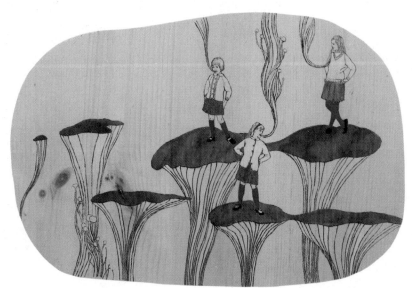

TITLE: The Wolf Girl*
MEDIA: Pyrography
MATERIAL: Panel
DESCRIPTION: Pyrography is the traditional art of burning into wood (or leather) with a heated tool. All of these pieces were created using this method. The piece begins with a drawing (either directly on the wood or transferred with carbon paper), when all the lines have been burned into the wood; colour is sometimes added (usually watercolour or gouache). This wood burn was part of a series of drawings inspired by the stories of feral children. The artist's desire was not to depict the tragic fate of these individuals, but to imagine an alternative story illustrating the bond between humans and nature.

TITLE: Spore** (incl. next spread)
MEDIA: Pyrography, Gouache
MATERIAL: Plywood
DESCRIPTION: This is a series of 3 wood burns executed on plywood, the final pieces were then cut into organic shapes.

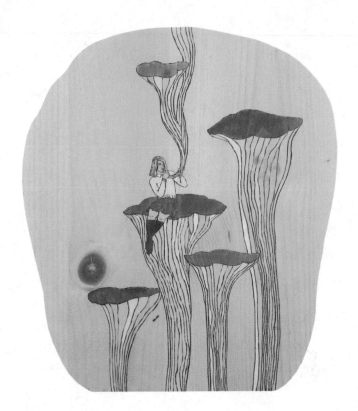

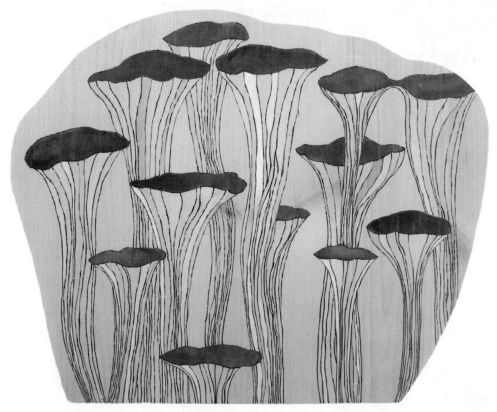

**

GENEVIEVE DIONNE

Vancouver, Canada

GENEVIEVE DIONNE LIVES AND WORKS IN VANCOUVER, CANADA. SHE SPENDS HER BETTER DAYS DRAWING, SCREEN PRINTING, SEWING, AND MAKING ART. SHE STUDIED DRAWING AT THE ALBERTA COLLEGE OF ART & DESIGN, AND GRADUATED FROM THE NOVA SCOTIA COLLEGE OF ART & DESIGN IN 2002.

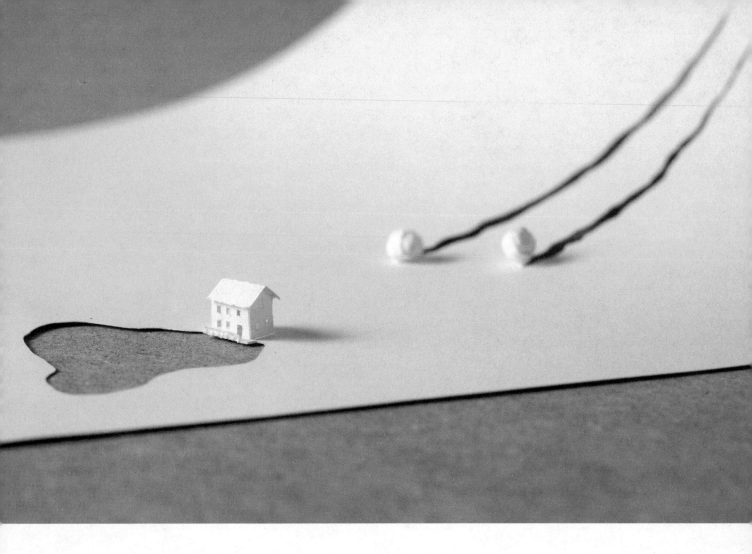

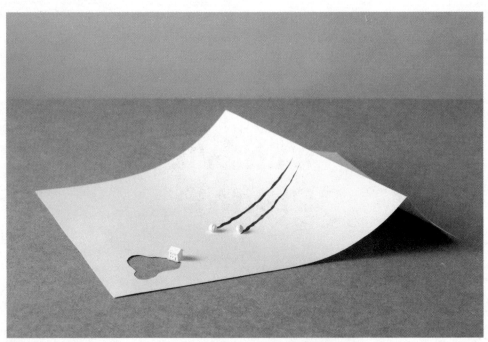

TITLE: Snowballs
MEDIA: Paper cut
MATERIAL: Acid free A4 80 gsm paper, Glue
DESCRIPTION: -

All images courtesy of the artist, Helen Nyborg Contemporary, Copenhagen, and Emily Tsingou Gallery, London

TITLE: Unter dem Nebelmeer
MEDIA: Paper cut
MATERIAL: Acid free A4 80 gsm paper, Acrylic paint,
Oak frame (39 x 29 x 7 cm)
DESCRIPTION: -

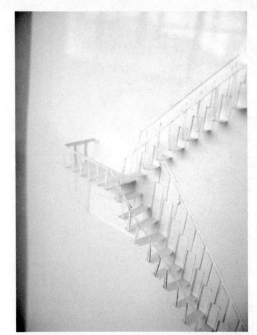

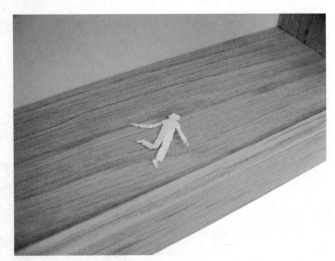

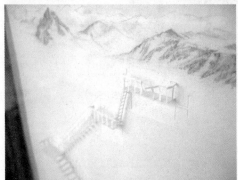

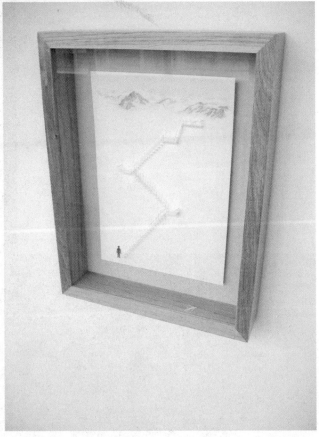

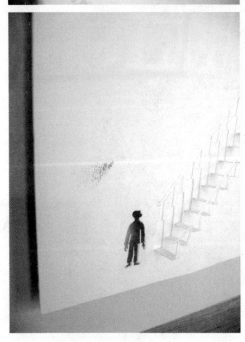

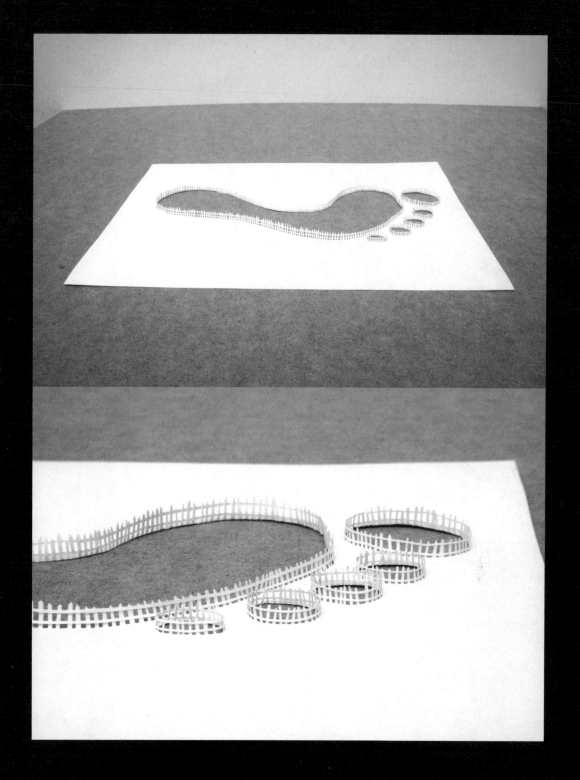

TITLE: Do Not Enter
MEDIA: Paper cut
MATERIAL: Acid-free A4 115 gsm paper, Glue
DESCRIPTION: -

TITLE: Half Way Through
MEDIA: Paper cut
MATERIAL: Acid-free A4 115 gsm paper, Glue
DESCRIPTION: -

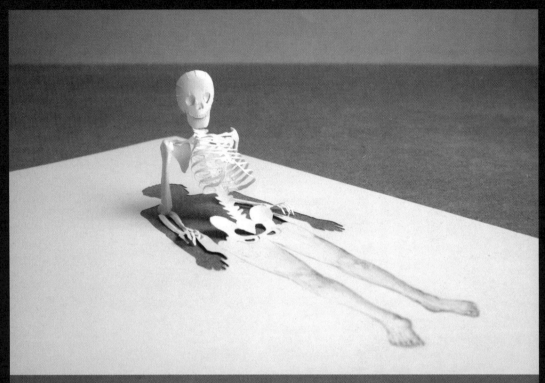

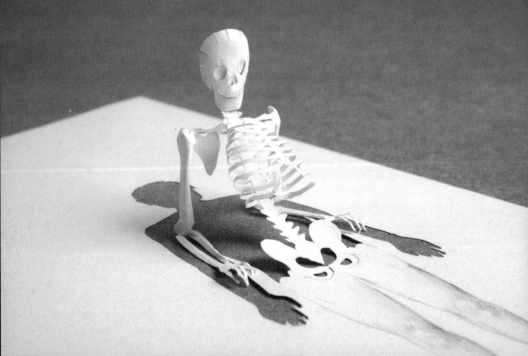

TITLE: Apple Blossom
MEDIA: Paper cut
MATERIAL: Acid-free A4 80 gsm paper, Acrylic paint,
Oak frame (39 x 29 x 7 cm)
DESCRIPTION: -

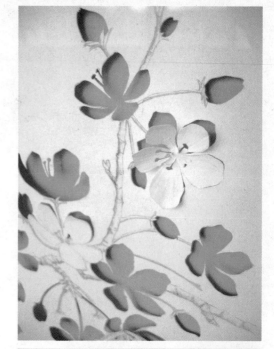

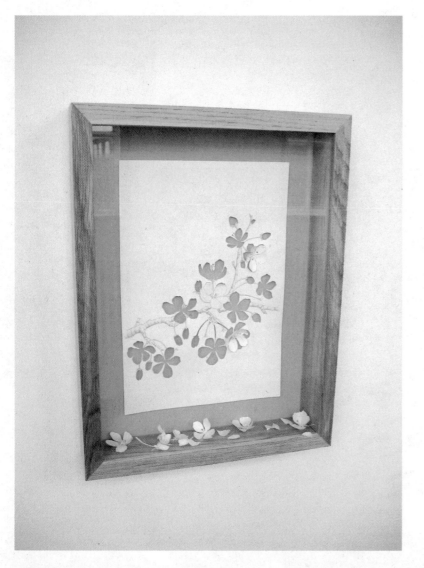

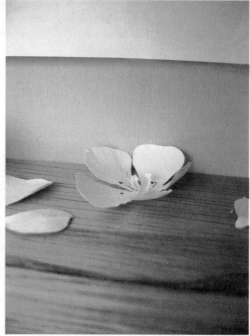

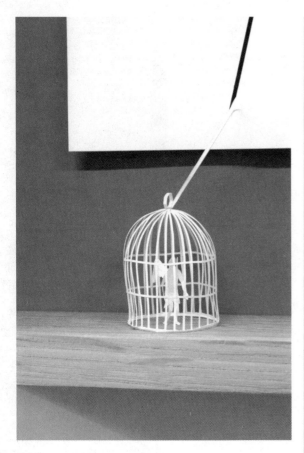

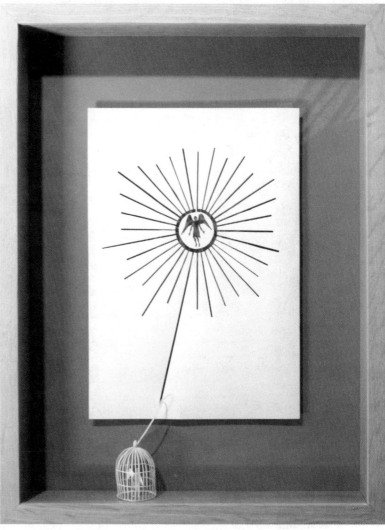

TITLE: Angel
MEDIA: Paper cut
MATERIAL: Acid-free A4 80 gsm paper, Acrylic paint,
Oak frame (39 x 29 x 7 cm)
DESCRIPTION: -

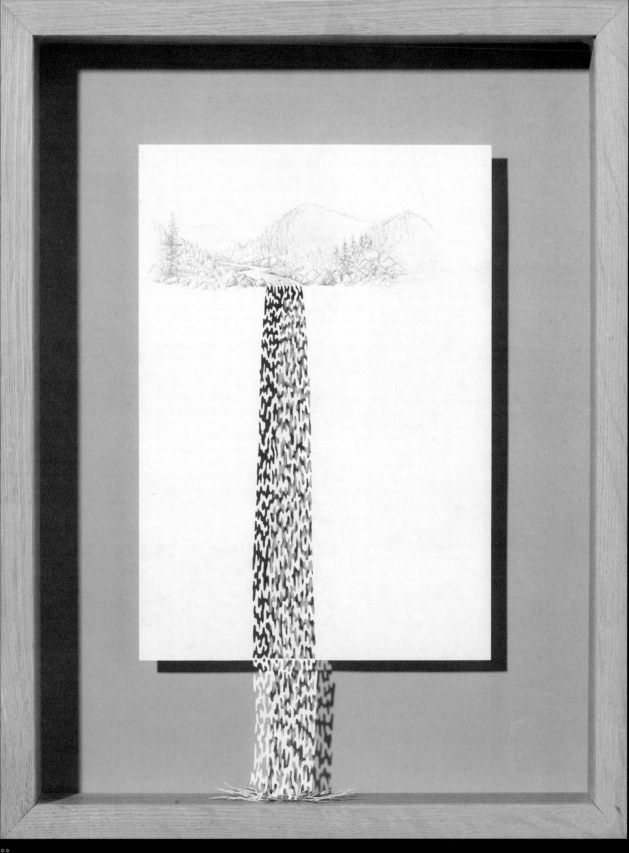

TITLE: Traces in snow*
MEDIA: Paper cut
MATERIAL: Acid free A4 80 gsm paper, Glue
DESCRIPTION: -

TITLE: Water Always Finds its Way**
MEDIA: Paper cut
MATERIAL: Acid free A4 80 gsm paper, Glue,
Pencil, Acrylic paint, Oak frame (47.5 x 37 x 7 cm)
DESCRIPTION: -

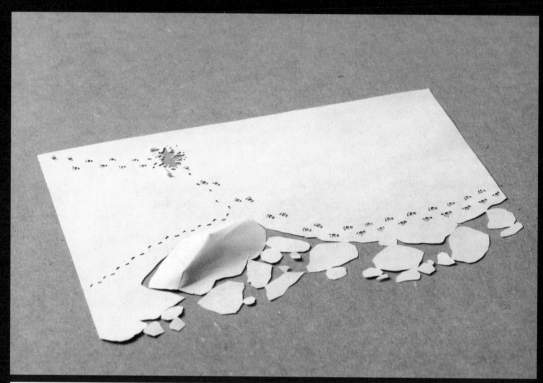

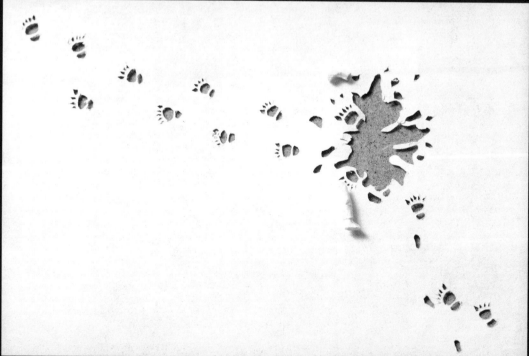

*

TITLE: The Core of Everything
MEDIA: Paper cut
MATERIAL: Acid-free A4 115 gsm paper, Acrylic paint,
Oak frame (48 x 37 x 7 cm)
DESCRIPTION: -

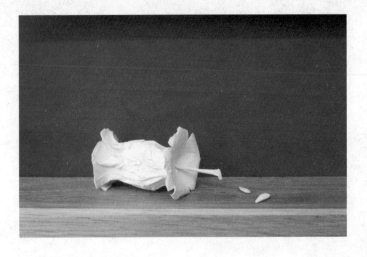

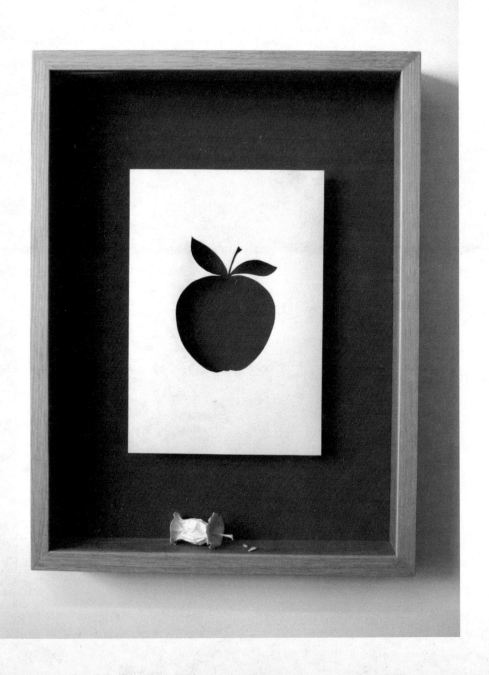

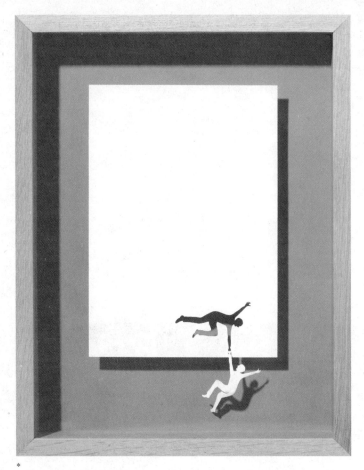

*

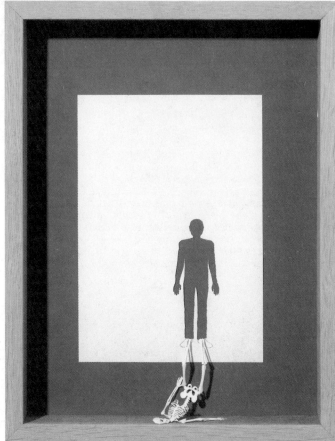

**

TITLE: Holding on to Myself*
MEDIA: Paper cut
MATERIAL: Acid free A4 80 gsm paper, Acrylic paint,
Oak frame (47.5 x 37 x 7 cm)
DESCRIPTION: -

TITLE: The Outline of a Skeleton**
MEDIA: Paper cut
MATERIAL: Acid free A4 80 gsm paper, Glue, Acrylic
paint, Oak frame (47.5 x 37 x 7 cm)
DESCRIPTION: -

PETER CALLESEN

Copenhagen, Denmark

PETER CALLESEN LIVES AND WORKS IN HIS NATIVE DENMARK. HE CREATES HIS
BEAUTIFULLY INTRICATE PAPER SCULPTURES FROM HIS STUDIO IN COPENHAGEN.
CALLESEN STUDIED AT GOLDSMITH COLLEGE, LONDON AND AT THE ART ACADEMY OF
JUTLAND, ARHUS, DENMARK.

HE MAKES MANIFEST SEEMINGLY IMPOSSIBLE IMAGININGS FROM A MODEST AND
UBIQUITOUS MATERIAL OF OUR AGE – A4 COPY PAPER. ALONGSIDE HIS LARGER
SITE-SPECIFIC INSTALLATIONS, CALLESEN IS PERHAPS BEST KNOWN FOR HIS
SIGNATURE A4 PAPERCUTS WHICH WEAVE REFERENCES TO A MYRIAD NARRATIVE
SOURCES – FROM GREEK MYTHOLOGY, DANISH FAIRYTALES AND BIBLICAL STORIES
TO CHILDHOOD MEMORY. THE AUSTERITY OF SUBJECT MATTER AND THE STARKNESS
OF THE PURE WHITE PAPER ARE HUMBLED WITH A SOMEWHAT QUIRKY ATTITUDE
TOWARDS LIFE AND DEATH. THE APPARENT FRAGILITY OF CALLESEN'S CREATIONS,
WHICH IS THE CORE OF HIS WORK, MAY BE INTERPRETED AS A POETIC GESTURE TO
THE TRANSIENCE AND IMPERMANENCE OF BEAUTY. HE IS COLLECTED INTERNATION-
ALLY AND IS REPRESENTED BY EMILY TSINGOU GALLERY, LONDON.

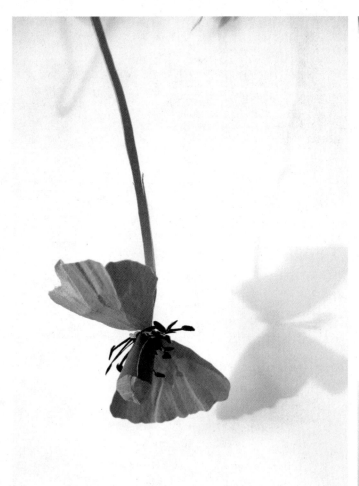

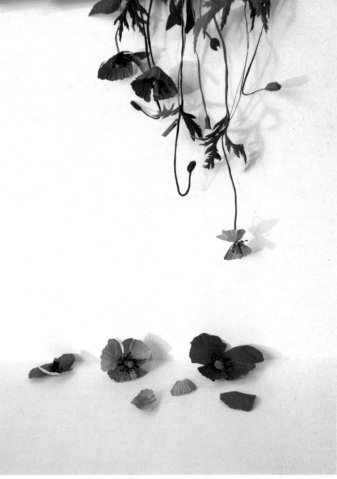

TITLE: Alive, but Dead
MEDIA: Paper cut
MATERIAL: Acid Free paper, Glue, Gouache colour,
Artist made frame (127 x 94 x 11.5 cm)
DESCRIPTION: -

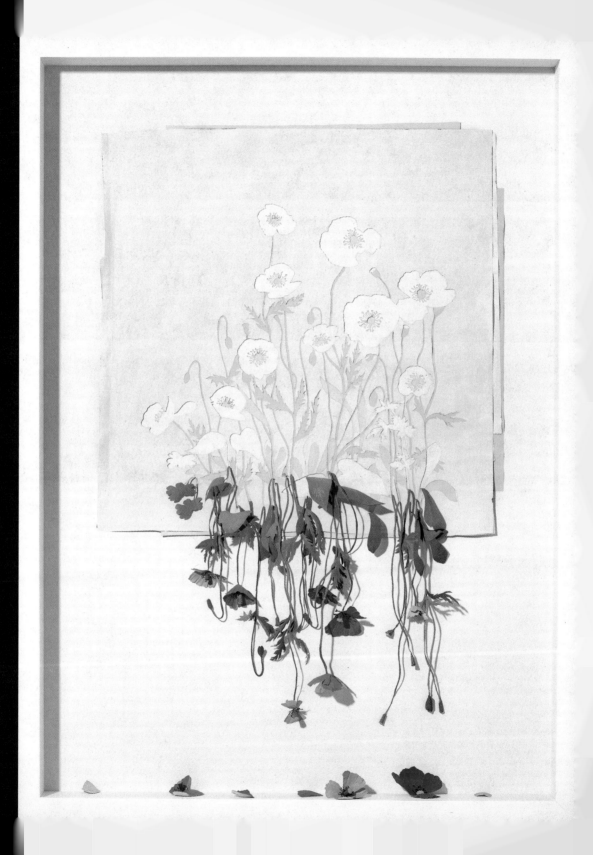

TITLE: Starter Pistols Series
(1919/01/21 12:39:31:03 - 1919/01/21 12:39:31:04 Soloheadbeg* / 1917/10/25
21:45:49:26 - 1917/10/25 21:45:49:27 Petrograd** / 1994/04/06 12:38:26:64
- 1994/04/06 12:38:26:65 Kigali (detail)*** / 1914/06/28 10:15:53:11 - 1914/06/28
10:15:53:12 Sarajevo**** / 1945/08/06 08:16:25:81 - 1945/08/06 08:16:25:82
Hiroshima***** / 1994/04/06 12:38:26:64 - 1994/04/06 12:38:26:65 Kigali****** /
1968/04/04 18:01:42:79 - 1968/04/04 18:01:42:80 Memphis*******)
MEDIA: Needlepoint
MATERIAL: Wool needlepoint, Cotton canvas
DESCRIPTION: For this series Louisa researched times in the 20th century when
history was changed by the shot of a single weapon. These moments included:
• The shot that killed the Archduke of Austria in Sarajevo, starting World War I
• The shot that killed the Irish constables in Soloheadbeg, claiming to start the Irish
War of Independence
• The shot that brought down the airplane carrying the Rwandan president starting the
Rwandan genocide
• The shot that killed Martin Luther King, Jnr, starting race riots in the USA
• The shot that signaled the moment for the Bolsheviks to storm the Winter Palace in
Petrograd, commencing the second phase of the Russian Revolution of 1917
• The bomb that fell on Hiroshima, putting an end to World War II
Having found the weapons used in each of these cases, Louisa researched the sounds
they each made and isolated the one one-hundredth of a second when each weapon
was fired. The needlepoint style is based on the old European technique of Bargello.
Traditionally it involves variations of tones across a regular wave pattern.

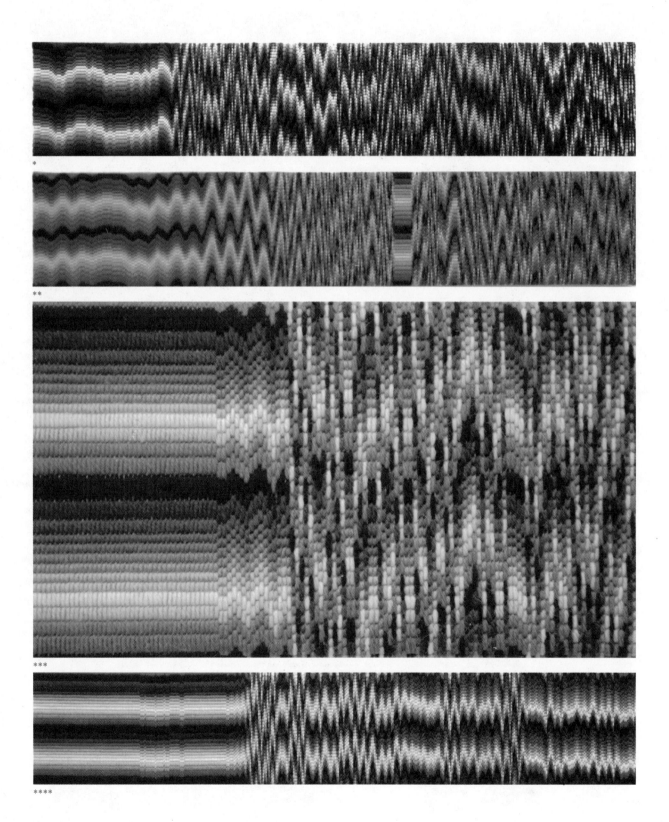

*

**

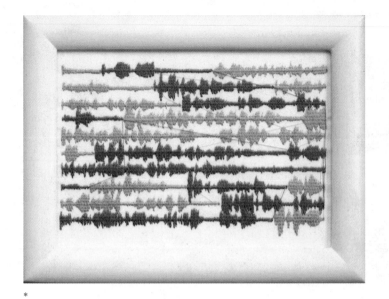

*

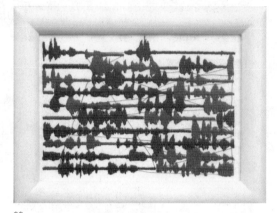

**

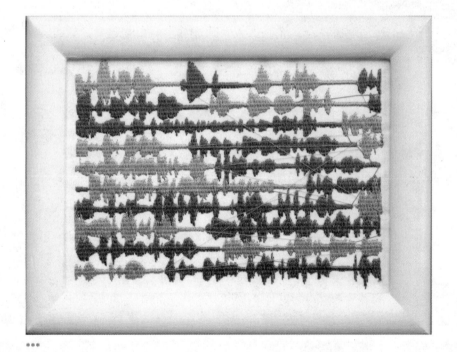

TITLE: 13 Captured Conversations – All One Minute Long
(1997/02/28 03:12-03:13 Someone In Australia With Someone In The United
States Of America* / 2006/03/04 21:03-21:04 Her With Masato Takasaka** /
2006/01/16 20:33-20:34 Her And You***)

MEDIA: Machine embroidery

MATERIAL: Cotton thread, Cotton fabric, Wood frames

DESCRIPTION: Creating this series involved recording telephone conversa-
tions and finding recorded telephone conversations, entering them into the
computer to visualise the soundwave, isolating one minute from the conversation
and translating the visual soundwave into a jpeg. The jpegs were then transferred
to a computer connected to an automated sewing machine. The sound waves
were stitched automatically into the fabric.

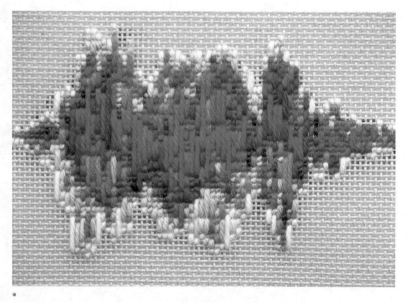

TITLE: Anti-War Speeches Series
(Important Point Detail* / Not, Ahhh Detail**)
MEDIA: Stitching
MATERIAL: Wool needlepoint, Cotton canvas
DESCRIPTION: Making this series involved collecting audio files of anti-war speeches from the Internet and rendering them as sound waves with an audio software programme. Louisa took a snapshot of the sound wave of a phrase and she wanted to use and brought it into Photoshop. In Photoshop she resized the image so it matched the number of squares per inch of her canvas and chose a series of colours she wanted to use. This image became her stitching guide and she hand-stitched the image with wool in a cotton canvas.

*

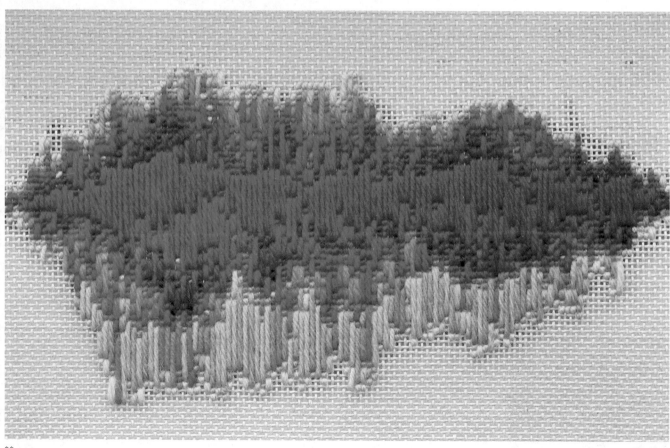

**

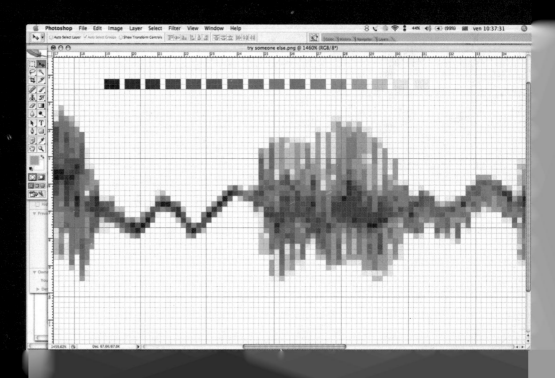

TITLE: Anti-War Speeches Series
(Maybe People Would* / Try Someone Else** /
...ot, Ahhh*** / Important Point**** / Is A
...isaster Detail*****)

MEDIA: Stitching

MATERIAL: Wool needlepoint, Cotton canvas

DESCRIPTION: Making this series involved
collecting audio files of anti-war speeches from
the Internet and rendering them as sound waves
with an audio software programme. Louisa took a
snapshot of the sound wave of a phrase and she
wanted to use and brought it into Photoshop. In
Photoshop she resized the image so it matched
the number of squares per inch of her canvas and
chose a series of colours she wanted to use. This
image became her stitching guide and she hand-
stitched the image with wool in a cotton canvas.

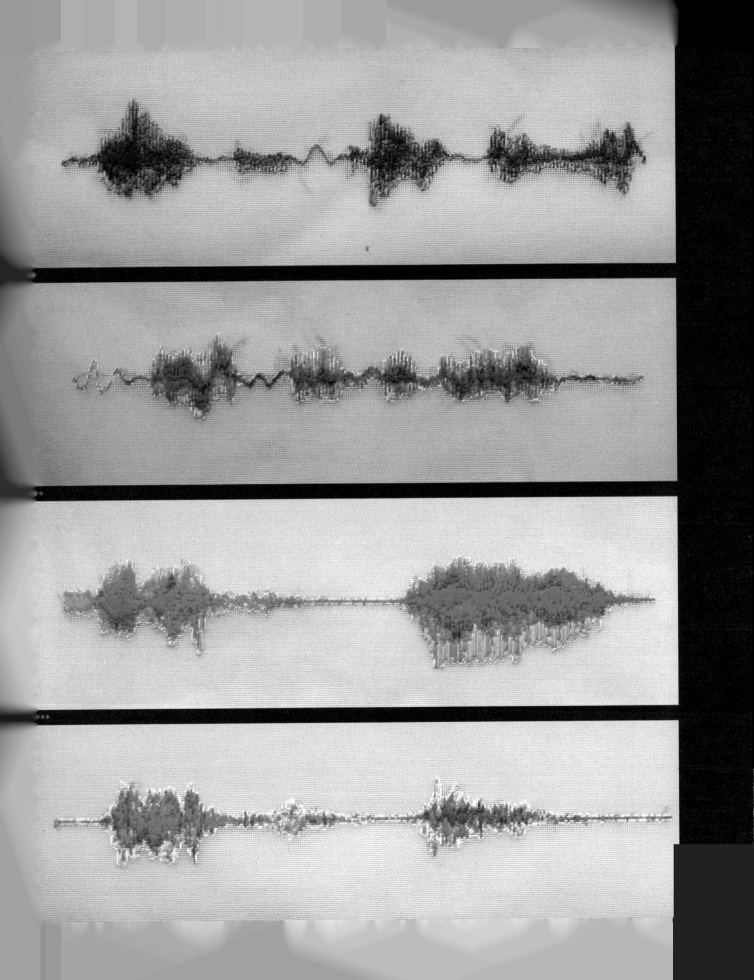

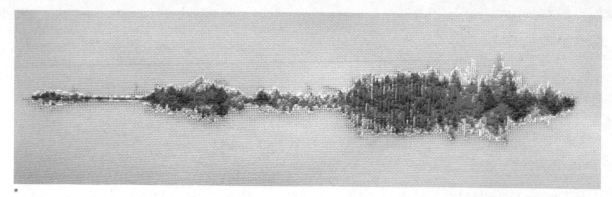

*

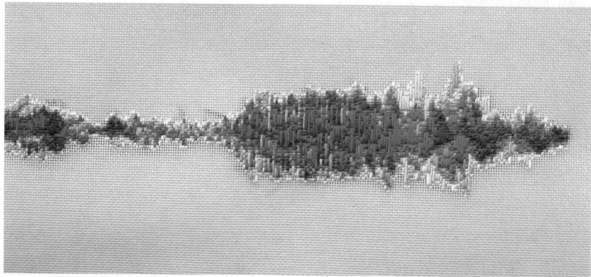

**

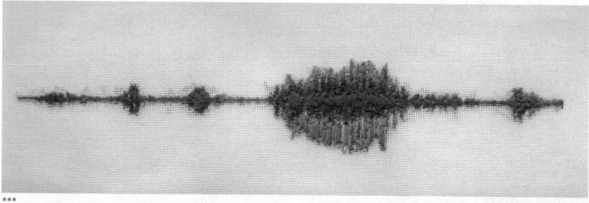

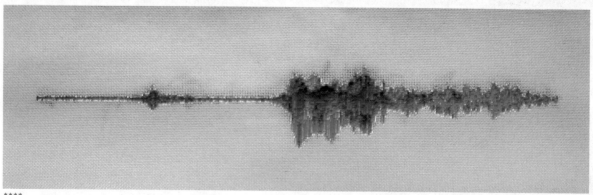

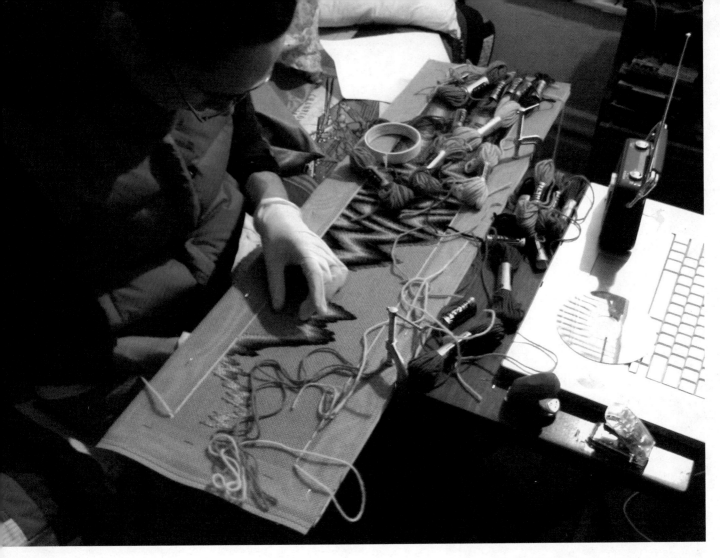

TITLE: Anti-War Speeches Series
(Before The War* / Before The War Detail** /
Is A Disaster*** / Australians****)
MEDIA: Stitching
MATERIAL: Wool needlepoint, Cotton canvas
DESCRIPTION: Making this series involved collecting
audio files of anti-war speeches from the Internet and
rendering them as sound waves with an audio software
programme. Louisa took a snapshot of the sound wave
of a phrase and she wanted to use and brought it into
Photoshop. In Photoshop she resized the image so it
matched the number of squares per inch of her canvas
and chose a series of colours she wanted to use. This
image became her stitching guide and she hand-stitched
the image with wool in a cotton canvas.

LOUISA BUFARDECI

New York, USA

LOUISA BUFARDECI WAS BORN IN 1969 IN MELBOURNE, AUSTRALIA AND
CURRENTLY LIVES AND WORKS IN BROOKLYN. IN 2006 SHE RECEIVED AN MFA
FROM SAIC, CHICAGO. SHE ALSO HOLDS A BFA FROM THE VICTORIAN COLLEGE
OF THE ARTS, MELBOURNE, AND A BED FROM THE UNIVERSITY OF MELBOURNE.

SHE HAS PRESENTED HER WORK INTERNATIONALLY INCLUDING AT THE SYDNEY
OPERA HOUSE, THE AUCKLAND TRIENNIAL, ARTISSIMA IN ITALY, AND IN
SOUTH AFRICA, BELGIUM, INDIA, ROMANIA, THE UNITED STATES AND ELSE-
WHERE. TO DATE LOUISA HAS COMPLETED RESIDENCIES IN MELBOURNE, LOS
ANGELES, NEW DELHI AND NEW YORK AND HAS RECEIVED NUMEROUS GRANTS,
AWARDS AND SCHOLARSHIPS FROM THE AUSTRALIAN GOVERNMENT AND VARI-
OUS PRIVATE INSTITUTIONS.

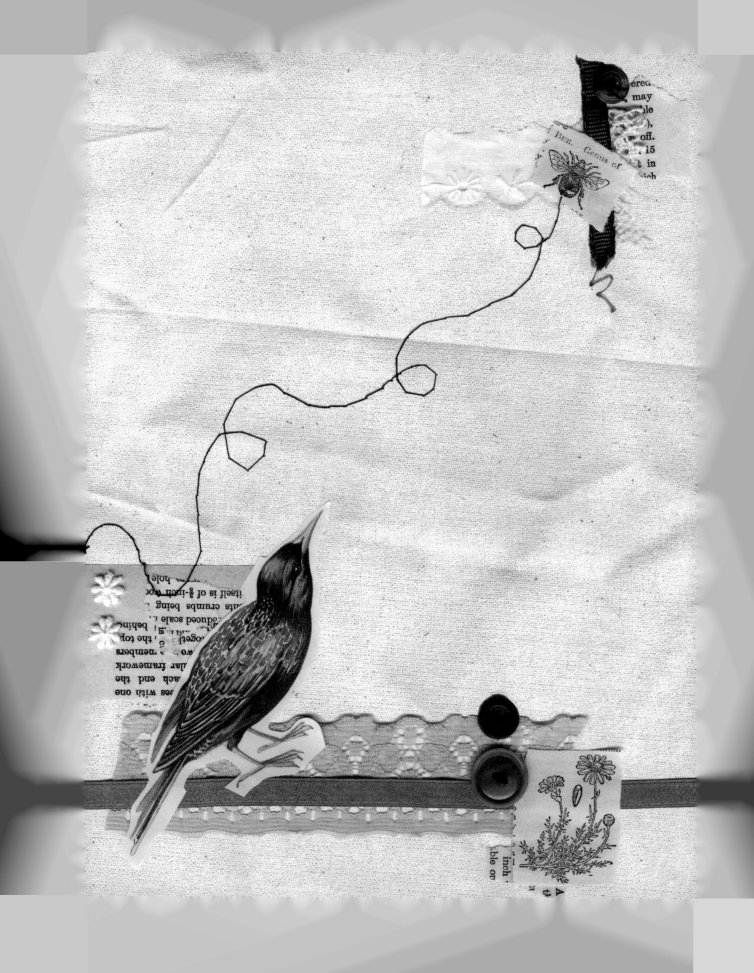

TITLE: Why Do Birds Have Bright Feathers*
MEDIA: Collage, Stitching
MATERIAL: Felt, Paper
DESCRIPTION: A page from a children's book illustrating the story 'Why Do Birds Have Bright Feathers?' It is created with felt and papers by paint and through stitching.

TITLE: WATCHING/WATING**
MEDIA: Collage, Stitching
MATERIAL: Lace, Buttons, Scraps
DESCRIPTION: A self-motivated collage based on ideas and inspiration from a trip in China.

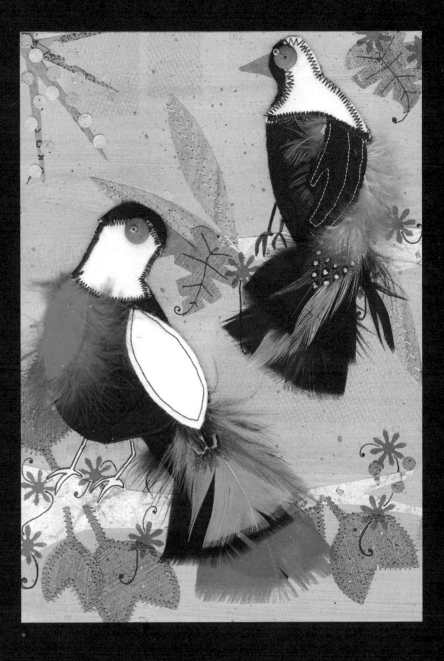

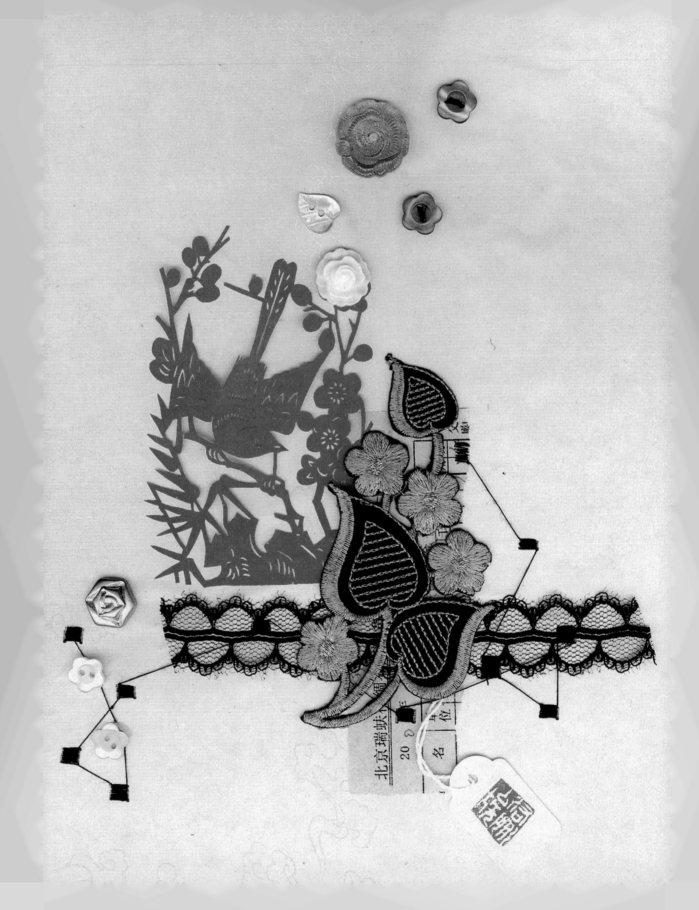

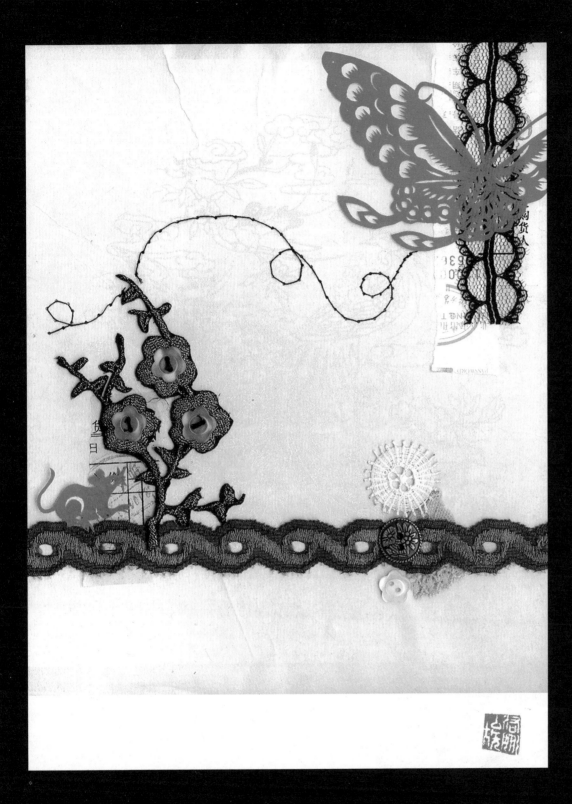

TITLE: Butterfly* / Bird**
MEDIA: Collage, Stitching
MATERIAL: Paper, Silk, Trimmings
DESCRIPTION: On a visit to China last September, Eleanor collected
a variety of traditional papers and collage elements such as cut paper
pieces as well as many traditional silks and trimmings. She combined
these by sewing and stitching to make a decorative series of images
along with elements such as bus and train tickets.

TITLE: Cherry Blossom*
MEDIA: Freehand stitching, Painting
MATERIAL: Fabrics, Trimmings, Paint
DESCRIPTION: Created from a deconstructed pair of trousers, the image depicts a Japanese tanka using freehand embroidery, hand drawings and photographs, scanned and combined with text typed on a traditional typewriter.

TITLE: Gingko Leaves**
MEDIA: Stitching, Drawing, Typing via typewriter
MATERIAL: Fabrics, Lace
DESCRIPTION: Created from a deconstructed knitted jumper, the image depicts a Japanese tanka using freehand embroidery, hand drawings and photographs, scanned and ironed it onto thin silk, then combined with text typed on a traditional typewriter.

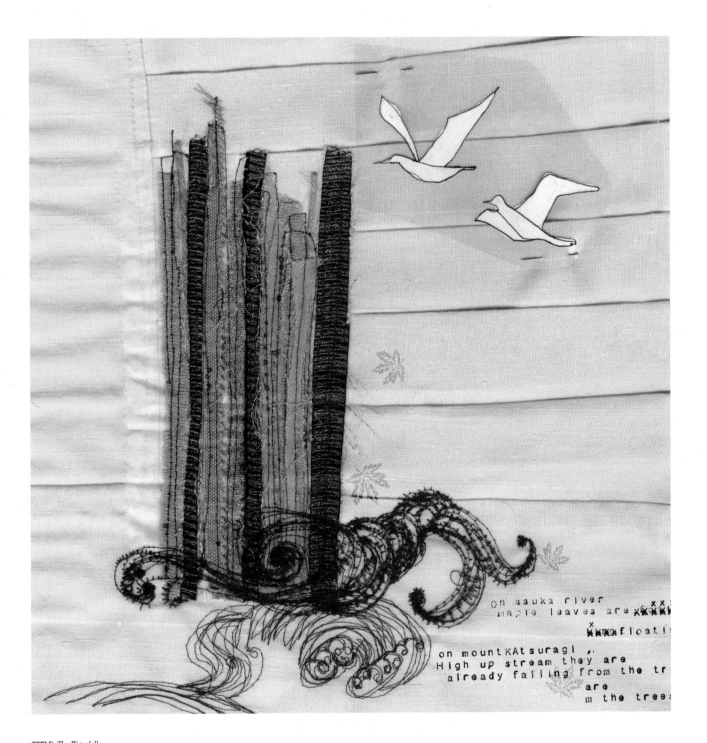

TITLE: The Waterfall

MEDIA: Stitching

MATERIAL: Fabrics

DESCRIPTION: Created from a deconstructed pleated cloth, the image depicts a Japanese tanka using freehand embroidery, hand drawings, scanned and combined with text typed on a traditional typewriter.

TITLE: Idle Thoughts
MEDIA: Freehand stitching
MATERIAL: Fabrics, Paint
DESCRIPTION: Created from a deconstructed jacket the image depicts a Japanese tanka using freehand embroidery, hand drawings and photographs, scanned and combined with text typed on a traditional typewriter.

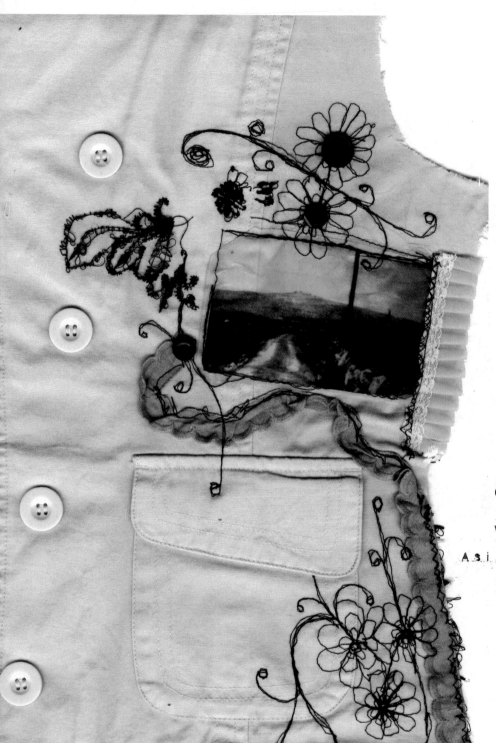

COLOURe of th e flo
 already f
while in idle though
My life passes va
Asi watch the long rain

left on the beach
full of water, A Worn Out Boat

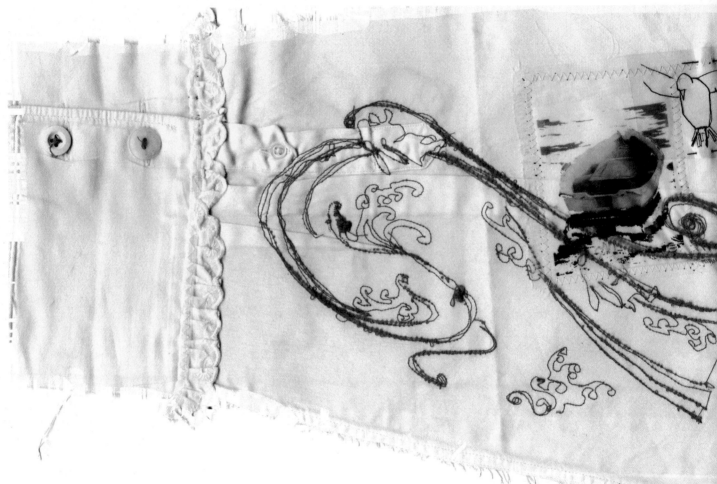

white
reflects the xxxxxx of
early autumn

TITLE: A Worn Out Boat
MEDIA: Stitching
MATERIAL: Fabrics, Trimmings, Acetate
DESCRIPTION: Created from a deconstructed men's shirt the image depicts a Japanese tanka (a tradition poem consisting of 31 syllables in 5 lines) using freehand embroidery, hand drawings and photographs, scanned and combined with text typed on a traditional typewriter.

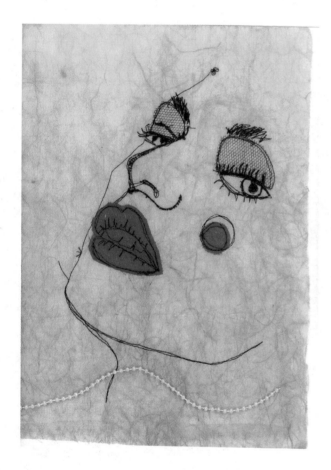

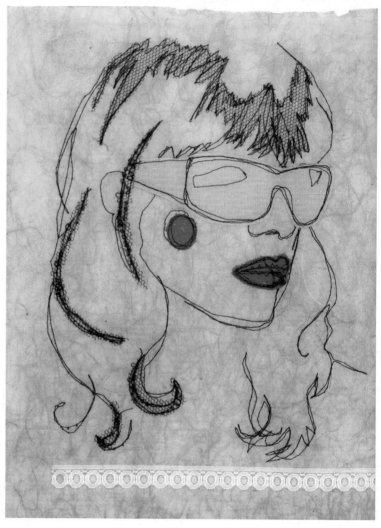

TITLE: Experimental Faces

MEDIA: Stitching

MATERIAL: Photos, Fabrics, Buttons, Ribbons

DESCRIPTION: These are part of a series of experimental faces. Using
photos pinned to a blank fabric Eleanor traced over the outline of the face
so that the back of the stitching became the front of her work. It was further
embellished with fabrics, buttons and ribbons.

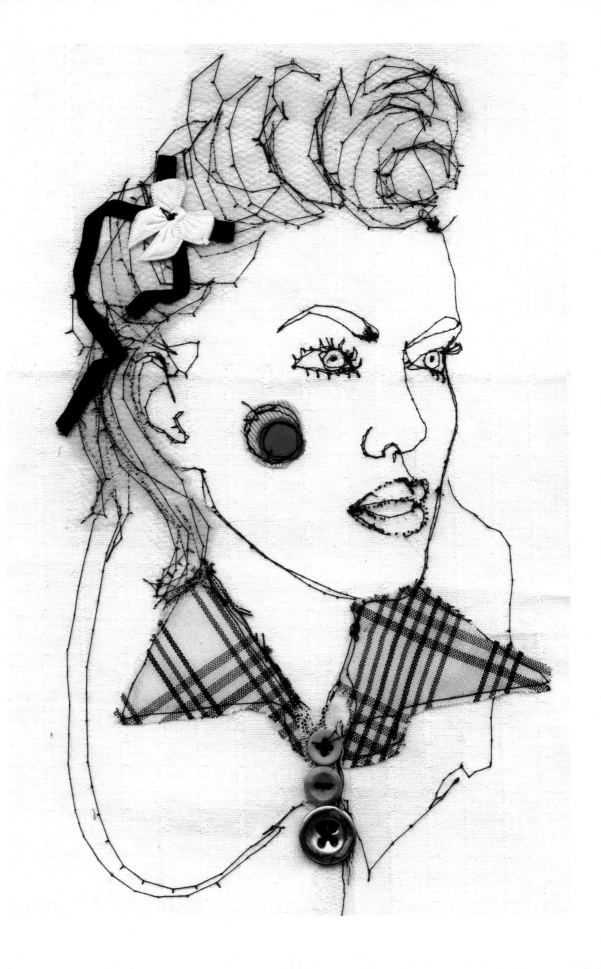

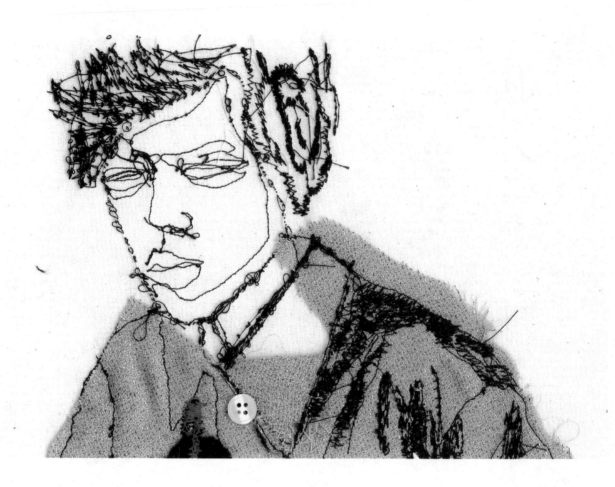

ELEANOR BOWLEY

Surrey, UK

ELEANOR BOWLEY'S WORK IS MAINLY DECORATIVE USING TRADITIONAL METHODS OF PAPER COLLAGE COMBINED WITH STITCHING, FABRICS AND HABERDASHERY EMBELLISHMENTS.

SHE OFTEN TRIES TO SOURCE WASTE MATERIALS SUCH AS DISCARDED FABRICS FROM TEXTILE DESIGNERS AND SECOND HAND BUTTONS. SHE USUALLY DECONSTRUCTS ELEMENTS OF CLOTHING AND USES THE FABRICS AS A BASE. SHE TRACES USING A FREEHAND STITCH ON A SEWING MACHINE, OVER IMAGES ESPECIALLY THOSE OF THE FACE. SHE LOVES THE UNEVENNESS OF THE LINES AND AS SHE WORKS FROM BACK TO FRONT THE UNPREDICTABILITY OF THE FINAL IMAGE. ELEANOR RARELY USES THE COMPUTER TO DEVELOP HER WORK EXCEPT FOR CREATING A FINAL DIGITAL FILE.

Unlike Sandrine, Richard Saja did not start his art life with hand embroidery work. It was a sudden thought from a night and that he found the amusement of needlework. His initial concept was to 'tattoo,' through hand embroidery, upon toile prints on old canvas that many could find in second hand shops. Impactful bright colours from newly added thread made the old toile print back to live again; and usually Richard stimulates our eyes with fresh hairstyles and funny patterns with just a needle!

In the meantime of the 'rise' of the embroidery media, another traditional media – paper cutting is getting more and more admired in the field too. You may well understand from its name, it is an art of cutting paper. However, not only paper that can be cut, artists sometimes use aluminum foil, blades of grass, or even film negatives. For more than thousand years, it has been evolving uniquely in different cultural styles. Chinese paper cutting with traditional Zodiac animals, Japanese Kirie paper cutting, German and Swiss Scherenschnitte and Mexican Papel picado are known to be the most skillful and accomplished among all. Here, we find Peter Callesen from Denmark who demonstrates how expert the technique and media can be. Paper is his love, and A4 80gsm paper is his dearest. Many of his work are made from that without any breakage of course. By his skillful hands, 2-dimensional images appear in 3-dimensional scenes. A flower, a bird, a fence, or even a running river, all become lively in front of you! Movements are captured accurately and presented with just a piece of paper! From his work, you will understand although paper cut has been a traditional medium with a very long history background; it is still an amazing yet potential medium to explore!

While there are so many alluring possibilities in traditional media, how can one explore and differentiate himself/herself from others by using 'ordinary' materials through expected media? Ian Wright is sure the representative here. He makes art with daily materials that are always neglected or forgotten by the public. Simple resources but great result! Let's look at his 'Angela Davis "1000 Lashes",' the work is made of 1000 mascara brushes! And the window display 'I Get High When You Walk By', the 144" x 72" butterfly goes alive in complex arrangement of 1-inch coloured strips of ribbon! Another impressive work is the one that is made of batches with images of food and pornography from magazines cuttings. With that, he made a detailed portrait of Trevor Jackson! This is what we call 'magic!' And there is much more excitement from this limelight in the book!

By reading the above, it is obviously that illustrators work across a broad range of traditional skills besides computing software. Creating great illustration work requires specialized skills and knowledge, in addition to practical applications. Not only be aware of the technology availability, we should all put equal emphasis on more traditional techniques and media, which are now often used in conjunction with each other and bring the industry or our daily life more refreshing styles. So let's explore the new wave of illustration together and flip to the next pages!

Looking at its origin, illustration is a piece of visualizing art. Back to the old times, it was made to help enhancing writing that corresponds to the content of the associated text; it may be used to clarify complicated concepts or objects that are difficult to describe in words, or simply for decoration as those in greeting cards or cover art bringing people very simple and direct message. It was considered as a small part of the creative industries. In early years, traditional illustrators was confronted a challenge from the boom of using computer software such as Adobe Illustrator, Photoshop, FreeHand and InDesign. Advanced technology investment and studies have helped to increase the ability of drawing and painting directly on computers. The widespread of computing brands like Apple and IBM is another key factor to the growth and maintenance of the digital illustrating style. Computer is firmly established as a main creative tool during the design process, contemporary illustration and graphic design are mostly and commonly the outcome of pure computer-made. However in the last few years, there has been a noticeable move towards a handcrafted style, perhaps a logical reaction to the torrent of digital imagery.

Living in the flood of pure computer-made graphics nowadays, people are getting numbed and forget about many other traditional or new potential media that illustration can possibly be compiled and leveraged with. More and more artists, designers and image-makers are turning to different kinds of tools and techniques, and their methods vary widely. Motifs are not only being produced in pencil, chalk, airbrush and marker but also by mixing media, for example by combining illustration, photography and wallpaper. Some work solely with pen, pencil and paint; others create images using tapestry and embroidery, and many incorporate digital elements into handmade art. When it comes to handmade art, it includes collage; silkscreen; embroidery like sewing, stitching, fabric piecing using thread or any other possible materials; hand knit; quilting; crochet; carving and etching, baking and burning; sticking with labels, batches, nails, etc.; paper cutting; origami, and more.

'Illustration • Play: Craving for the Extraordinary' is a challenge to the role of the computer-dominated design world. It aims to explore the new illustration attitude and media, and attempts to reveal the very different signature skills and style of various illustration techniques and experiment. By showcasing the unparallelled personal as well as commissioned work that was made in some traditional yet unusual media, you will find out how the selected artists from around the world 'play' with their illustration in the chosen media and end up to be beautiful illustration. Different perspective of artwork will ultimately show you how these extraordinary media of illustration stand out of the digital-dominated industry.

Media of illustrating is the focus of this title. It is never an easy pick. It depends on various grounds. Sometimes, the initial idea determines the media while other times it is the desire to differentiate from other artists the most motivating. Or, artists may hate to rely heavily on computers and simply trusts their gut instincts. Among all the media mentioned above, embroidery is the most popular. It is an art or handicraft raised and stitched with a needle or a sewing machine in yarn or threads of silk, cotton, gold, silver, metal or other possible materials, upon any woven fabric, leather, paper, or even a piece of wet clay. It may incorporate with other materials such as buttons, pearls, beads, etc. There are many different types of embroidery like Hungarian lead cross-stitch embroidery and traditional Chinese style free embroidery.

Sandrine Pelletier from Swiss has caught our attention here. She has been practicing the technique since the very beginning of her career. Weaving is always her choice of media in presenting her work. She illustrates mostly with lace, leather, wool and many other different kinds of fabrics. Images with scenes of stories can usually find in Sandrine's work and she is very good at playing with the impact that threads can bring out! A good example is the series of her zombie portraits. She left the thread 'dropping' from the point where she stitched and it gives the work a bloody and scary feeling. She also collaged the work with blood and tea!

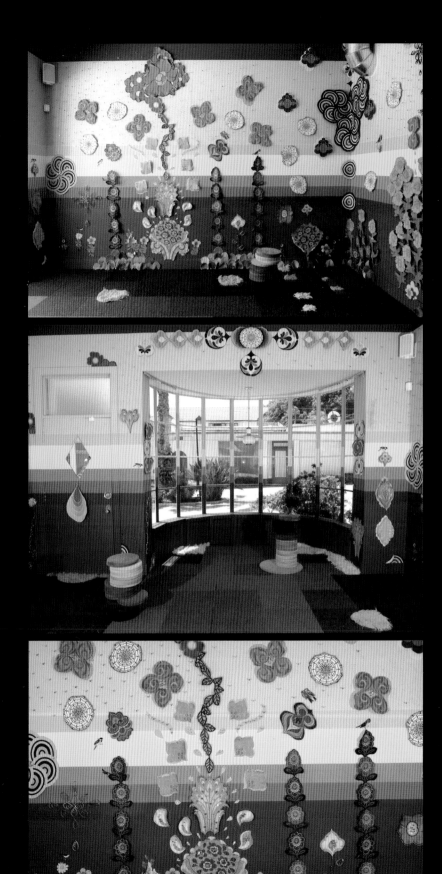

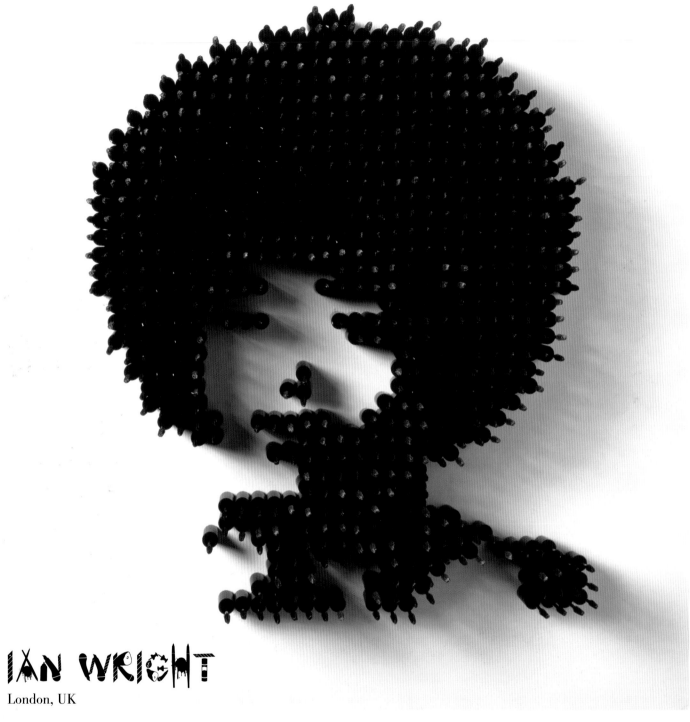

IAN WRIGHT

London, UK

PLAYFULNESS IS IMPORTANT TO IAN; HE ALWAYS TRIES TO PUSH HIS WORK SOMEWHERE NEW, SOMEWHERE ELSE. HE IS INTERESTED IN WHAT COULD BE DONE. HE SOMETIMES REACHES THAT POINT BY MAKING MISTAKES AND GENERALLY MISUSING TECHNOLOGY; HE OFTEN ARRIVES AT SOLUTIONS BY ACCIDENT. IAN PREFERS TO LET THE MATERIALS HE USES INFLUENCE THE OUTCOME.

ENJOYING THE UNPREDICTABILITY THEY OFFER, HIS UNCONVENTIONAL USE OF MATERIALS HAS INCLUDED SALT, JELLY, CASSETTE TAPE, BUTTONS, BEADS, PAPER CUPS AND DRAWING PINS.

HE ESPECIALLY ENJOYS MAKING PORTRAITS AND THE PROCESS OF COLLABORATION EXCITES HIM. HE LOVES CONVERSATION AND IS OBSESSED BY MUSIC. HE ALWAYS LOOKS FORWARD TO WHAT HAPPENS NEXT.

TITLE: Angela Davis '1000 Lashes'
MEDIA: Mascara brushes
MATERIAL: Mascara brushes
DESCRIPTION: A portrait of Civil Rights activist
Angela Davis '1000 Lashes,' made of 1000 Mac
mascara brushes, commissioned for the Protest issue
of Black Book magazine.

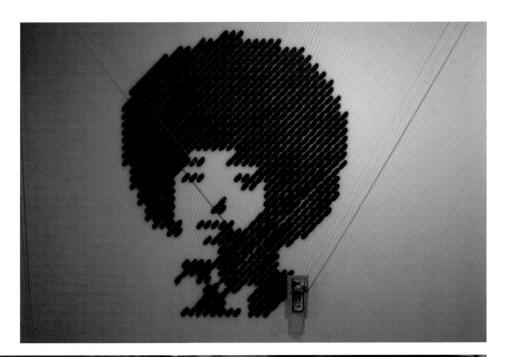

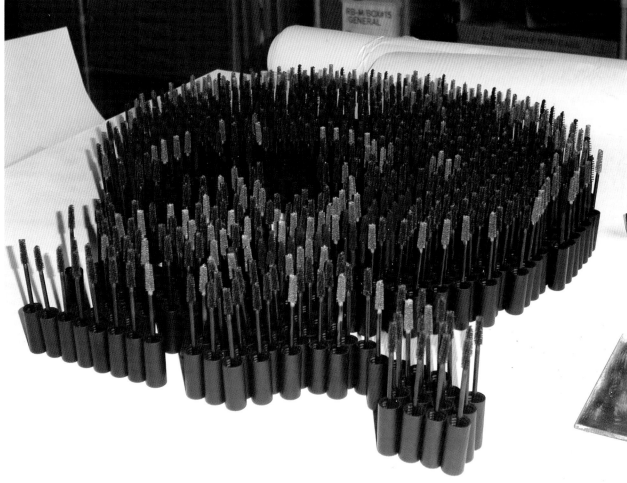

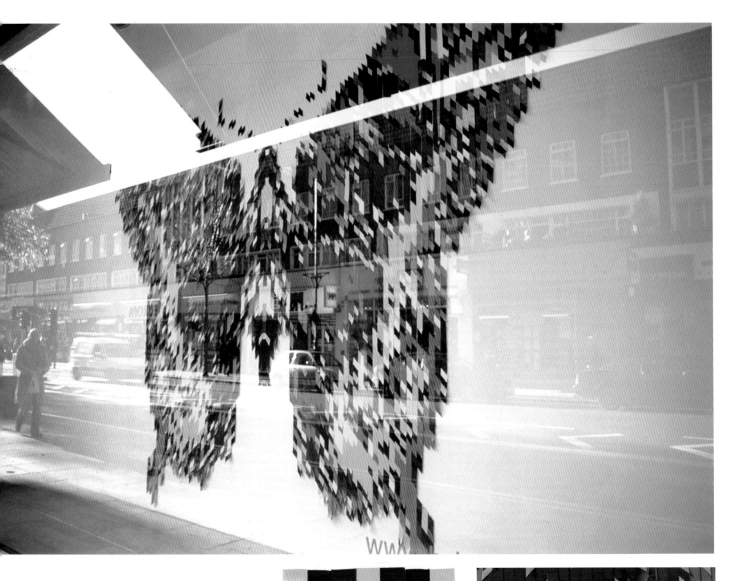

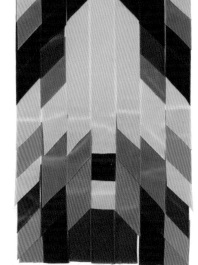

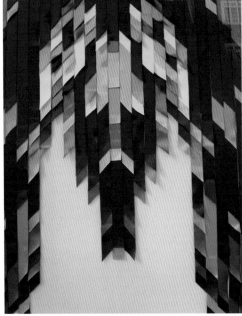

TITLE: I Get High When You Walk By
MEDIA: Ribbon
MATERIAL: Ribbon
DESCRIPTION: A Butterfly portrait measuring 144" x
72" for a site-specific display in a curated window space.
Constructed of 1" strips of Ribbon, it was commissioned
by Brinkworth Architects, London.

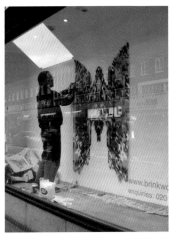

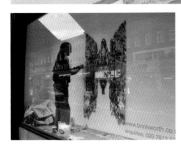

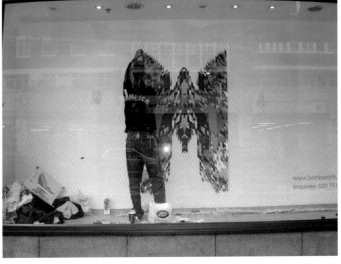

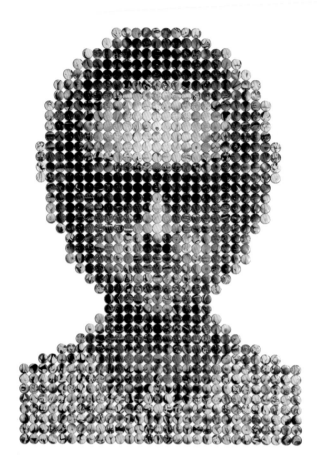

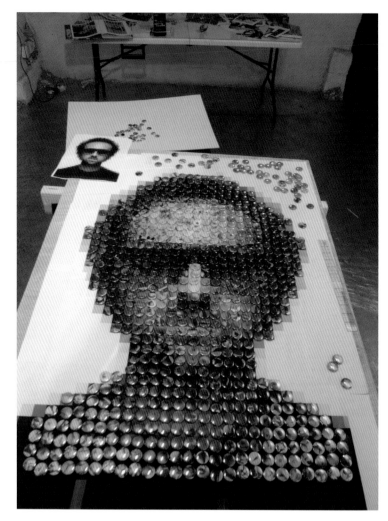

TITLE: Trevor Jackson Two Faced Portrait

MEDIA: Badges

MATERIAL: Badges

DESCRIPTION: A portrait made of badges with images of food and pornography cut from magazines in response to the subject's love of food and sex for the Two Faced portrait project, commissioned by Darren Firth at Two Faced.

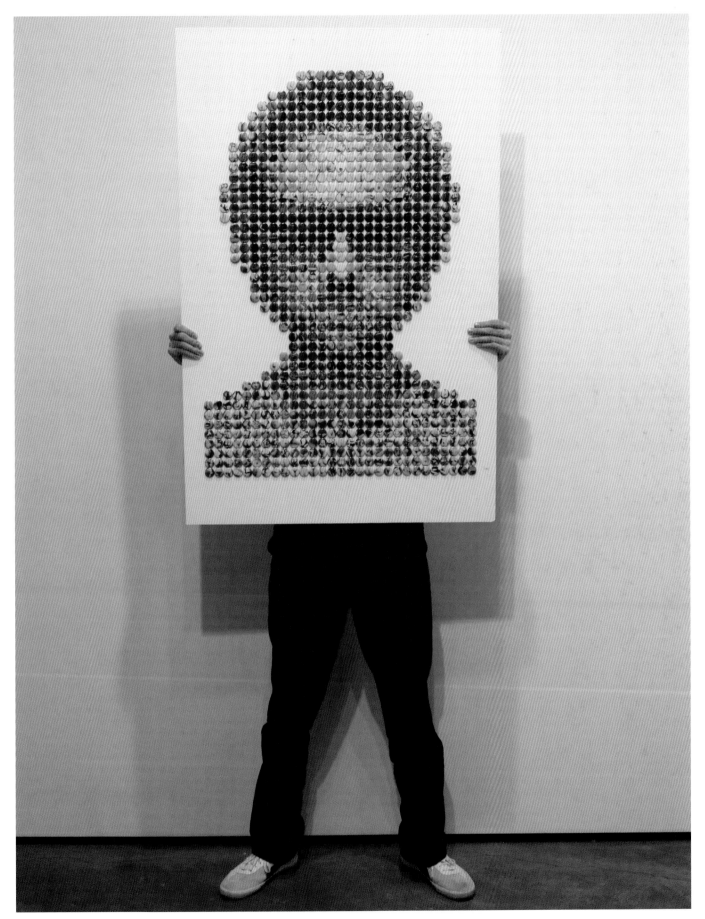

TITLE: Mick Jones* / Cheik Lo**
MEDIA: Pixelblocks
MATERIAL: Pixelblocks
DESCRIPTION: Portraits of Mick Jones and Cheik
Lo for 'It Takes Two,' an article about collaboration,
commissioned by Phil Bicker, the art director of Fader
magazine US.

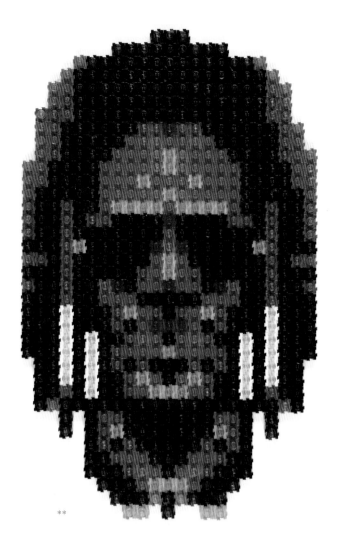

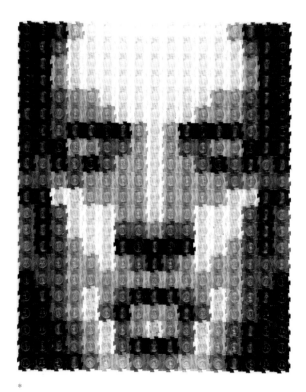

*

**

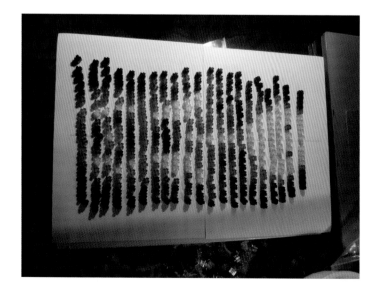

TITLE: Ghost Gorilla
MEDIA: Paper Cups
MATERIAL: Paper Cups
DESCRIPTION: A Ghost Gorilla made of 4370 paper cups, part of an installation called 'Heads/Up,' commissioned by Issey Miyake, Tribeca NYC, US and Neville Brody.

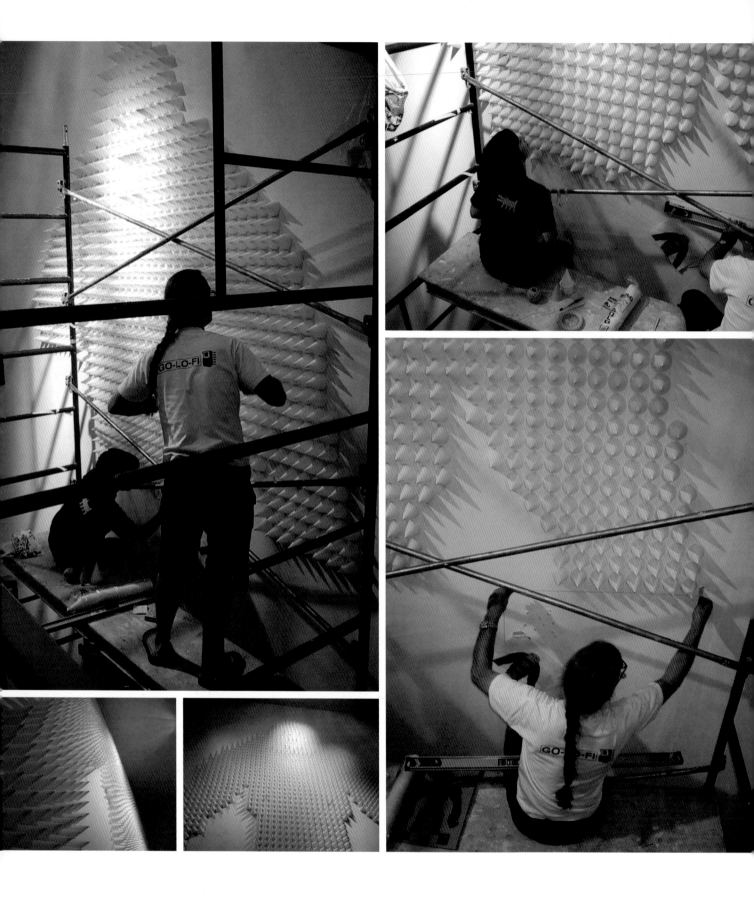

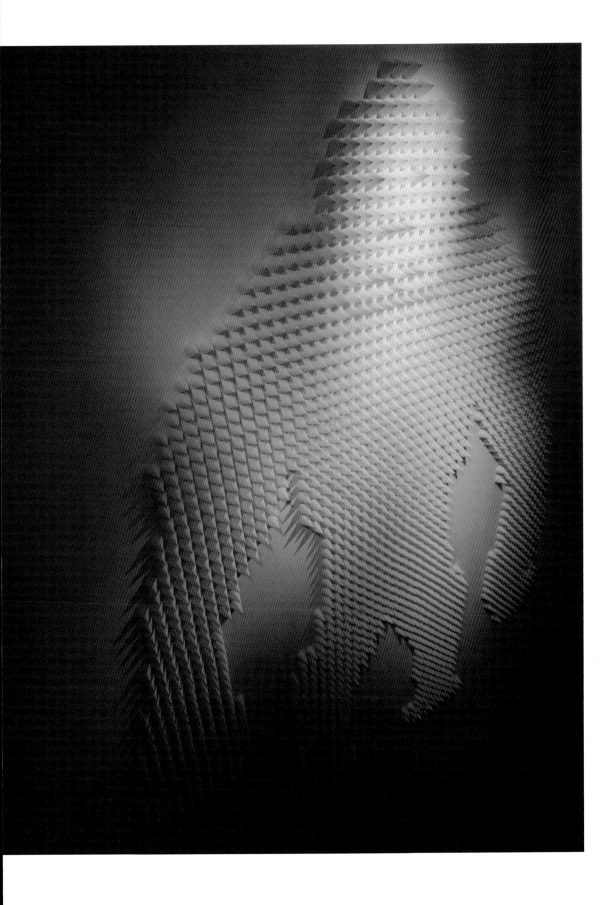

TITLE: Experience Jimi Hendrix (Slight Return)
MEDIA: Beads
MATERIAL: Beads
DESCRIPTION: Bead portrait of Jimi Hendrix in response to the project 'If you could do anything tomorrow, what would it be...' commissioned by Alex Bex and Will Hudson at 'If You Could....' Photography by Ed Park.

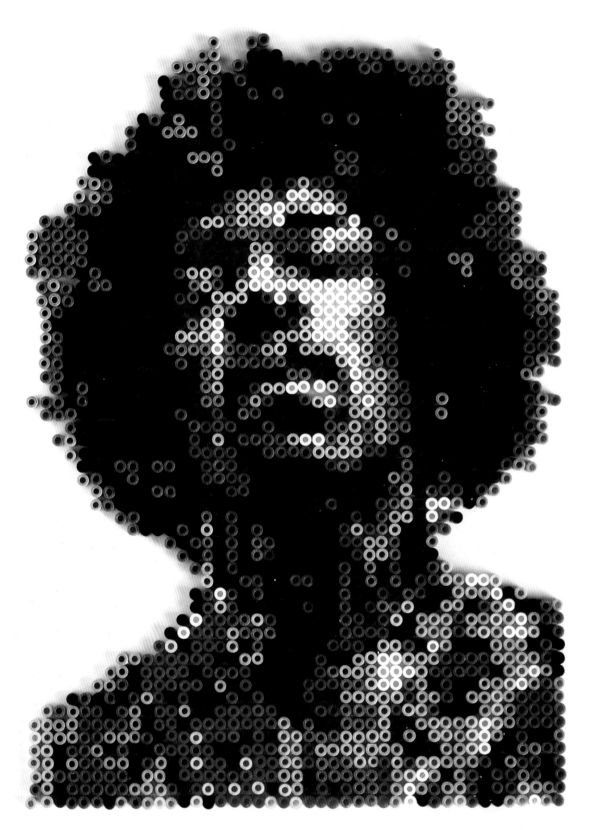

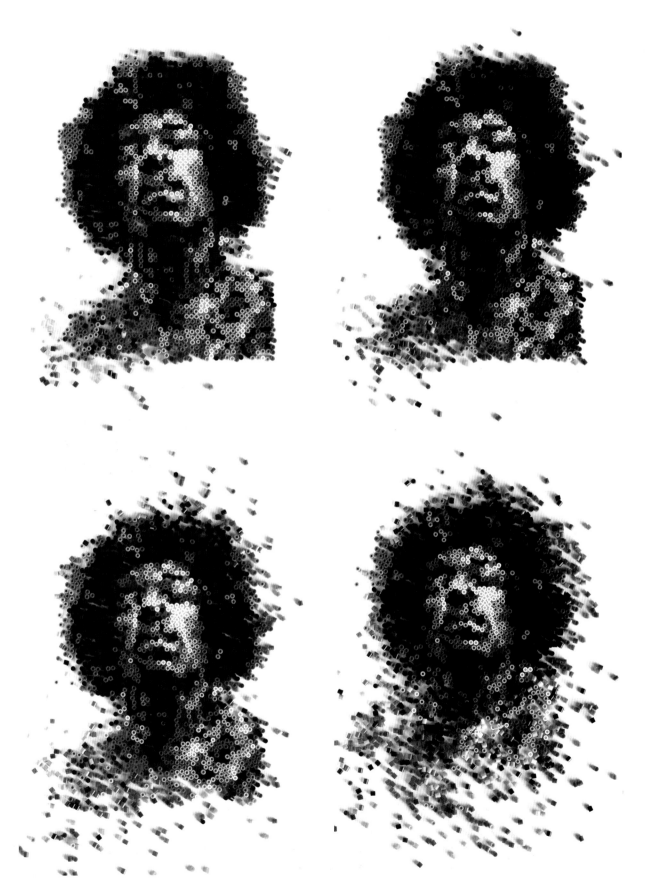

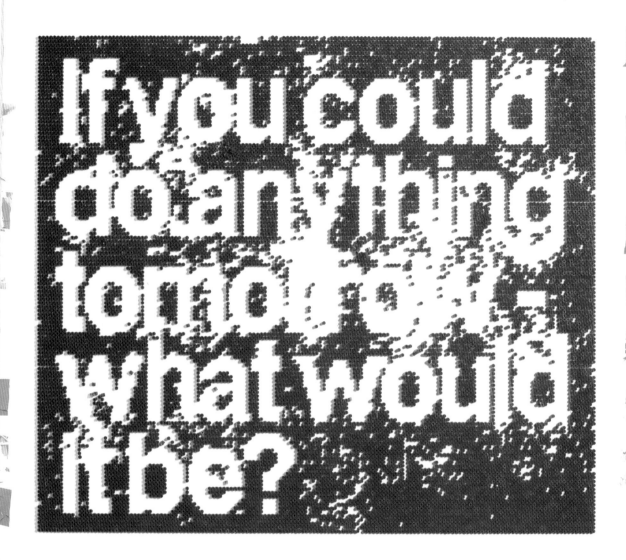

TITLE: If You Could...
MEDIA: Beads
MATERIAL: Beads
DESCRIPTION: In collaboration with Alex Bex and
Will Hudson at 'If you could...,' this cover image is art
directed by the artist for the project 'If you could do
anything tomorrow....'

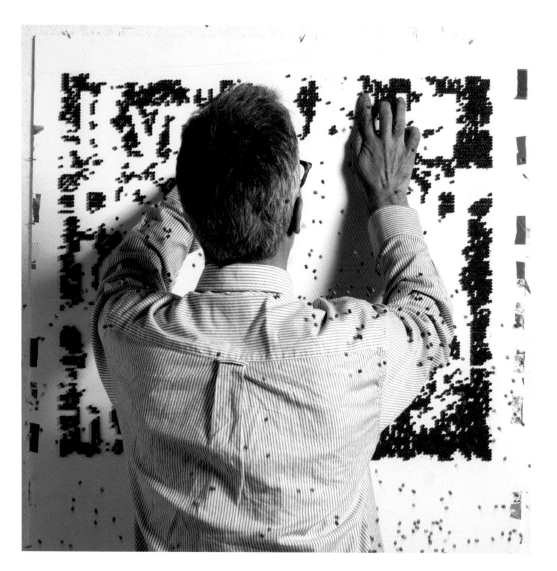

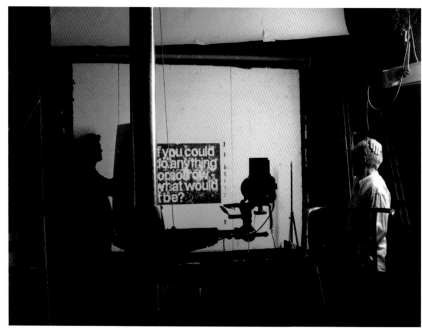

INTERVIEW

INTRIGUING QUESTIONS FOR 23 FEATURED
ARTISTS WITH UNIQUE ANSWERS. LET'S EXPLORE
THE ARTISTS' CREATIVE WORLD!

ELEANOR BOWLEY

1. How do you describe your work?

An eclectic mix of memories and forgotten treasures.

2. What inspires you to create?

Anything unusual — other peoples handwriting, an odd button, old coins, found images.

3. What do you find the most playful and exciting in the process?

Researching new themes. I enjoy the process of building up an image from a single found image

4. What makes you choose the current media and execution approach for your work? to a finished

I like my images to be tactile, it involves | Piece.
the viewer in the illustration.

5. What other media would you like to challenge yourself with?

Integrating hand drawn images into my work.

6. Who in the field catches your attention the most recently?

Sarah Fanelli & Marie O'Connor

7. Who would you like to collaborate with and why?

Either of the above! Their work has great depth, all their images ar inspiring and no matter how many times you see them you'll always

8. What would you like to be if not an artist?

A textile designer.

find something new.

9. Please close your eyes and draft the first image in your mind.

LOUISA BUFARDECI

1. How do you describe your work?

Generally in stuttered sentences, mumbling something about the perceived ideals of democracy or the representation of information.

2. What inspires you to create?

Many different things. Sometimes I find a material that I want to work with and devise a project around it, or sometimes it's a space or some information I've gleaned from the media.

3. What do you find the most playful and exciting in the process?

Coming up with an idea that I really like and that I can see has the potential to communicate multiple ideas. Sometimes I get butterfly feelings in my stomach when that happens.

4. What makes you choose the current media and execution approach for your work?

I'm always open to trying new media. I've been using needlepoint for a couple of years now but there are many other techniques I'd like to try. There's a place in New York with a 3D printer. I'd like to try that!

5. What other media would you like to challenge yourself with?

Anything is fine!

6. Who in the field catches your attention the most recently?

I like hearing about artists who do interesting art projects within their communities. Like Temporary Services in Chicago or BAMP in Melbourne or people like Alfredo Jaar.

7. Who would you like to collaborate with and why?

I'd like to collaborate with my husband. He's a very thoughtful artist. We talk about collaborating sometimes but then we get lost in our individual projects.

8. What would you like to be if not an artist?

I'd like to be involved in music somehow — a composer, a musician, a singer — anything!

9. Please close your eyes and draft the first image in your mind.

Louisa Bufardeci

PETER CALLESEN

1. How do you describe your work?

'Semi romantic conceptual crafted paper cuts' - I see paper cuts as art. I often use the universal 80g A4 paper sheet, cut out and fold up shapes and images that become three-dimensional forms, and of course they don't detach from where they were folded. Frequently the paper cuts echo small romantic dramas or poetic narratives. It seems to have a certain romantic sense of loss/tragic as well as playfulness in my work and they are often in between dream and reality.

2. What inspires you to create?

It's difficult to describe, I get inspiration from all sort of places: my daily life, fairytales, the wild nature, relationships, cities or other artists. I could get inspired wherever and from whatever. What is important is your openness towards your surroundings.

3. What do you find the most playful and exciting in the process?

Many of my work are explorations of the relationship between two and three dimensionality, between image and reality. But my work is not only formal investigations. I turn a flat piece of paper into a 3D form in an almost magic process and the figures still stick to their origin, without 'escaping.'

4. What makes you choose the current media and execution approach for your work?

I find paper and especially A4 paper interesting because it is such an ordinary material and media. Everyday we all consume enormous amounts of A4 paper without noticing it as material. That has given me the freedom to rediscover it as a material. I also like its fragility. Some of the work are so small and delicate that you don't dare to touch them, which gives me a more intensive experience.

5. What other media would you like to challenge yourself with?

At the moment I find plenty of challenge in working with paper, but maybe I would like to combine my paper cuts with more drawing, as I feel that adds another dimension to the work.

6. Who in the field catches your attention the most recently?

Some video work that I found moving and haunting. They are shadow plays; their simplicity combined with the sad music creates a significant beauty.

7. Who would you like to collaborate with and why?

Maybe working on a stage set for a theatre play, in which I use paper in another way. A theatre director and I have spoken about maybe doing something together one day.

8. What would you like to be if not an artist?

9. Please close your eyes and draft the first image in your mind.

GENEVIEVE DIONNE

1. How do you describe your work?

Light hearted, humorous, a bit melancholy at times.

2. What inspires you to create?

Craft supplies, found materials, scrap wood, old photos, and other ephemera. Just having a lot of different materials at my fingertips.

3. What do you find the most playful and exciting in the process?

it's most exciting when an idea is just starting to form, almost spontaneously and without over thinking it. I can't wait to get it out of my head and into the world.

4. What makes you choose the current media and execution approach for your work?

My drawing style has always been very linear. when I saw a woodburning tool at a craft supply store I realized how lovely it would be to actually burn the line into the surface I quickly fell in love with the colour and qaulity of the line, as well as the cozy smell of toasting wood.

5. What other media would you like to challenge yourself with?

Id like to try and unite drawing with ceramics because I really love wheelthrowing and working with clay.

6. Who in the field catches your attention the most recently?

There are many canadian artists who catch my attention, such as Matthew Feyld, Julie Morstad + Ray Fenwick.

7. Who would you like to collaborate with and why?

I like to collaborate with many of my friends, we often get together and have collaborative drawing nights. I like it because it's unpretentious, the results can be awful or amazing, but always very interesting!

8. What would you like to be if not an artist?

I would like to bake pies all day ~~████████████~~

9. Please close your eyes and draft the first image in your mind.

SOME QUESTIONS ANSWERED BY....

Artist 05 WWW.MILESDONOVAN.CO.UK / WWW.PEEPSHOW.ORG.UK

MILES DONOVAN / FOR 'ILLUSTRATION/PLAY'

1. How do you describe your work? \ CRAVING FOR THE EXTRAORDINARY

TRADITIONAL PAINTING MIXED WITH THE
FLEXIBILITY OF MODERN DIGITAL TECHNIQUES.

2. What inspires you to create?

THINGS IN THE STREET, THINGS IN BOOKS, STUFF ON TV, PEOPLE
IN THE STUDIO, NEW YORK, LONDON, WARHOL, HITCHCOCK, SAUL BASS,
BASQUIAT, M SASEK, N/M PARIS, MINGERING MIKE, COLUMBO.

3. What do you find the most playful and exciting in the process?

ANYTHING. BUT THE PROCESS (THAT'S THE BORING BIT) SO
EITHER THE VERY START, RESEARCHING, EXPERIMENTING OR
WHEN IT IS FINISHED. (HURRAH!)

4. What makes you choose the current media and execution approach for your work?

MY WORK TENDS TO JUMP AROUND A BIT IN TERMS OF STYLE, AT THE MOMENT
IT'S QUITE INKY & SPONTANEOUS FEELING, NOTHINGS PLANNED, JUST
SORT OF HAPPENED.

5. What other media would you like to challenge yourself with?

I THROW ANYTHING INTO THE MIX WITHIN REASON, NOT SURE WHERE
NEXT JUST YET. I THINK SOME DRAWING IS CALLED FOR.

6. Who in the field catches your attention the most recently?

UMM...HELLOVON, ERIN PETSON, LITTLE FRIENDS OF PRINTMAKING,
MICHAEL GILLETTE, AUTUMN WHITEHURST, ANYONE WHO CAN DRAW.
THE MEMBERS OF PEEPSHOW. CHRIS DENT. MATTHEW HAWKINS.

7. Who would you like to collaborate with and why?

AUTUMN WHITEHURST, IT'S BEEN ON THE CARDS FOR A
WHILE BUT JUST HASN'T HAPPENED YET, WE BOTH NEED TO
FIND THE TIME (I'LL EMAIL HER IN A SECOND...)

8. What would you like to be if not an artist?

STUNTMAN, SPACEMAN, ~~LIBRAN~~
 TING LIBRARIAN, (IN THAT ORDER) OHH..WORK IN A
RECORD SHOP OR PUT THINGS IN ORDER (I LIKE DOING THAT)

9. Please close your eyes and draft the first image in your mind.

STEPHANIE DOTSON

1. How do you describe your work?

Multi media prints and installations… or printstallations.

2. What inspires you to create?

Anything can inspire me! It can be interesting formal properties from my landscape or in printed matter.. and sometimes there are situations, aesthetic or just feelings where things, out of context create a new narrative.. sometimes they both happen at the same time and that's what I look for. That and when making something new that excites me, coming up with a new idea or a new design, this motivates me to keep on working.

3. What do you find the most playful and exciting in the process?

Putting things together. When you have made all of the components of your installation and you spend weeks arranging and re-arranging the pieces to get to the place where it just feels right.
Painting on the wall is really fun too

4. What makes you choose the current media and execution approach for your work?

Whatever material is light enough to ship, strong enough to ship and collapsible enough to fit into my truck.
All this and whatever allows me to work in layers.

5. What other media would you like to challenge yourself with?

Clay. I'd like to explore the "small object" facet of my work.
That and I love the feeling of working with something so malleable.

6. Who in the field catches your attention the most recently?

David Ellis, Michael Kruegger, MK12.
And a mess of others who've been catching my attention for quite some time now.

7. Who would you like to collaborate with and why?

Maybe Kyle Field or Will Oldham because I like to pair pictures with words and sounds.

8. What would you like to be if not an artist?

Probably a hairdresser.

9. Please close your eyes and draft the first image in your mind.

It's a shape that looks like a bunch of commas put together, with rounded and pointy parts sticking out.
It's green but the sides of it are beige with burgundy polka dots. I saw that and an orange alternately.

CATALINA ESTRADA

1. How do you describe your work?

It's a bit difficult to describe your own work, but I'd say it's very emotional, colorful, detailed and very personal.

2. What inspires you to create?

Many, many things: Nature, music, people, traveling to exciting new places, reading books, songs lyrics, folk art, memories from my childhood, movies, and love.

3. What do you find the most playful and exciting in the process?

The moment when I realize that what I'm doing is defenetly comming out the right way. Then I get really excited about it!

4. What makes you choose the current media and execution approach for your work?

It depends on the project I'm up to. Sometimes I want to work in big format so this leads me to certain media, sometimes I feel like working small and I want to try some other media.

5. What other media would you like to challenge yourself with?

Ceramics, I want to draw "porcelain.

6. Who in the field catches your attention the most recently?

There are many great people out there doing the most amazing stuff, Evan B. Harris, Olaf Hajek, Kathy Ruttemberg, Yuka Yamaguchi, just to name a few.

7. Who would you like to collaborate with and why?

M. Ward, because I'm in love with his voice and with his music.

8. What would you like to be if not an artist?

Professional dancer or a Super Cheff.

9. Please close your eyes and draft the first image in your mind.

Catalina estrada.

AJ Fosik

1. How do you describe your work?

"AN EARTHQUAKE WRAPPED IN A HURRICANE,
NESTLED IN A BOX OF TSUNAMIS."

2. What inspires you to create?

"GIMME A PIGFOOT AND A BOTTLE OF BEER, SEND
ME 'CAUSE I DON'T CARE."

3. What do you find the most playful and exciting in the process?

"CREATIVE ACTIVITY COULD BE DESCRIBED AS A
TYPE OF LEARNING PROCESS WHERE THE TEACHER
AND PUPIL ARE LOCATED IN THE SAME PERSON"

4. What makes you choose the current media and execution approach for your work?

"BEAUTY MAY BE SKIN DEEP BUT UGLY GOES
CLEAR TO THE BONE"

5. What other media would you like to challenge yourself with?

"THERE IS A TIME TO STOP READING TO STOP TRYING TO
WRITE, THERE IS A TIME TO KICK THE WHOLE BLOATED
SENSATION OF ART OUT ON ITS WHORE ASS"

6. Who in the field catches your attention the most recently?

WILLIAM BUZZELL, MATT LIENES, ALEX LUKAS
KEITH JONES, RICHARD COLEMAN, JOSH KEYS,
ELIZABET HUEY

7. Who would you like to collaborate with and why?

"TOO MANY MIDWIFES MAKE A LAZY CHILD"

8. What would you like to be if not an artist?

"A WORKING CLASS HERO IS SOMETHING TO BE"

9. Please close your eyes and draft the first image in your mind.

"A CLOUD EATEN BY THE MOON"

MELVIN GALAPON

1. How do you describe your work?

 BRIGHT, COLOURFUL, ~~████~~ VARIED AND PLAYFUL.

2. What inspires you to create?

 MUSIC, FILMS, TV, HUMOUR AND FELLOW FRIENDS / FAMILY.

3. What do you find the most playful and exciting in the process?

 I GUESS NOT REALLY KNOWING WHAT I'M GOING TO CREATE NEXT IS THE
 EXCITING PART AND DECIDING WHAT MEDIA TO USE IS THE PLAYFUL PART.

4. What makes you choose the current media and execution approach for your work?

 IT DEPENDS ON THE PROJECT, SOMETIMES THE INITIAL IDEA DETERMINES THE
 MEDIA AND OTHER TIMES THE MEDIA I WANT TO USE OFTEN MAKES ME
 CONSIDER IDEAS THAT COMPLIMENT THE PROJECT AT HAND.

5. What other media would you like to challenge yourself with?

 PAINTING AS ITS SOMETHING I HAVEN'T DONE SINCE COLLEGE.

6. Who in the field catches your attention the most recently?

 I DON'T THINK THERE'S ONE INDIVIDUAL THAT CATCHES MY ATTENTION, BUT MORE
 OF A HANDFUL OF PEOPLE. THE WORKS OF MELLOVON, MR. BINGO, ADAM HAYES,
 DANNY SANGRA, SI SCOTT, IAN WRIGHT, EMILY ALSTON AND HOLLY WALES ALWAYS SEEM
 TO KEEP MY ATTENTION.

7. Who would you like to collaborate with and why?

 I'D REALLY LIKE TO COLLABORATE WITH MUSICIANS IN A BAND. I'VE ALWAYS
 WANTED TO DO AN ALBUM COVER EVER SINCE I ~~████~~ WENT TO MY FIRST
 GIG WHEN I WAS 16.

8. What would you like to be if not an artist?

 A LEAD / RHYTHM GUITARIST IN AN INDIE / ELECTRO BAND.

9. Please close your eyes and draft the first image in your mind.

MELVIN

STEVEN HARRINGTON

1. How do you describe your work?

LINE, SHAPE, COLOR, FORM, LIFE.

2. What inspires you to create?

THE WHOLE OF EVERYTHING TOGETHER AT ONCE, THE CONGOS, PLANET EARTH, YOU.

3. What do you find the most playful and exciting in the process?

MISTAKES AND INTUITION.

4. What makes you choose the current media and execution approach for your work?

THE UNIVERSE.

5. What other media would you like to challenge yourself with?

CLAY.

6. Who in the field catches your attention the most recently?

TADANORI YOKOO.

7. Who would you like to collaborate with and why?

MY DAD, BECAUSE HE HAS AN AMAZING BRAIN.

8. What would you like to be if not an artist?

AN OAK TREE.

9. Please close your eyes and draft the first image in your mind.

STEVEN HARRINGTON

JENNY HART

1. How do you describe your work?

An obsession with embroidering

2. What inspires you to create?

Anything that's overly embellished

3. What do you find the most playful and exciting in the process?

The unpredictable way thread creates lines and texture

4. What makes you choose the current media and execution approach for your work?

I'm addicted to it

5. What other media would you like to challenge yourself with?

Leather tooling

6. Who in the field catches your attention the most recently?

Matt Rodriguez

7. Who would you like to collaborate with and why?

I want Dave Cole to build a giant embroidered wall with me

8. What would you like to be if not an artist?

a French teacher

9. Please close your eyes and draft the first image in your mind.

CAROLINE HWANG

1. How do you describe your work? My work usually has somber undertones, but I hope that it reflects a bit of hope as well. It has a homespun aesthetic but with a modern twist.

2. What inspires you to create? A lot of things, anything from films to music to other people's art. Most of the time, the experiences that people have inspires me to create. I like to people watch and I wonder what's going on in their lives. I take a lot from what goes on in my life as well.

3. What do you find the most playful and exciting in the process?

Seeing it all come together in the end. I plan, as well as organically place each color/fabric down, but it never makes sense until its all done. I think that's the most exciting part.

4. What makes you choose the current media and execution approach for your work?

As a kid, I always used to watch my grandmother knit and crochet and took comfort in that. I think a part of that stuck with me. Due to my work being so somber, I like the fact that the quilting/homespun quality lends a bit of comfort.

5. What other media would you like to challenge yourself with?

I'd liked to work three-dimensionally more with fabric and thread. I still have yet to figure out how to do that dynamically but I've seen a lot more people do it recently and it's been really inspiring.

6. Who in the field catches your attention the most recently?

I've become a really big fan of charley Harper's. His work is so graphic yet it portrays so much depth. Its so different from what how I work so I'm very much in awe of it.

7. Who would you like to collaborate with and why?

Ideally it would be someone like miranda July or Wes anderson. Someone who uses a different medium than I do but also conveys the same kind of human emotion that I hope to convey.

8. What would you like to be if not an artist? A cook or a baker. Its still creative and at the same time you could bring joy to the many foodies. My hobby is to cook and bake now so sometimes I daydream about being a cook or baker.

9. Please close your eyes and draft the first image in your mind.

Caroline Hwang

Artist 13

1. How do you describe your work?

Whimsical, cute but dark in Grimm fairytale way.

2. What inspires you to create?

Everyday silly conversations with friends, films, NYC library picture collections, Science page of NYTimes, and walking around different country and seeing different cultures.

3. What do you find the most playful and exciting in the process?

Uuu this is heard I enjoy all the process.
But I get excited the most when I'm creating a story that I want to tell or draw about.

4. What makes you choose the current media and execution approach for your work?

I usually make my story and the idea first then pick materials that make most sense for each projects. So I've been open and using different media for different projects.
Last installation idea was me creating an imaginary tribe and their rituals, so I decided of doing a display like natural history museum.
I made a drawings that tells a story about the tribe, little sculptures, and embroidery blankets which my imaginary tribe used for their rituals.

5. What other media would you like to challenge yourself with?

I'm would love to make more 3D objects,
and also i would love to make some animation one day!

6. Who in the field catches your attention the most recently?

I love drawings Julie Morstad makes and Andrew Brandou's paintings.
Also Camille Rose Garcia, Melinda Beck and David Sandlin and I love Miwa Koizumi's food performance.

7. Who would you like to collaborate with and why?

I would love to collaborate with chief, flower arrangements or tea ceremony professionals.
Because I think it would be interesting and challenging to collaborate with people who has really different way of presenting art.

8. What would you like to be if not an artist?

Work in a zoo as penguin or seal's care taker.
Or Explore

9. Please close your eyes and draft the first image in your mind.

In a open filed on to of a mountain with Sheeps looking at nice view together, Sheeps hair are made out of ice cream so I enjoy the view and put some toppings on sheeps and eat them.

JOHANNA LUNDBERG

1. How do you describe your work?

Design trying to communicate the subject by being straightforward and playful, exploring new mediums to use.

2. What inspires you to create?

Everything from other designers to my cousin's children's toys lying around the house.

3. What do you find the most playful and exciting in the process?

Visualising the concept I developed through my research.

4. What makes you choose the current media and execution approach for your work?

Circumstances, what the subject is, where I am etc...

5. What other media would you like to challenge yourself with?

Moving image

6. Who in the field catches your attention the most recently?

GH a visual agency from New York

7. Who would you like to collaborate with and why?

My friend Linnea Mählén because we work great together.

8. What would you like to be if not an artist?

Meteorologist – I'm obsessed with the weather.

9. Please close your eyes and draft the first image in your mind.

Johanna Lundberg

Artist 15
CAROLINA MELIS

1. How do you describe your work?

Angharad Lewis - from Grafik, the magazine - once wrote about my work something like "a subtle drama with delicate flamboyance..." it's my favourite description, thanks Angharad!

2. What inspires you to create?

Many things, many people, many films, many songs, many dreams, many days doing nothing and thinking a lot (and eating even more..)

3. What do you find the most playful and exciting in the process?

Probably when I realise I had a good idea and I truely believe it's a good idea.
(sometime I pretend just to make myself happy-)

4. What makes you choose the current media and execution approach for your work?

In the case of the embroidery work, it was pure chance.. I bought some fabric and I felt I had to use it somehow - So I started stitching bits together and I couldn't stop for weeks...

5. What other media would you like to challenge yourself with?

Outfittism. I would like to design and make an entire outfit. Everything from shoes to clothes to hairstyle to make-up. I'm actualey working on it but it may take awhile ... as long as it is

6. Who in the field catches your attention the most recently? ready for my wedding I'm fine.

uhmm...

7. Who would you like to collaborate with and why?

Who? Someone with incredible ideas, amazing skills, lots of patience, unique personality.
Why? Why not, could be handy.

8. What would you like to be if not an artist?

Still an artist but maybe of a different kind. I wanted to become a ballet dancer but it didn't work out, shame. Otherwise a doctor, everybody respect doctors..

9. Please close your eyes and draft the first image in your mind.

Carolina Melis in person

(SORRY ABOUT MY ENGLISH)

SANDRINE PELLETIER

1. How do you describe your work?

ARTS & CRAFT SHOWBUSINESS ON ACID TRIP

2. What inspires you to create?

MUDANE, INSANE, ABSURDITY, BEAUTY AND UGLYNESS
OF EVERY DAY'S LIFE

3. What do you find the most playful and exciting in the process?

CURIOUSLY, I'M INTERESTED AND EXCITED BY THE MANUFACTURE.
ONCE IT'S DONE, AND SHOWED, IT'S SORT OF ALREADY OVER AND "DONE"
THINKING ABOUT THE NEXT STEP / NEXT PROJECT

4. What makes you choose the current media and execution approach for your work?

HAZARD, CURIOUSITY AND 'SAVOIR FAIRE' FASCINATION

5. What other media would you like to challenge yourself with?

I AM ACTUALLY STARTING TO WORK ON A "CARTOON". I WANTED
TO TRY MULTIMEDIA AND ANIMATION.
AND OF COURSE, A MUPPET SHORT FILM ANIMATION, TOO

6. Who in the field catches your attention the most recently?

RENÉ LALIQUE'S EXHIBITION IN PARIS. HE WAS A FABULOUS
JEWELLER FROM THE 20THCENTURY. THIS IS WHAT I CALL
JEWELLERY.

7. Who would you like to collaborate with and why?

JIM HENSON AND FREDDIE MERCURY IN THE AFTER LIFE. WE WILL HAVE
A LOT OF FUN. EXEPT FROM THAT, IF YOU READ THIS, MARYLIN MANSON,
I'M VOLUNTARY TO DESIGN YOUR NEXT SLEEVE
RECORD

8. What would you like to be if not an artist?

A POOL DANCER OR A DRUM PLAYER IN A METAL
BAND

9. Please close your eyes and draft the first image in your mind.

CAT-A-SHOE.

SANDRINE
PELLETIER

ROBERT RYAN

RobRyan

1. How do you describe your work?

Painstaking Romantic ☆ ☀
Soul Searching ○ Questioning.

2. What inspires you to create?

The need to share, to communicate
with the rest of the world.....

3. What do you find the most playful and exciting in the process?

I like to sit and work on something for one hour, 2 hours
3 hours and after about 4 hours the ideas are
formulating and coming quickly. It is still
an EXCITING feeling.

4. What makes you choose the current media and execution approach for your work?

I just choose a way to say things
SIMPLY and BOLDLY and BEAUTIFULLY
as possible.

5. What other media would you like to challenge yourself with?

I would (and am going to start soon) like to work in Jewellery.
and FILM. CERAMICS. Wooden Sculpture. Small Buildings.

6. Who in the field catches your attention the most recently?

The English Photographer TIM WALKER (a fresh eye)
The American Illustrator → Maira Kalman (a big soul)

7. Who would you like to collaborate with and why?

The Above
But they are a million times better than me.

8. What would you like to be if not an artist?

NOTHING THIS QUESTION is an impossibility

9. Please close your eyes and draft the first image in your mind.

One day
YOU WILL FLY!

RICHARD SAJA

1. How do you describe your work?

cheeky & irreverent

2. What inspires you to create?

the voices in my head

3. What do you find the most playful and exciting in the process?

the spontaneity of my method.

4. What makes you choose the current media and execution approach for your work?

toile excites w/ all it's possibilities

5. What other media would you like to challenge yourself with?

ceramics

6. Who in the field catches your attention the most recently?

Megan whitmarsh

7. Who would you like to collaborate with and why?

were he alive, Fornasetti - he's a kindred spirit

8. What would you like to be if not an artist?

a silvery marmoset

9. Please close your eyes and draft the first image in your mind.

Richard Saja

VICKY SCOTT

1. How do you describe your work?

fashion based, paper collages inspired by the 20's, humour and making people smile

2. What inspires you to create?

Daydreams, Vogue, 1920s fashion and life in general, going for walks, 60's pschedilia, fairytales

3. What do you find the most playful and exciting in the process?

Collages give you the chance to discover new things and allow you to make (good) mistakes either by cutting out wrong things or placing colours together that I wouldn't have considered.

4. What makes you choose the current media and execution approach for your work?

Desire to be different and not rely to heavily on Photoshop, as well as time constraints

5. What other media would you like to challenge yourself with?

3D - making my collages into 3 dimensional scenes

6. Who in the field catches your attention the most recently?

It changes all the time - but at the moment I like Miss Led, Pilar Alvarez and Ray Caesar, although I'll always love 20's Illustrator Erte and early Andy Warhol.

7. Who would you like to collaborate with and why?

A fashion designer or a Photographer - maybe both at the same time, I can imagine elements of my pieces work in a fashion photo.

8. What would you like to be if not an artist?

I've never wanted to do anything else, so can't imagine it.

9. Please close your eyes and draft the first image in your mind.

Vicky Scott

LISA SOLOMON

1. How do you describe your work?

I try to use a blend of old & new tecthiques to make work that I think is rooted in drawing. I hope to create work that is both conceptually & aesthetically appealing.

2. What inspires you to create?

It sounds corny - but everything. things that surround me, changes in light, smells, moments & objects both big & small.

3. What do you find the most playful and exciting in the process?

Happy accidents ξ and then being able to reproduce them ξ

4. What makes you choose the current media and execution approach for your work?

I try to trust my gut instincts. I get giddy around all kinds of tools & materials. I try to choose what is right for each piece/idea.

5. What other media would you like to challenge yourself with?

I'd like to try more things with sculpture. I wish I knew how to weld.

6. Who in the field catches your attention the most recently?

It's to hard to pick. I feel inspired by & indebted to so many creative people.

7. Who would you like to collaborate with and why?

I'm open to collaborations of all sorts. I'm really attracted to collaborating with people in seemingly disperate fields (like scientists). An impossible - but dream collaboration would be one with Eva Hesse.

8. What would you like to be if not an artist?

A gardener in a bontanical garden.

9. Please close your eyes and draft the first image in your mind.

MEGAN WHITMARSH

1. How do you describe your work? My work details the detritus of pop culture & the modern world, augmented by a subjective iconography and recorded in the low tech manner of sewing, stop action animation, comics & drawing.

2. What inspires you to create?

A desire to order the ataxia of modern life, without however, managing to make it discernible. I want to transform the everyday into something magical-feeling.

3. What do you find the most playful and exciting in the process?

Becoming lost in the details of a created world- the supernatural & precious elements subverted by mundane accroutements.

4. What makes you choose the current media and execution approach for your work?

A humble medium transmits optimism as one can feel inspired to create as well without the interference of machinery or skill. It is an amateur medium.

5. What other media would you like to challenge yourself with?

I would like to make more stop action animated films.

6. Who in the field catches your attention the most recently?

I like Misaki Kawaii, C.F., Andrew Jeffrey Wright, Paper Rad, Chris Johansen...

7. Who would you like to collaborate with and why?

I would like to finish a stop action puppet video Matt Salata and I are making as a music video for his band "Dolphinforce."

8. What would you like to be if not an artist?

A science fiction novelist.

9. Please close your eyes and draft the first image in your mind.

An ice cream cone.

Megan Whitmarsh

MEGAN WILSON

1. How do you describe your work? I'm interested in the relationships between power, space, and culture. Most recently I've been exploring the intersections between "fine art," design, architecture, and traditional craft.

2. What inspires you to create?
All my experiences & observations — traveling to new places, — local, national & world politics and social/economic justice — a desire for beauty in environments

3. What do you find the most playful and exciting in the process?
All of it — researching, learning, developing ideas, creating the work and seeing where it takes me and transpires in the world.

4. What makes you choose the current media and execution approach for your work?
It always depends on the concept that I'm working with — I work in many different media forms

5. What other media would you like to challenge yourself with?
Film & video, architecture

6. Who in the field catches your attention the most recently?
Yayoi Kusama, TSUI Design & Research, Maurice Agis, Rural Studio

7. Who would you like to collaborate with and why?
Yayoi Kusama, TSUI Design & Research, Rural Studio — I love their senses of space & design — and imagination

8. What would you like to be if not an artist?
Designer or gardener or architect — ideally all three combined

9. Please close your eyes and draft the first image in your mind.

Megan Wilson

IAN WRIGHT

1. How do you describe your work?

PORTRAITURE → CURRENTLY
LARGE SCALE / MODULAR / INTRICATE
OBSESSIVE!

2. What inspires you to create?

PEOPLE / MUSIC / LITERATURE / MATERIALS
→ THE IDEA THAT YOU CAN

3. What do you find the most playful and exciting in the process?

THE DEVELOPMENT OF THE PROCESS ITSELF
— EXPERIMENTING WITH WHAT COULD BE

4. What makes you choose the current media and execution approach for your work?

IT SEEMS LIKE A NATURAL PROGRESSION

5. What other media would you like to challenge yourself with?

BIGGER / LOUDER / FASTER / BRIGHTER

6. Who in the field catches your attention the most recently?

THE WORK OF BARRY MCGEE / J. DILLA /
JAMIE HEWLETT / KAREL MARTENS /
RICHARD PRINCE / GARY PANTER

7. Who would you like to collaborate with and why?

LIKE MINDED PEOPLE FROM OTHER FIELDS
→ TO TRY TO BREAK / EXPLORE NEW
AREAS

8. What would you like to be if not an artist?

STILL WORKING ON THE ARTIST IDEA

9. Please close your eyes and draft the first image in your mind.

IT'S FOREVER CHANGING

IW AUGUST 2007